# THE CLASSIC
# COLLECTION

**LIFE Books**

EDITOR Robert Sullivan
DIRECTOR OF PHOTOGRAPHY Barbara Baker Burrows
CREATIVE DIRECTOR Richard Baker
DEPUTY PICTURE EDITOR Christina Lieberman
WRITER-REPORTER Hildegard Anderson
COPY CHIEF Parlan McGaw
PHOTO ASSISTANT Forrester R. Hambrecht
CONSULTING PICTURE EDITORS
Mimi Murphy (Rome), Tala Skari (Paris)

PRESIDENT Andrew Blau
BUSINESS MANAGER Roger Adler
BUSINESS DEVELOPMENT MANAGER Jeff Burak

EDITORIAL OPERATIONS Richard K. Prue,
David Sloan (Directors), Richard Shaffer
(Group Manager), Brian Fellows, Raphael Joa, Angel Mass,
Stanley E. Moyse, Albert Rufino
(Managers), Soheila Asayesh, Keith Aurelio,
Trang Ba Chuong, Charlotte Coco, Osmar Escalona,
Kevin Hart, Norma Jones, Mert Kerimoglu,
Rosalie Khan, Marco Lau, Po Fung Ng, Rudi Papiri,
Barry Pribula, Carina A. Rosario,
Christopher Scala, Diana Suryakusuma, Vaune Trachtman,
Paul Tupay, Lionel Vargas, David Weiner

Time Inc. Home Entertainment
PUBLISHER Richard Fraiman
GENERAL MANAGER Steven Sandonato
EXECUTIVE DIRECTOR, MARKETING SERVICES Carol Pittard
DIRECTOR, RETAIL & SPECIAL SALES Tom Mifsud
DIRECTOR, NEW PRODUCT DEVELOPMENT Peter Harper
ASSISTANT DIRECTOR, BRAND MARKETING Laura Adam
ASSOCIATE COUNSEL Helen Wan
SENIOR BRAND MANAGER TWRS/M Holly Oakes
BOOK PRODUCTION MANAGER Suzanne Janso
DESIGN & PREPRESS MANAGER Anne-Michelle Gallero
SENIOR MARKETING MANAGER Joy Butts
BRAND MANAGER Shelley Rescober

Special thanks to Alexandra Bliss,
Glenn Buonocore, Susan Chodakiewicz, Margaret Hess, Arnold Horton,
Robert Marasco, Dennis Marcel, Brooke Reger, Mary Sarro-Waite,
Ilene Schreider, Adriana Tierno, Alex Voznesenskiy

ISBN 10: 1-60320-030-4
ISBN 13: 978-1-60320-030-1
Library of Congress #: 2008902954

"LIFE" is a trademark of Time Inc.

We welcome your comments and suggestions about LIFE Books.
Please write to us at:
LIFE Books
Attention: Book Editors
PO Box 11016
Des Moines, IA 50336-1016

If you would like to order any of our hardcover
Collector's Edition books,
please call us at 1-800-327-6388
(Monday through Friday, 7:00 a.m.–8:00 p.m.,
or Saturday, 7:00 a.m.–6:00 p.m., Central Time).

Printed in Thailand

# CONTENTS

# INTRODUCTION

# WELCOME TO OUR GALLERY

THE PICTURES IN THIS BOOK, which today stand as works of art, were created strictly in fulfillment of a journalistic enterprise. It was Henry Luce's dream back in the mid-1930s to give America an exciting, large-format magazine that told stories in words and pictures—particularly pictures. Its subject matter would be, in Luce's grand design, any- and everything. In his baroque "Prospectus for a New Magazine," Luce wrote (under the ponderous heading, THE PURPOSE): "To see life; to see the world, to eyewitness great events; to watch the faces of the poor and the gestures of the proud; to see strange things—machines, armies, multitudes, shadows in the jungle and on the moon; to see man's work— his paintings, towers and discoveries; to see things thousands of miles away, things hidden behind walls and within rooms, things dangerous to come to; the women that men love and many children; to see and take pleasure in seeing; to see and be amazed; to see and be instructed . . . To see, and to be shown is now the will and new expectancy of half mankind. To see and to show is the mission now, for the first time, undertaken by a new kind of publication, SCOPE, *The Show-Book of the World . . .*"

There never was a SCOPE, as you certainly have surmised. By the time Luce's newest magazine launched on Thursday, November 19, 1936, it had been rechristened LIFE, and under that banner it instantly wowed the country.

It continued to do so for decades, in different incarnations—weekly, monthly—and in hundreds of special issues and books. Countless thousands of photographs taken by many of the world's greatest photographers, as well as hundreds taken by the man in the street, graced LIFE's pages. Millions more images wound up on the cutting-room floor.

Over time, a sizeable selection of LIFE's best or most famous pictures took on the patina of classics. Many evoked a person or place or moment in time so acutely, they came to be regarded as the crucial visual representation of that person, place or moment in time. Others were simply so dynamic—so beautiful, so dramatic or so humorous—that they became icons of a sort, part of the nation's collective aesthetic consciousness.

There are more of these LIFE classics than just 100, to be sure. But in planning this book, we decided to pare our selection to that number. Why? Well, if Henry Luce wanted to create with his *Show-Book* "a new kind of publication," then our aspiration with the Classic Collection was to create a new kind of book.

In their original uses—and in subsequent appearances in LIFE books and commemoratives—these photographs were presented in a journalistic environment, which is to say a wordy one. They were

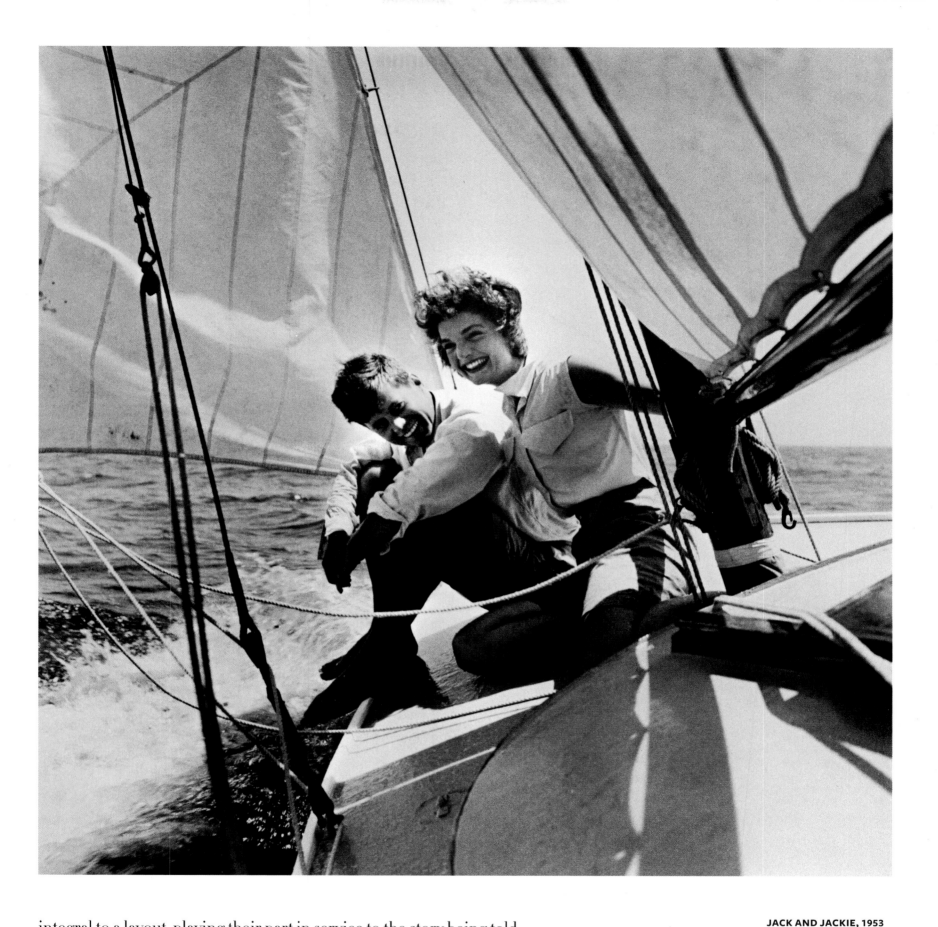

integral to a layout, playing their part in service to the story being told.

This time out, we wanted to give each picture the space and presentation it has earned. To that end, we even went so far as to take the page numbers off our pictorial pages. Do not worry, the book remains simple to navigate and, yes, there is information about the pictures: the photograph's title in quotation marks (if it has a formal title), the year the photo was taken, interesting shoptalk about the photographers and how they came to make their sensational images. These extended captions appear at regular, short intervals throughout the book on the pages backing the removable, suitable-for-framing prints.

**JACK AND JACKIE, 1953**
The couple's first cover shot for LIFE showed the senator and his fiancée sailing off Cape Cod. Another photo of Jackie and Jack beat this one for inclusion in our Classic Collection. Can you guess which one? Please see page 24.
PHOTOGRAPH BY
HY PESKIN

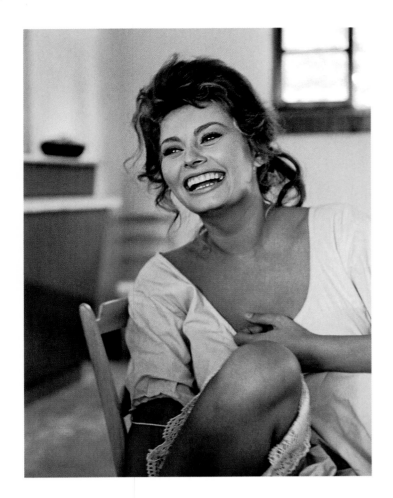

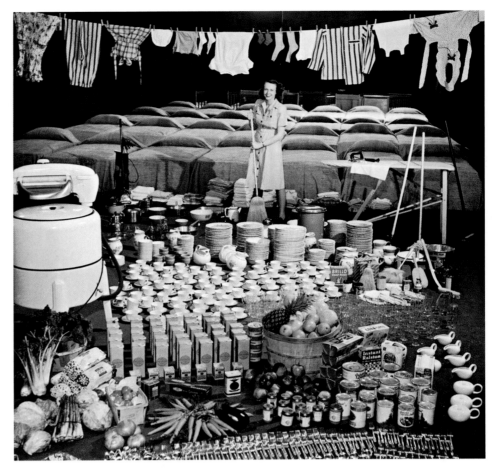

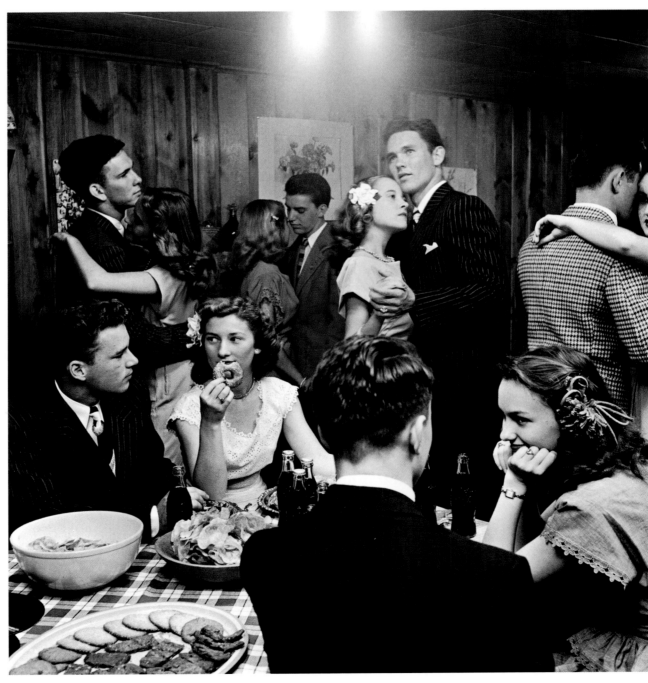

**SOPHIA LOREN, 1961**
Over the years, the Italian actress and photographer Eisenstaedt had a close relationship and it led to many memorable portraits, including this one. As we shall see, other LIFE photographers enjoyed similar trusting friendships with big stars—Gordon Parks with Ingrid Bergman, Milton Greene with Marilyn Monroe—and these, too, yielded classic pictures.
PHOTOGRAPH BY
ALFRED EISENSTAEDT

**"HOUSEWIFE," 1947**
Big photographic productions were features of LIFE, as here, when we depicted a week's housework as accomplished by Marjorie McWeeney, wife and mother of three from Rye, N.Y., who was surrounded by 35 beds to make, 750 items of glass and china to wash, 175 pounds of food to prepare and 250 pieces of laundry to handle.
PHOTOGRAPH BY
NINA LEEN

**TEENAGERS, 1947**
Here the versatility of a LIFE photographer is on display. Please consider that the staged shot of the housewife, above, and this intimate portrait of Tulsa teens were made in the same year by the same shooter, Nina Leen. It was hard for us to choose between this picture of Young America and the one that is found on page 136.
PHOTOGRAPH BY
NINA LEEN

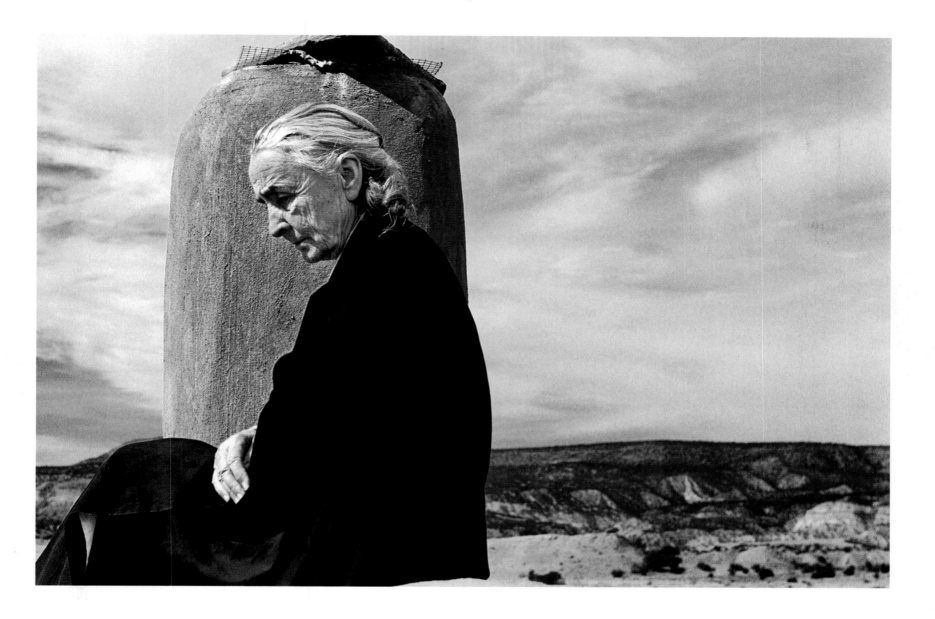

Ah, yes: the prints! That's the ultimate new feature of this new kind of book. It seemed obvious to us that a reader might, in traveling a volume such as this, say at some point, "I wish I could hang that on my wall." Now the reader can. We have selected 25 of the most sensational photographs ever to appear in LIFE to be part of this collection within a collection. And as you will find: When you remove the print, the picture still exists on the page, and your deluxe book remains whole.

So we came up with this plan, and figured out how to execute it. Now came the hard part. Which pictures would make the cut?

The good news is, our director of photography, Barbara Baker Burrows, has been with LIFE for more than four decades, and is the institutional memory of all things having to do with the magazine. You might say that the Classic Collection has existed in Bobbi Burrows's head for several years now. When a tough choice on this photo or that photo had to be made, we turned to Bobbi—who agonized, surely, but did make the call.

If you want the slightest hint as to what delights await you in the pages to follow, consider that the pictures that accompany this Introduction did not squeeze their way into the Classic Collection. You recognize some if not all of them, of course, and perhaps you would choose one or two of these over our selections—and we wouldn't blame you. If this is indeed the case, please accept our apology. Tempting as it might have been to include another vibrant shot of Jackie and Jack, or another actress as lovely as Sophia, we finally had to draw the line.

And now, the gallery doors are open.

# PEOPLE

... THE FACES OF THE POOR AND
THE GESTURES OF THE PROUD ...

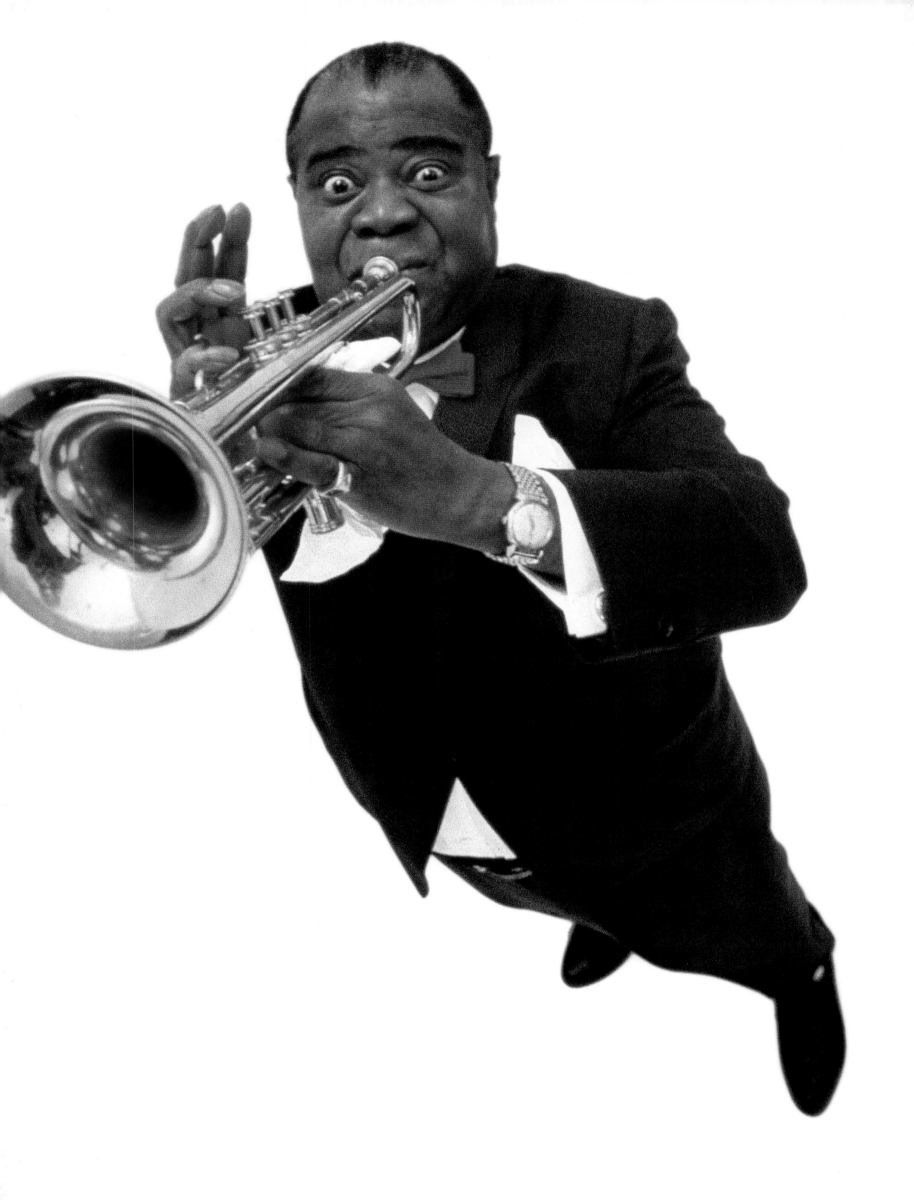

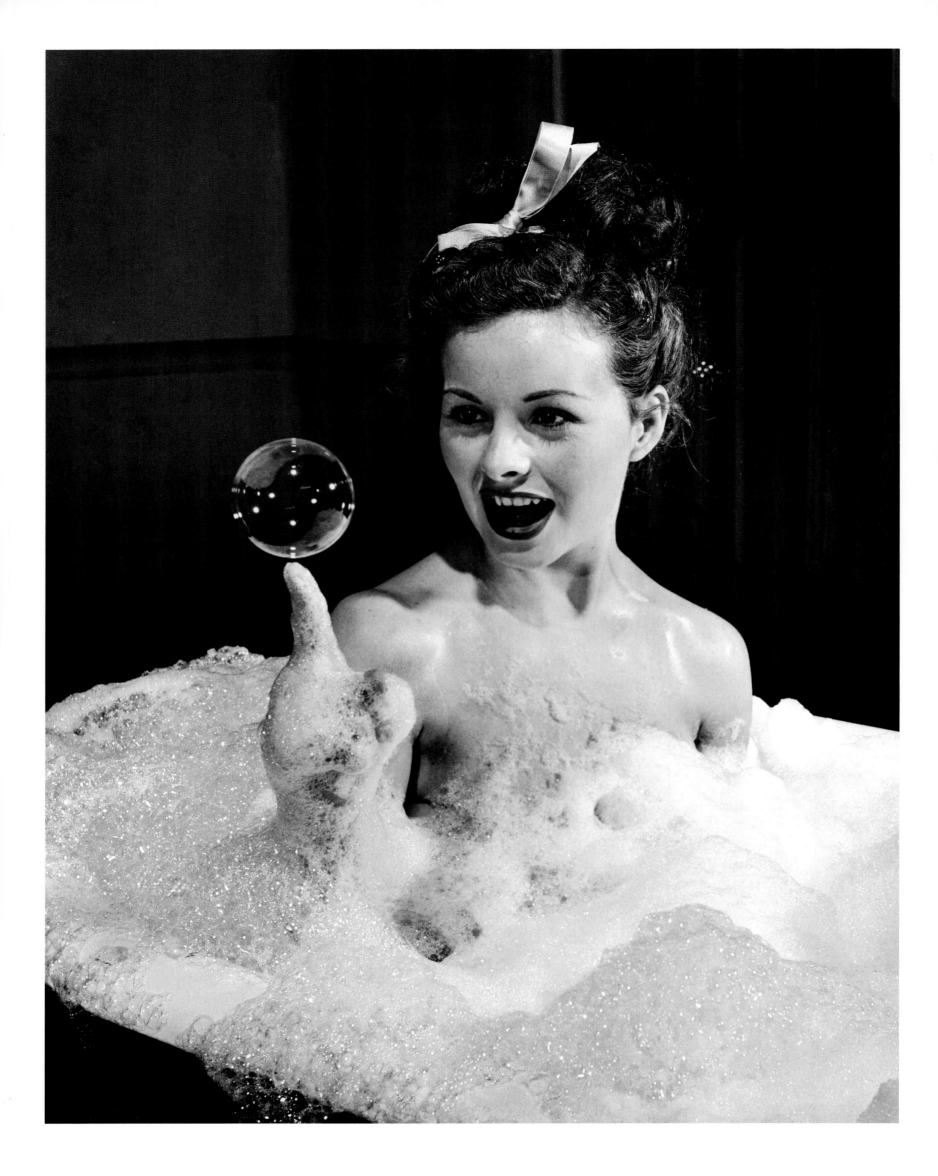

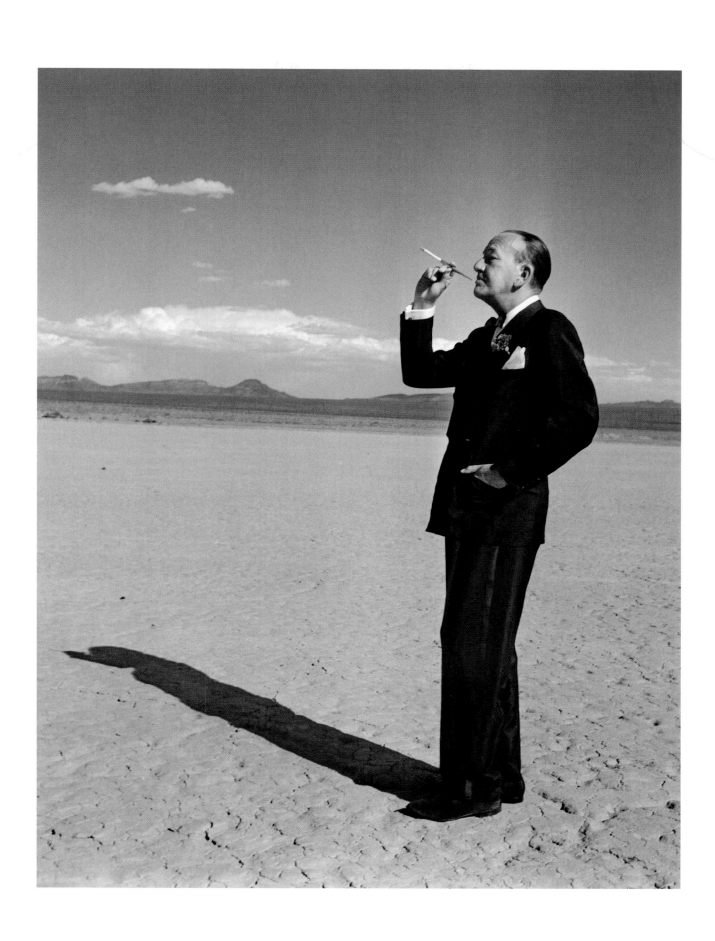

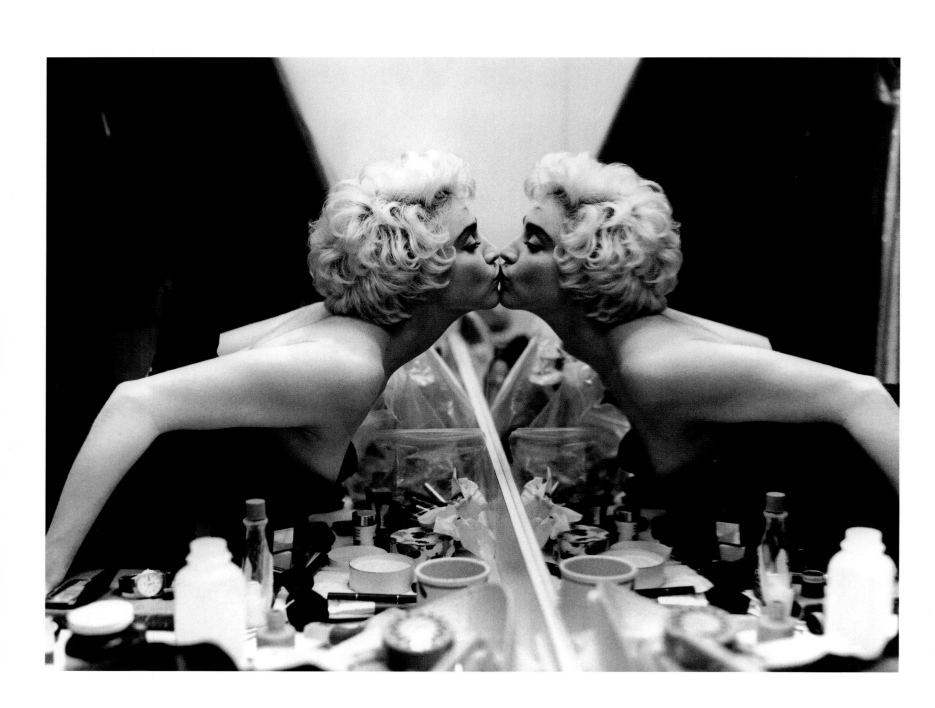

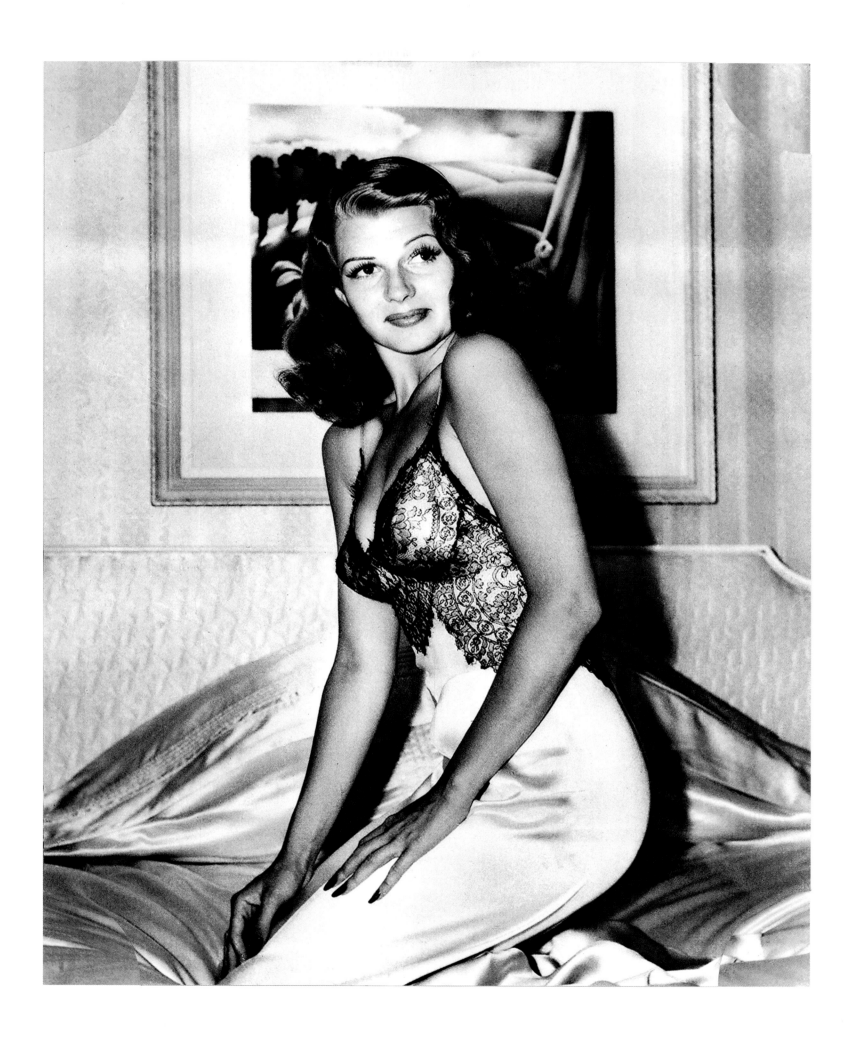

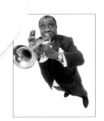

Page 9
**LOUIS ARMSTRONG, 1966**
"As a photographer, you try to use the tools of the trade," said Philippe Halsman. "If it is a painter you are photographing, you use a brush or an easel for a prop. For a sculptor, a chisel. For Mae West, you use a big bed." And for the American icon known as Satchmo, you make sure there's a trumpet. Halsman forged more cover images for LIFE—101—than any other photographer, and here is evidence of a pro at work: The shot is exciting in and of itself, and you can see where the logo could go.
PHOTOGRAPH BY PHILIPPE HALSMAN

Page 10
**JEANNE CRAIN, 1946**
A job requirement for a LIFE staff photographer was the ability to do it all, and Peter Stackpole, one of the magazine's four original staffers, was certainly up to that challenge. He entered battle zones in World War II, then returned home to tackle less tumultuous subjects. Working the Hollywood beat, Stackpole created memorable portraits of Gary Cooper, Shirley Temple and, here, Jeanne Crain. This cover shot is remembered today by many who can't recall who, exactly, Jeanne Crain was. (If you've forgotten: She was a semimajor star, appearing often as the female romantic lead.)
PHOTOGRAPH BY PETER STACKPOLE

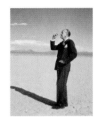

Page 11
**NOËL COWARD, 1955**
"We knotted our ties and set off to con people into all sorts of things they frequently didn't want to do," said Loomis Dean concerning the modus operandi of a LIFE photographer. The disarming Dean could coax and con with the best of them; he got the Prince of Liechtenstein to pose in his long johns and the urbane Noël Coward to depict his song "Mad Dogs and Englishmen [Go Out in the Midday Sun]" in the desert near Las Vegas. Coward protested, of course—"Dear boy, I don't get up until four o'clock in the afternoon"—but a limo with a tub of ice and liquor in the back was persuasive. "Splendid! Splendid! What an idea!" exclaimed Coward at last. "If we only had a piano!"
PHOTOGRAPH BY LOOMIS DEAN

Page 12
**"AN AFFAIR TO REMEMBER," 1986**
"I want this to be a collaboration," Madonna told the fashion photographer Bruce Weber, who was on assignment for LIFE. "I want us to create this together." And so the two artists went to work, producing many riveting images and one destined to become famous. It is difficult to make a signature picture of someone who poses so often (and has so many poses), but Weber has come closest to telling this megastar's story in a single frame. As LIFE's caption put it: "Madonna admits that Marilyn Monroe was among her girlhood idols, but there's no doubt about whom Madonna loves best."
PHOTOGRAPH BY BRUCE WEBER

Page 13
**RITA HAYWORTH, 1941**
Starting on a cruiser in the Pacific when the Japanese attacked Pearl Harbor, Bob Landry was in one important place after another during World War II. He captured memorable images in Egypt during the North African campaign and in the villages of France during the final push to Germany. (He had gone in with the first wave at D-Day, but all of his film was lost—and his shoes, to boot.) But it was a peacetime picture he took in the summer of '41 that he will be remembered for most. This photo stayed in the hearts and (well, maybe) minds of American GIs for the duration and mightily impressed a civilian as well: Orson Welles saw it in LIFE and vowed to marry the starlet—and he did.
PHOTOGRAPH BY BOB LANDRY

Page 15
**INGRID BERGMAN, 1949**
The Swedish beauty was one of the top stars of the 1940s (*Casablanca, Gaslight, Notorious*), but her career in the U.S. derailed in 1949 when she left her husband and daughter for the Italian director Roberto Rossellini. Bergman could not work in an American film for seven years, though upon her return, in 1956, she won an Oscar for *Anastasia*. In the interim, she certainly suffered, but as director Jean Renoir said: "She will always prefer a scandal to a lie." LIFE's Gordon Parks was a close friend, and Bergman trusted him to the extent that she invited him to the 1949 shoot for *Stromboli*— directed by Rossellini, at the time perceived as the villain—where he made this haunting portrait.
PHOTOGRAPH BY GORDON PARKS

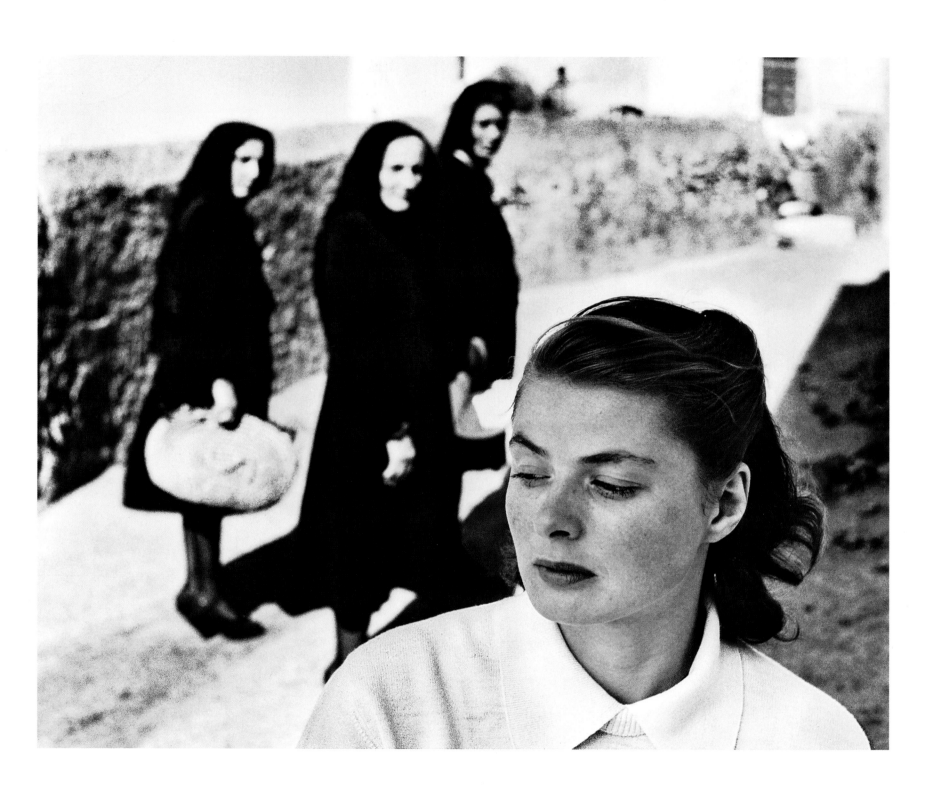

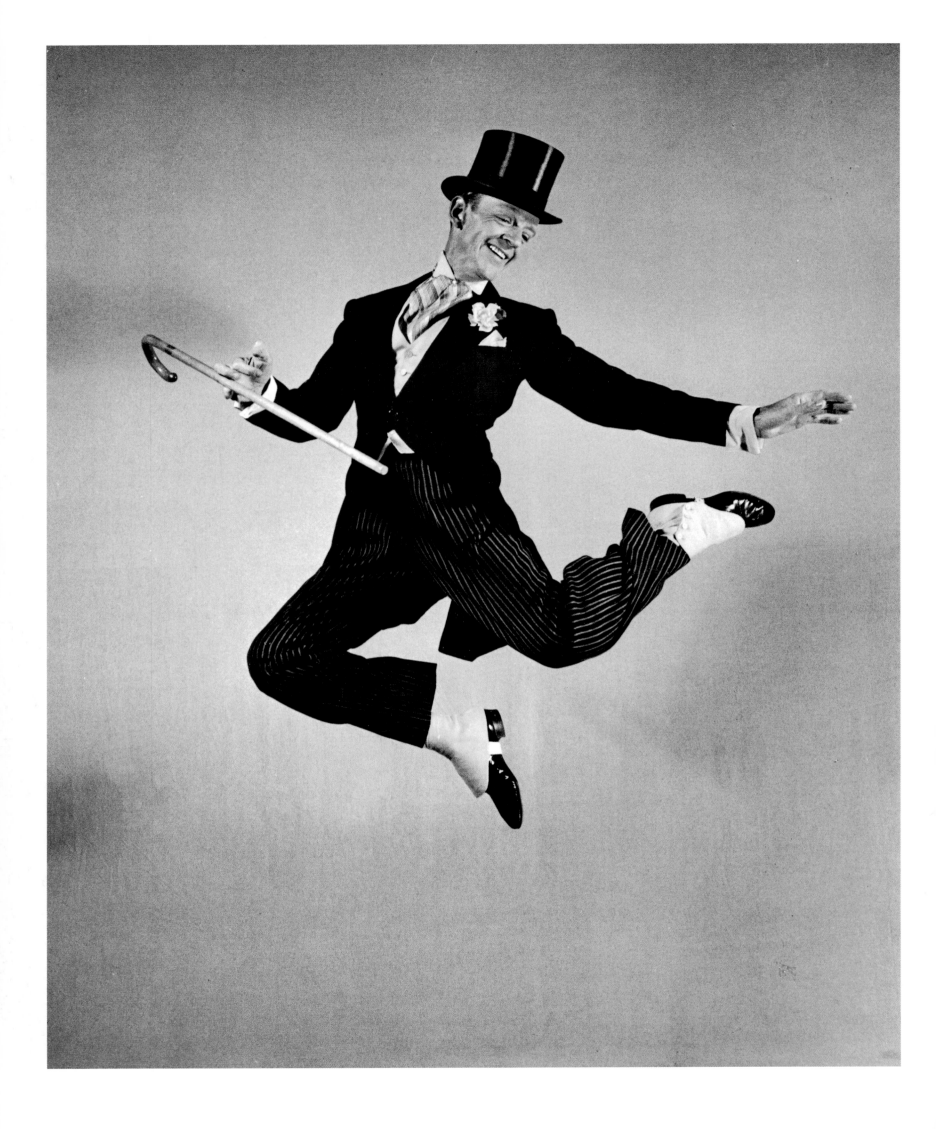

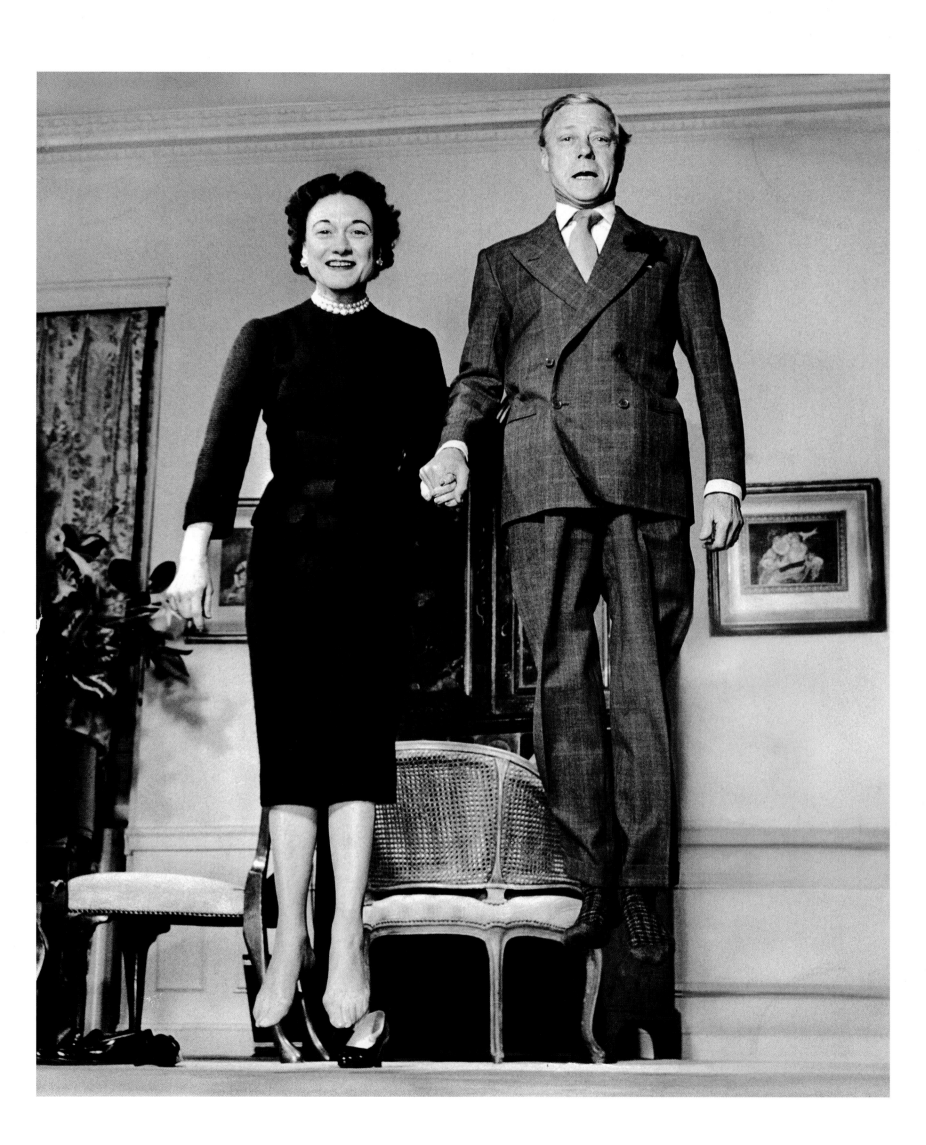

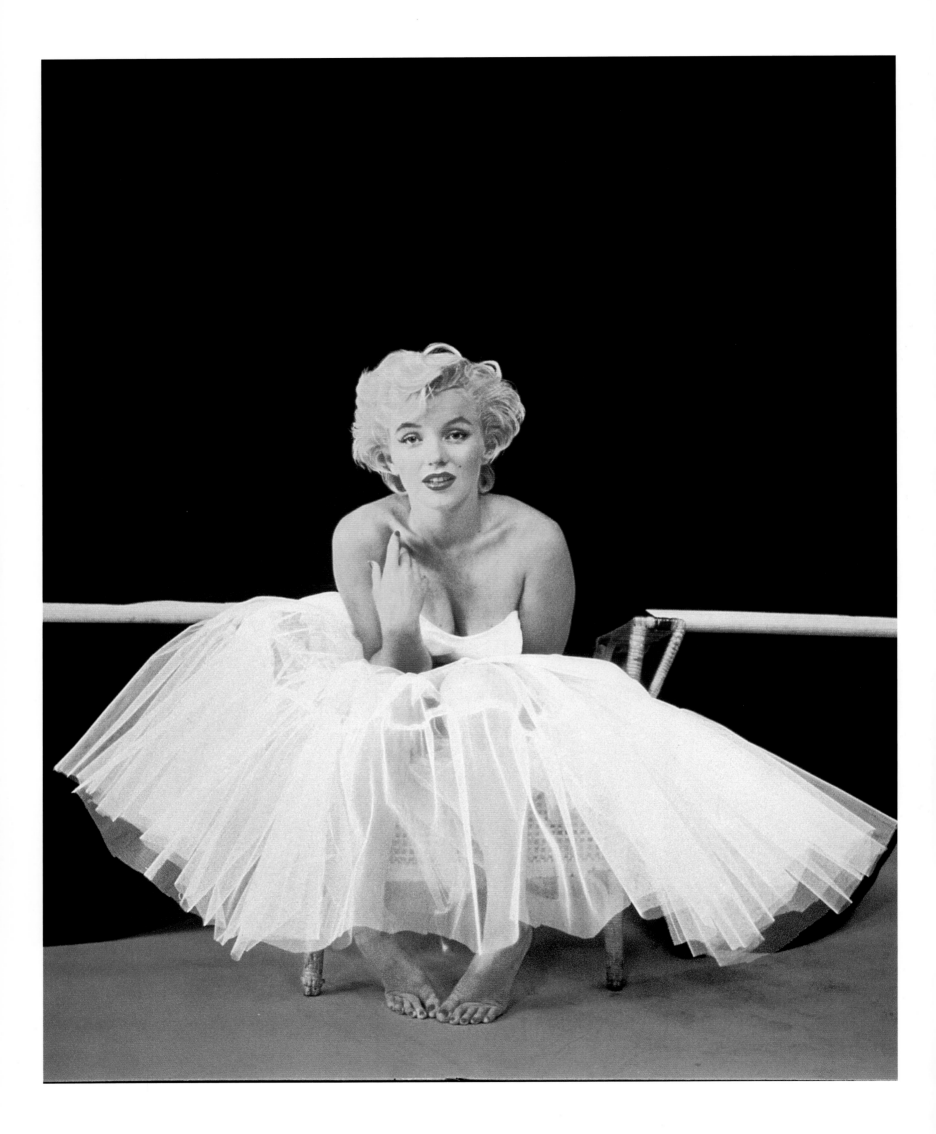

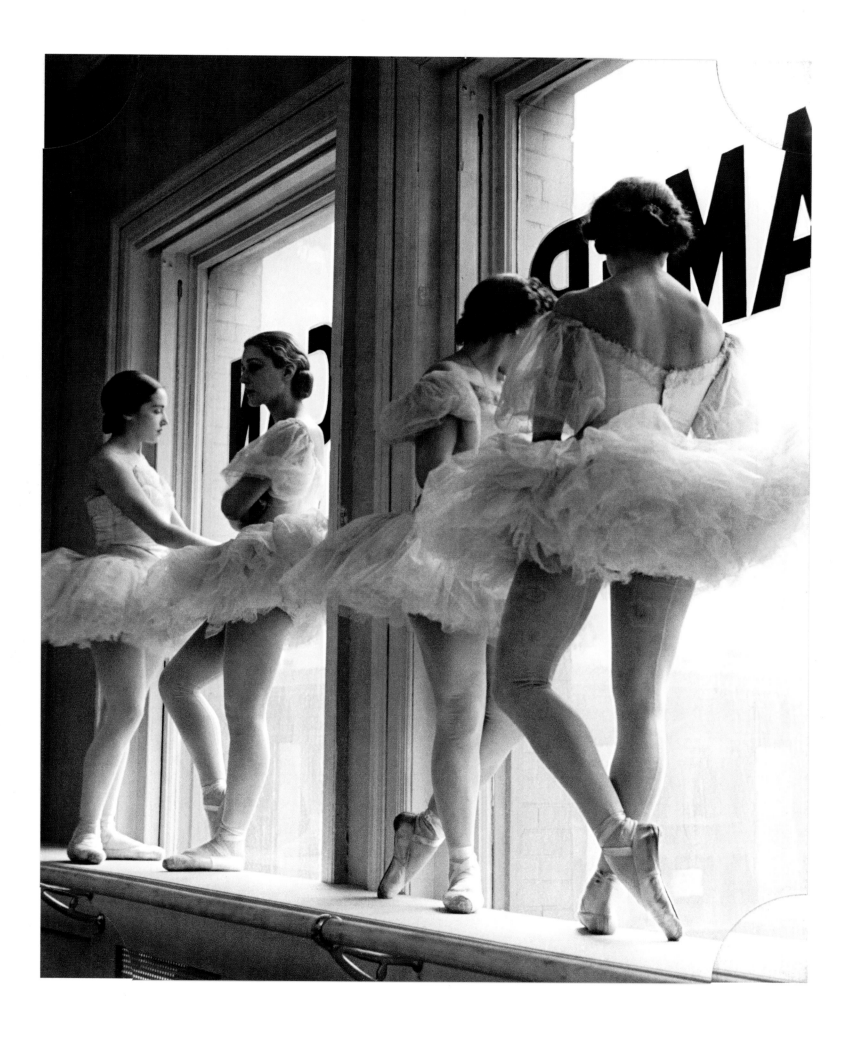

Page 16
**FRED ASTAIRE, 1945**
Even as thousands of copies of his Rita Hayworth pinup were zooming across the world to bolster the morale of U.S. troops fighting in the Pacific, Bob Landry, himself returned from the European Theater, entered the studio to make a lighter-than-air portrait of one of Hayworth's favorite dance partners. Landry could shoot fierce scenes and fun ones. Consider: Within a few months he made images for LIFE of a French woman discovering her husband's body in St. Marcouf, Normandy; of French patriots beating a German collaborator in Rennes; and this, of Hollywood's high-flying Astaire.
PHOTOGRAPH BY BOB LANDRY

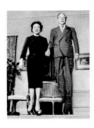

Page 17
**THE DUKE AND DUCHESS OF WINDSOR, 1956**
Halsman was one of the premier portraitists of the 20th century (three of his images appeared on postage stamps), producing work that traveled comfortably from zany to disarming to exquisite. In the former two categories—and, for that matter, maybe in the third as well—are his so-called jump photographs. Beginning in 1952 with Mrs. Edsel Ford, he routinely wound up a portrait session by asking his subjects to jump for the camera. He got Richard Nixon to jump and Marilyn Monroe to jump (she jumped 200 times, and before she left she told Halsman to call if he needed more "even if it is four in the morning"). Halsman, who called these pictures studies in "jumpology," was being whimsical. But often the joyous act of jumping allowed a mask to come off, and something true was revealed.
PHOTOGRAPH BY PHILIPPE HALSMAN

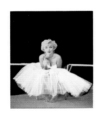

Page 18
**MARILYN MONROE, 1956**
His job, as he saw it, was to be "a photographer of beautiful women." Among Milton Greene's many subjects, in the fashion industry before joining LIFE and then for the magazine, none were more beautiful, celebrated and camera-ready than Marilyn Monroe. The two became such good friends that for a period she lived in Greene's Connecticut farmhouse with Greene and his wife. After Greene died in 1985, his photos of the famous movie star developed a life of their own: Greene's son digitally restored them; the government of Poland secretly bought them and then publicly sold them off. All these years later, they live on.
PHOTOGRAPH BY MILTON H. GREENE

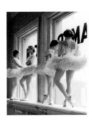

Page 19
**BALLERINAS, 1936**
Another of LIFE's original four staff photographers was Alfred Einsenstaedt, and one of Eisie's favorite subjects, from his earliest days of shooting in Germany, was the ballet. A 1936 visit he made to George Balanchine's School of the American Ballet in New York City produced no fewer than three classic images, including this one. Most of his memorable dance pictures are graceful, to be sure, but also have a Mona Lisa quality to them—the subjects, whether in action or at rest, are beautiful, focused and enigmatic. "I could stay for hours and watch a raindrop," Eisie once said. There is to his ballet photographs a feeling that we are watching lithe, lovely raindrops.
PHOTOGRAPH BY ALFRED EISENSTAEDT

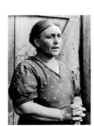

Page 21
**"MA JOAD," 1938**
She wasn't really Ma Joad; as photographer Horace Bristol freely admitted, "There was no Joad family." Here's what happened: After seeing Dorothea Lange's pictures of migrant workers, Bristol pushed John Steinbeck to work with him as a captionist for a book on the migrants' plight. After two months, Steinbeck begged off, saying there surely was a book to be made, but he saw it as a novel; Bristol later said that Steinbeck never mentioned his part in the birth of *The Grapes of Wrath*. Be that as it may, when the photographs appeared in LIFE, there were captions referencing Steinbeck characters. This anonymous woman was one of four Bristol subjects who informed the fictional Ma Joad.
PHOTOGRAPH BY HORACE BRISTOL

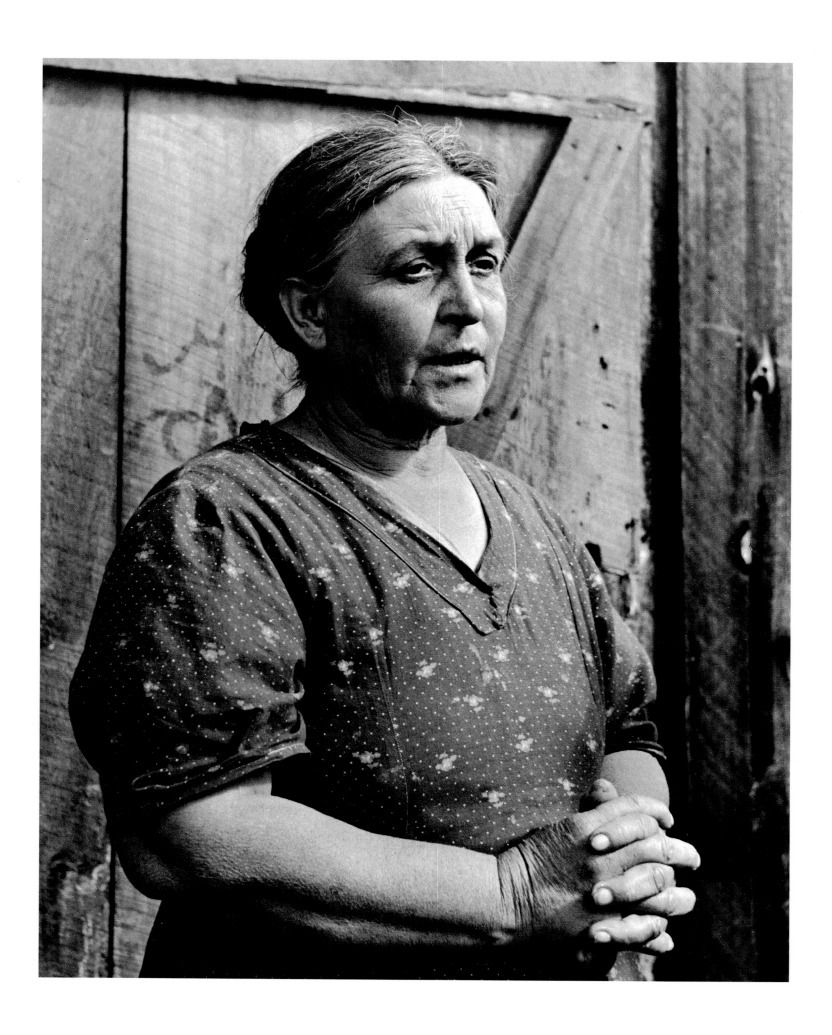

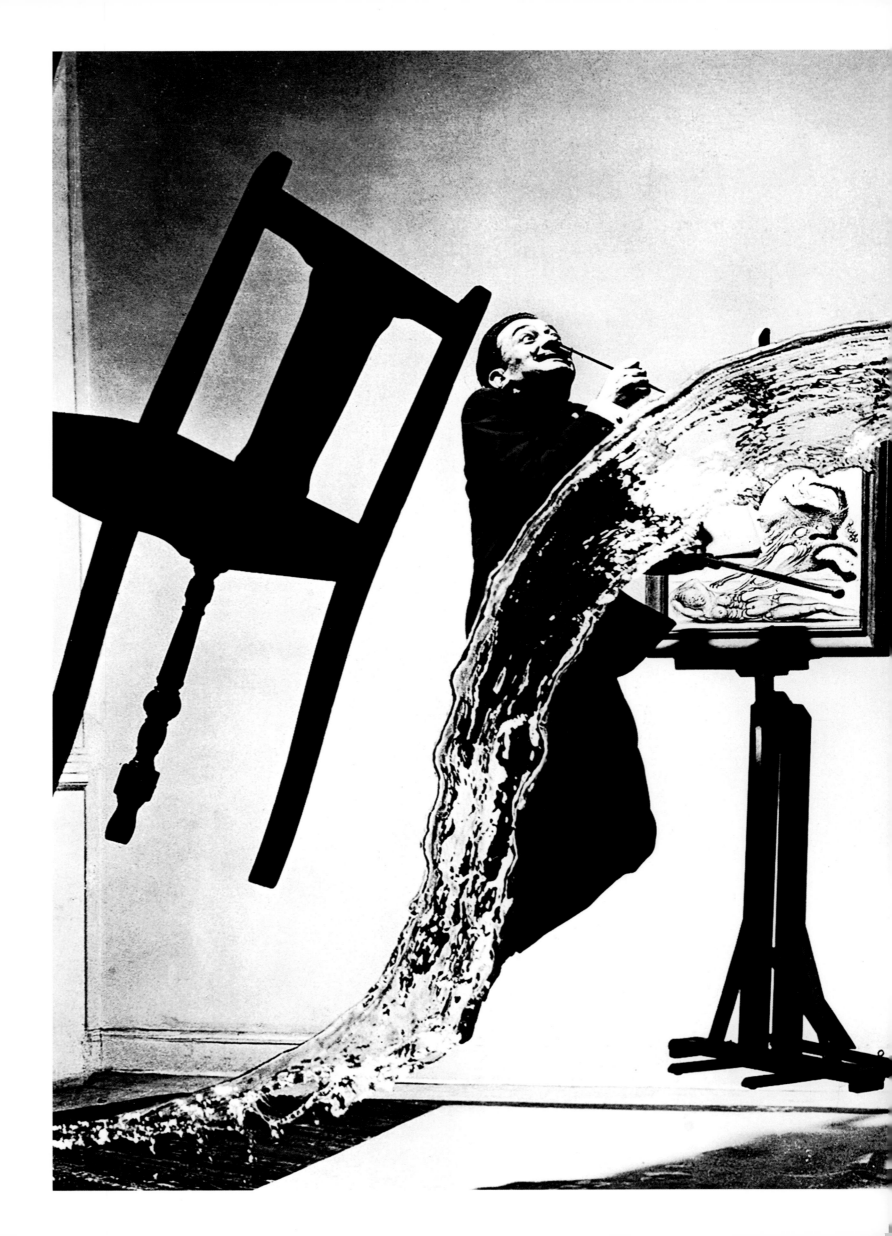

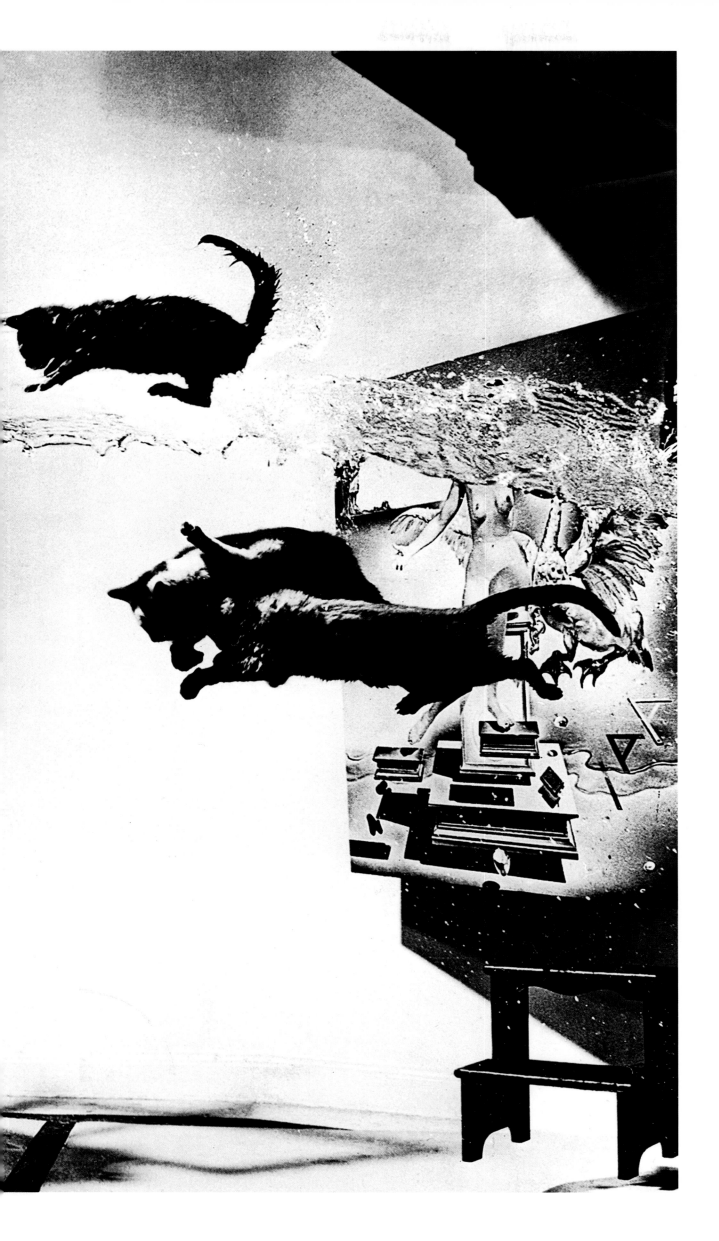

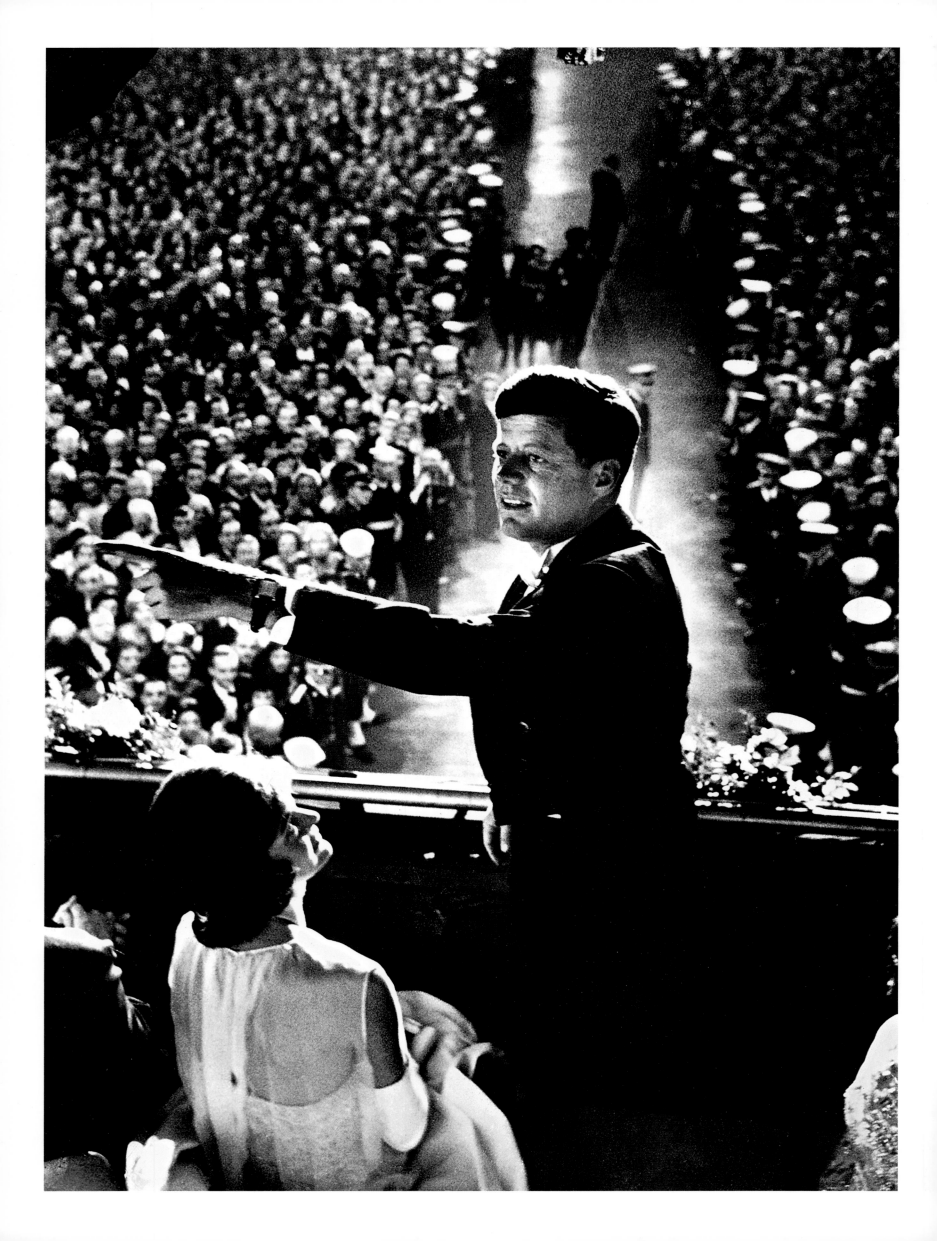

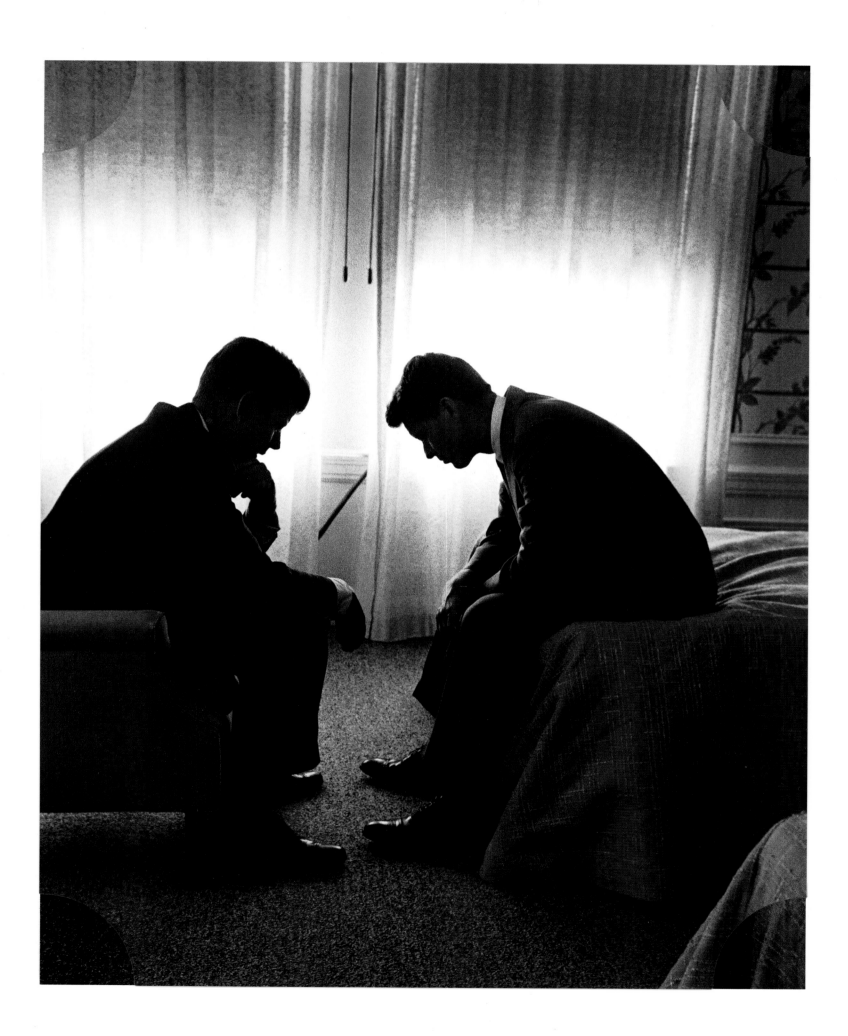

Page 22
**"DALI ATOMICUS," 1948**
Halsman met the surrealist Salvador Dali in 1941, kicking off three decades of collaboration; this remarkable portrait is the most famous result. Both artists contributed ideas for the picture, which was all about suspension—the repulsion of protons and electrons, everything in motion in the atomic world (Dali's "Leda Atomica" is seen in the right of the photo behind the two cats). In all, three cats are flying, there is a bucket of thrown water and Dali himself is airborne. Halsman engineered the production in his New York City studio, and it was his wife, Yvonne, who was off-screen, holding the chair. "Six hours and 28 throws later, the result satisfied my striving for perfection," Halsman reported. "My assistants and I were wet, dirty and near complete exhaustion—only the cats still looked like new."
PHOTOGRAPH BY PHILIPPE HALSMAN

Page 24
**JACKIE AND JACK, 1961**
The relationship between America's preeminent picture magazine and the preternaturally attractive Kennedy clan was both symbiotic and longstanding. LIFE was there early: A Hy Peskin photo that ran on July 20, 1953—showing Senator Jack Kennedy and his betrothed, Jacqueline Bouvier, enjoying a sail off the Massachusetts coast (see this book's introduction, page 5)—marked the first time Jackie appeared on the cover of a national magazine. It would be difficult to calculate how many would follow; for LIFE alone there were another 20. The most painful subsequent cover shots among Jack's 19 were, of course, from the Zapruder film of his assassination, which ran exclusively in LIFE in 1963. Here, in much happier times, Jackie and Jack attended an inaugural ball.
PHOTOGRAPH BY PAUL SCHUTZER

Page 25
**JACK AND BOBBY, 1960**
The intimacy routinely granted to LIFE's photographers by Jack (here, conferring with his brother and campaign chief in a Los Angeles hotel room during the presidential race) did not end once the White House was gained. Pictures of not only the First Couple but their children were devoured by an American public that couldn't get enough of the glamorous and energetic Kennedys. Caroline and her infant brother, John Jr., became unwitting media stars. Jackie was concerned that her children lead as normal lives as possible, but when her back was turned, JFK would sneak photographers into the West Wing. He knew not only that people loved his kids, but that the pictures were good for his own popularity.
PHOTOGRAPH BY HANK WALKER

Page 27
**RFK SLAIN, 1968**
Bill Eppridge made many tremendous images and photo essays, including a legendary piece on heroin addiction, for LIFE. But none is more famous than this one. In 1968, Eppridge was in the Ambassador Hotel in Los Angeles, where Bobby Kennedy was shot and killed by Sirhan Sirhan. While everyone's attention was on the assailant, "there in front of me was the senator on the floor being held by the busboy. There was nobody else around, and I made my first frame, and I forgot to focus the camera. The second frame was a little more in focus.... Then, for just a second...the busboy looked up, and he had this look in his eye. I made that picture, and then suddenly the whole situation closed in again. And it became bedlam."
PHOTOGRAPH BY BILL EPPRIDGE

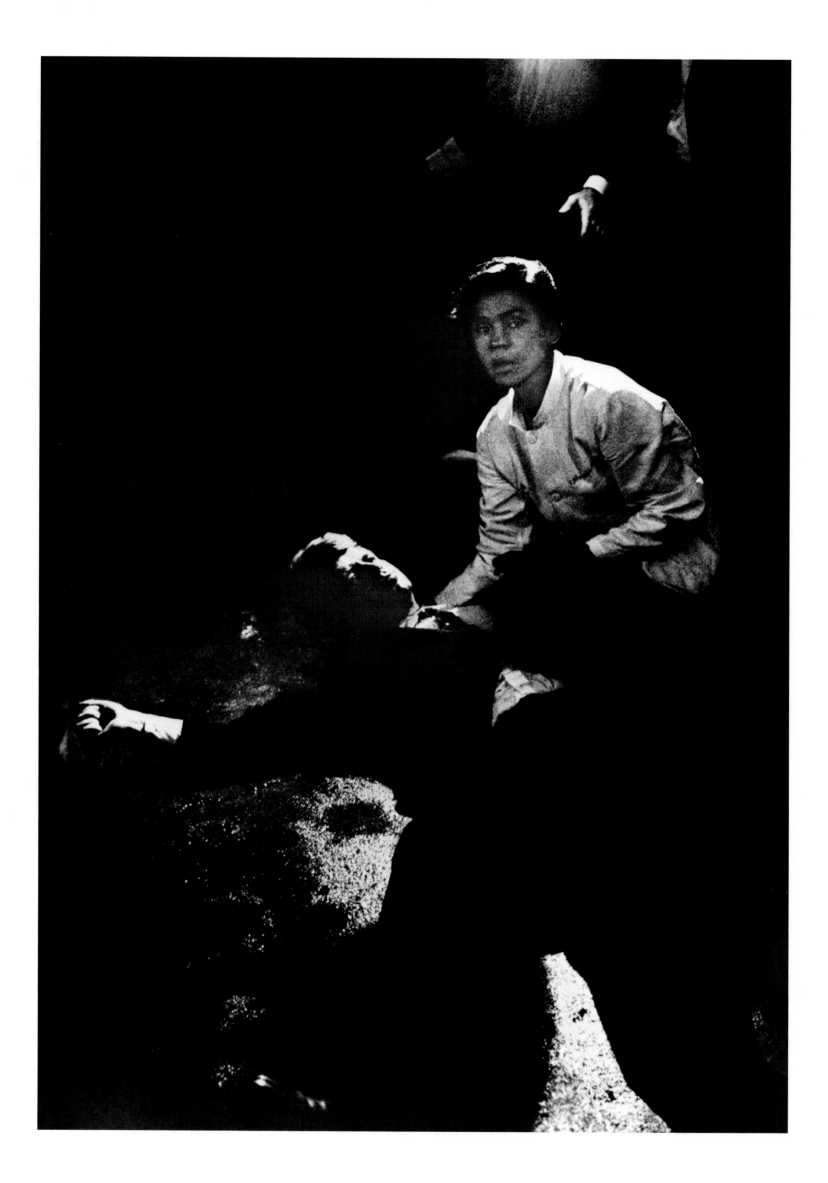

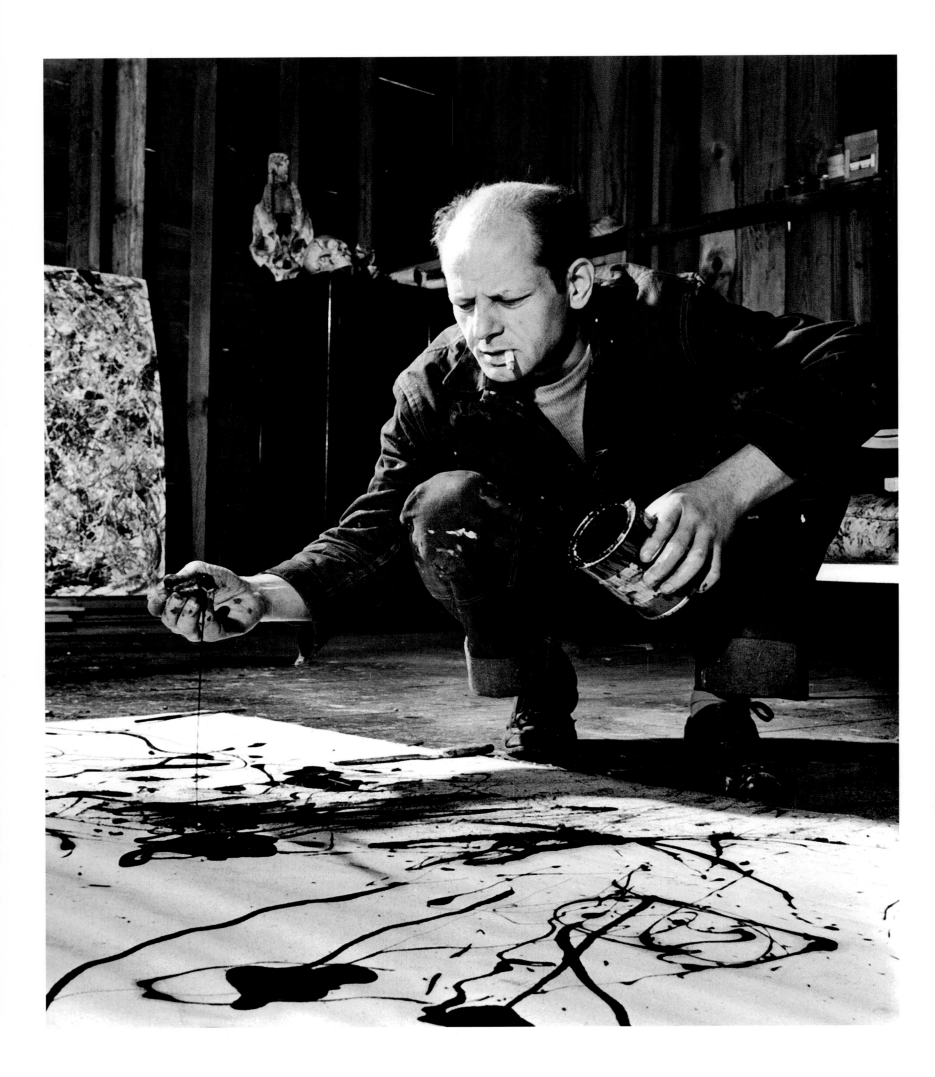

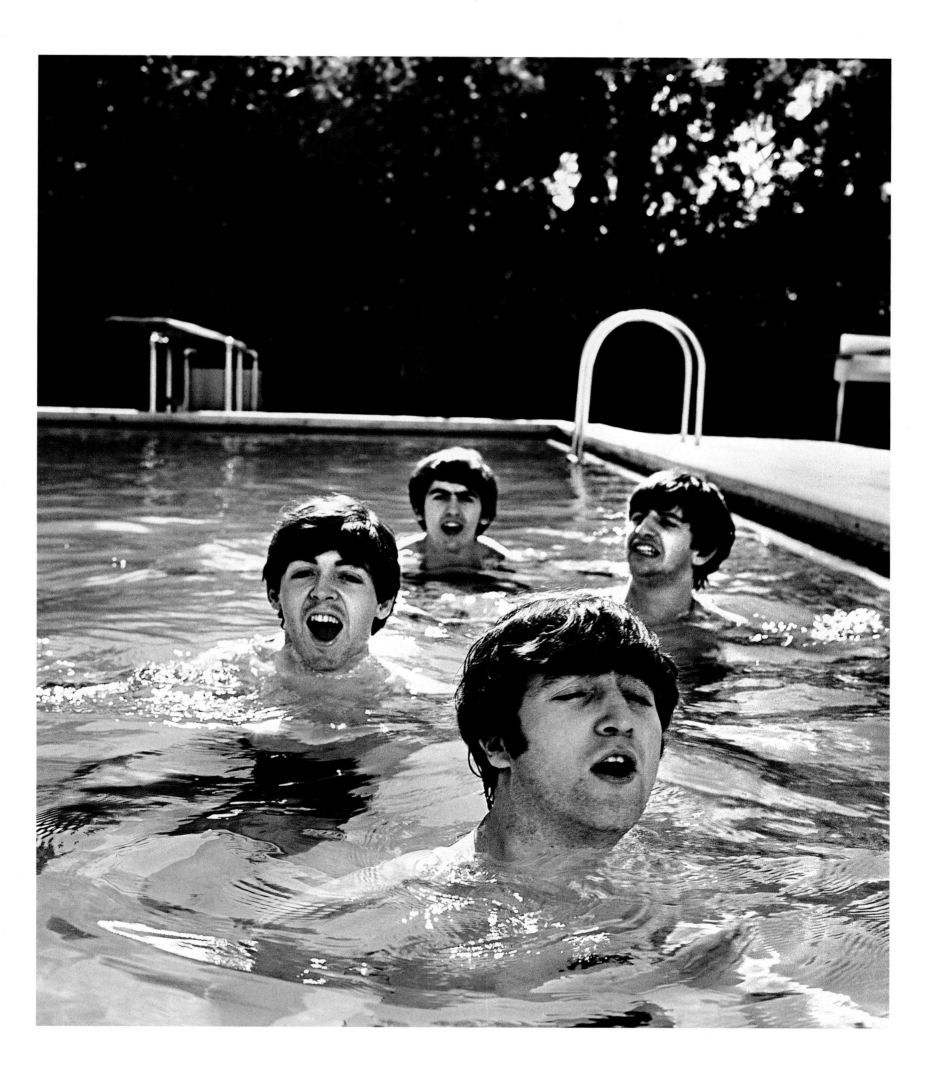

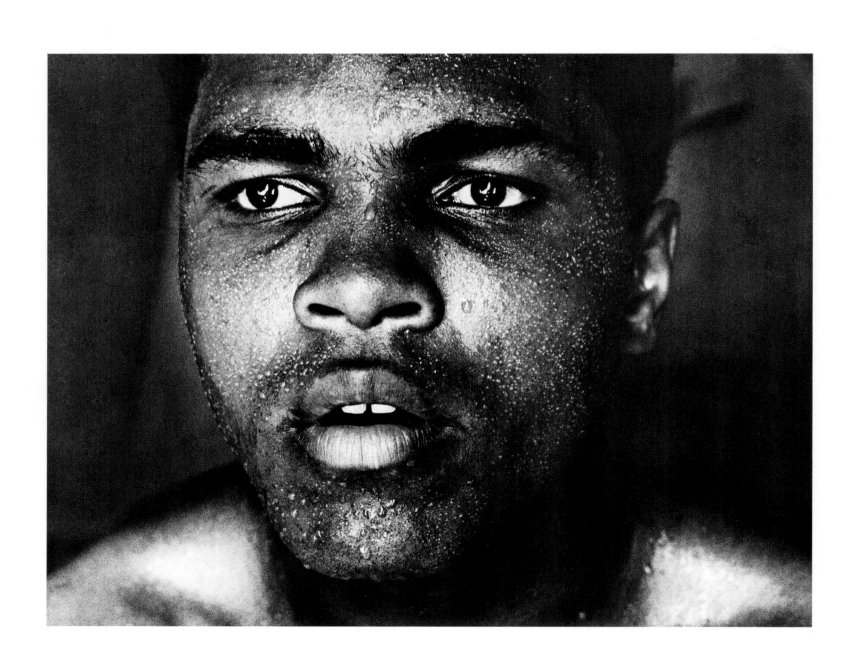

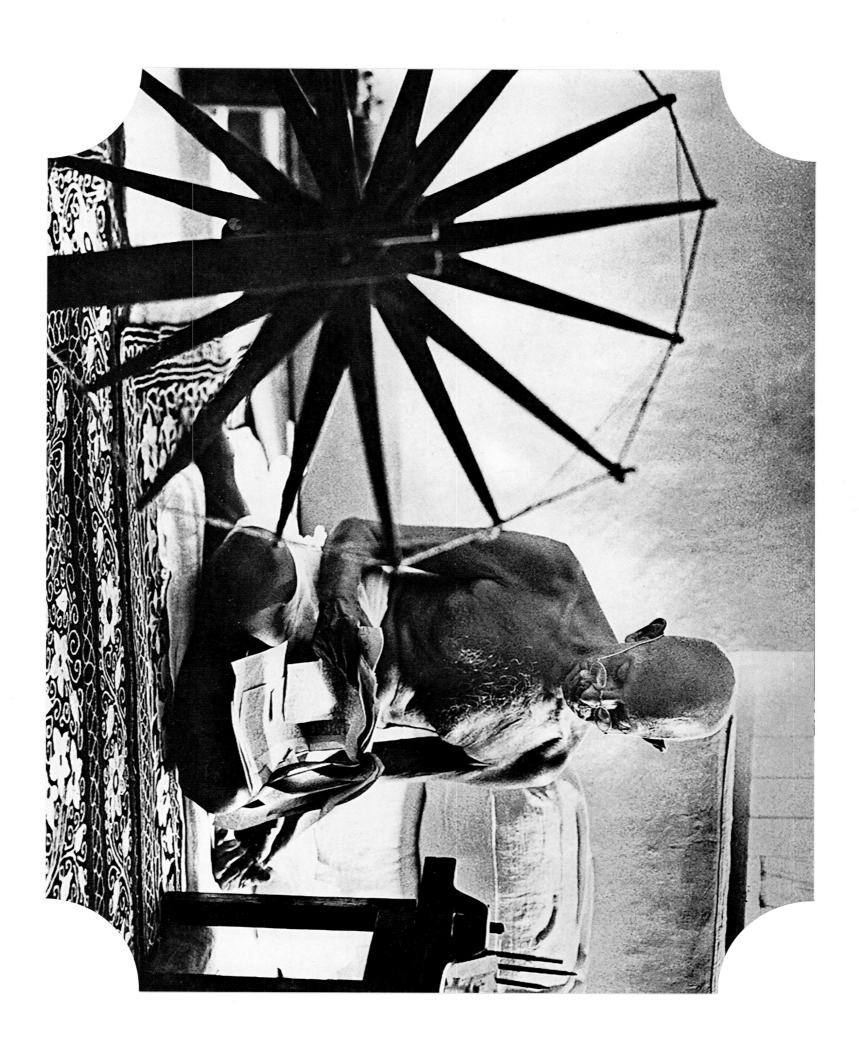

Page 28
**JACKSON POLLOCK, 1949**
LIFE's editors had heard that something weird and new—and perhaps important—was happening on Long Island, so Martha Holmes traveled out there to meet with the artist Jackson Pollock. Holmes recorded her day, including a session in the studio during which Pollock demonstrated his avant-garde technique by applying house paint and sand to a canvas that would become known as "Number 1, 1949." Holmes's pictures made the abstract expressionist famous when they graced the August 8 article, "Jackson Pollock: Is he the greatest living painter in the United States?" The Holmes visit was recounted in the 2000 biopic *Pollock*, and this portrait of the artist was the basis for a 33-cent postage stamp in 1999. The postal service insisted that the cigarette be deleted in the interest of public health.
PHOTOGRAPH BY MARTHA HOLMES

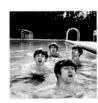

Page 29
**THE FAB FOUR, 1964**
Here we see Paul McCartney, George Harrison, John Lennon and Ringo Starr in the midst of their greatest triumph. They had, earlier in that week in 1964, invaded America, wowed the press, made their first appearance on *The Ed Sullivan Show*, rocked an audience at a Washington, D.C., concert and now were visiting Miami Beach for a bit of a breather before returning home to England. LIFE arranged for their dip in the pool, and assigned John Loengard, who would go on to be the magazine's chief picture editor, to the shoot. Note how careful the lads were to keep their mop tops dry.
PHOTOGRAPH BY JOHN LOENGARD

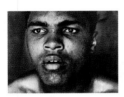

Page 30
**MUHAMMAD ALI, 1966**
He may well have been "The Greatest," as he was called. Born with the name Cassius Marcellus Clay Jr. in Louisville, he was by the mid-1960s a former Olympic gold medalist, a heavyweight champion and a convert to Islam named Muhammad Ali with more than fighting on his mind. His intensity was on full display in this photo taken in September 1966 as he prepared to defend his title against Germany's Karl Mildenberger. Ali would win on a technical knockout in the 12th round but would have his title stripped a half year later when he refused to enter the draft. He was banned from boxing until 1970. The following year, the Supreme Court ruled that his claim of being a conscientious objector had been just.
PHOTOGRAPH BY GORDON PARKS

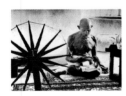

Page 31
**THE MAHATMA, 1946**
"I feel that utter truth is essential," Margaret Bourke-White once said of photography, "and to get that truth may take a lot of searching and long hours." This approach to the craft is, it can be said, Gandhi-esque, so perhaps it is fitting that the Mahatma, who spent many long hours searching for answers, was one of her regular subjects in the 1940s. Here, the great man of peace is at his spinning wheel in Poona, India. Bourke-White, the third of LIFE's original four staff photographers to be met in these pages, took her final portrait of Gandhi two years later, only hours before he was assassinated.
PHOTOGRAPH BY MARGARET BOURKE-WHITE

Page 33
**FLAVIO DA SILVA, 1961**
As part of a series on Latin America, LIFE sent photographer Parks to document the ghettos of Rio de Janeiro. He spent 19 days with the 10-member Da Silva family, who lived in a cramped shack fashioned from odds and ends. The parents were gone all day, trying to scrape together coins, so it fell to their eldest child, Flavio, to tend to himself and his siblings. This picture in particular, which showed Flavio finally resting on Sunday when his mother was free to look after the others, moved America, as did the information behind it: "Losing a battle against bronchial asthma and malnutrition, the 12-year-old says, 'I am not afraid of death. But what will they do after?'" Through the generosity of Parks and LIFE's readers, Flavio was brought to the United States, where he received successful medical treatment.
PHOTOGRAPH BY GORDON PARKS

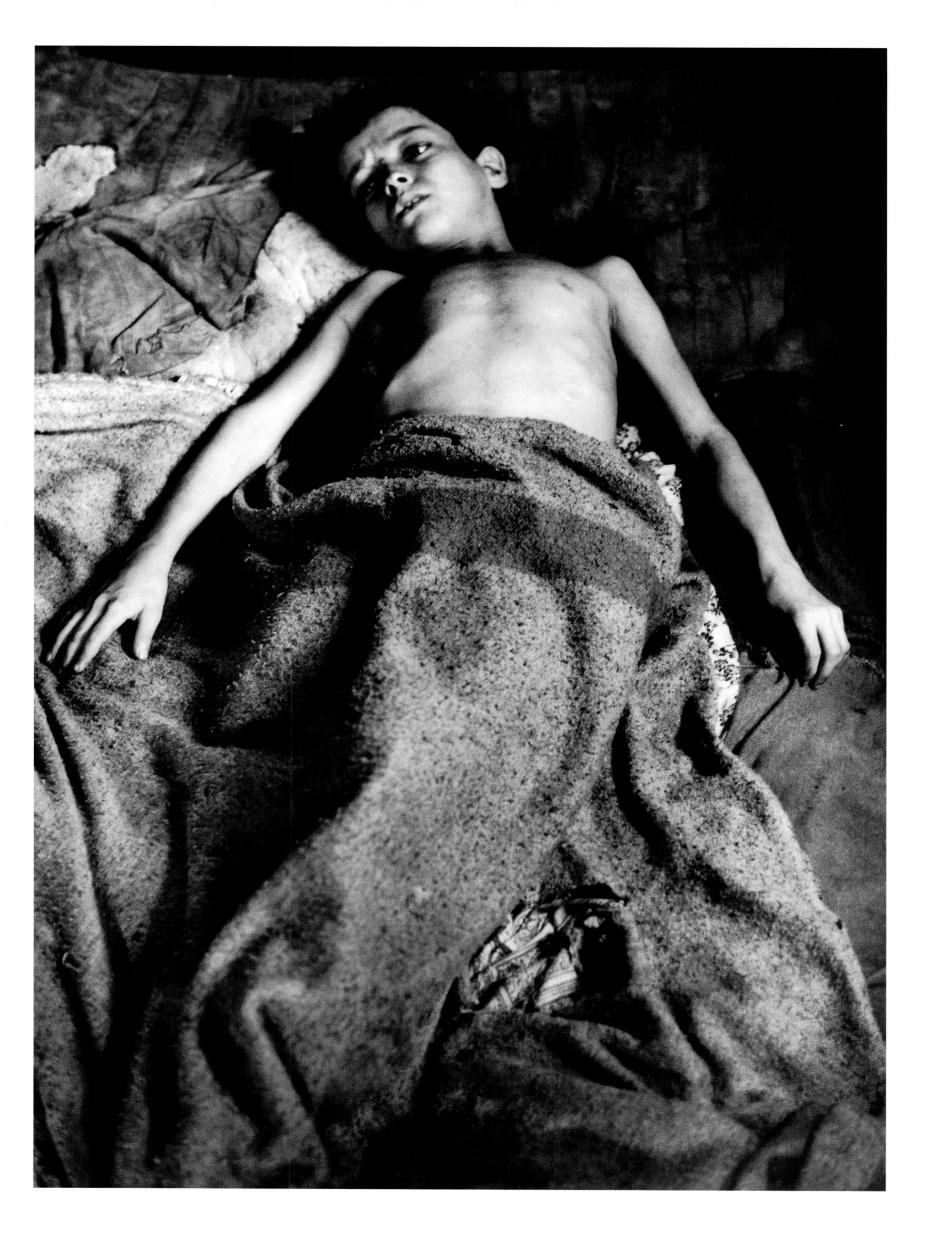

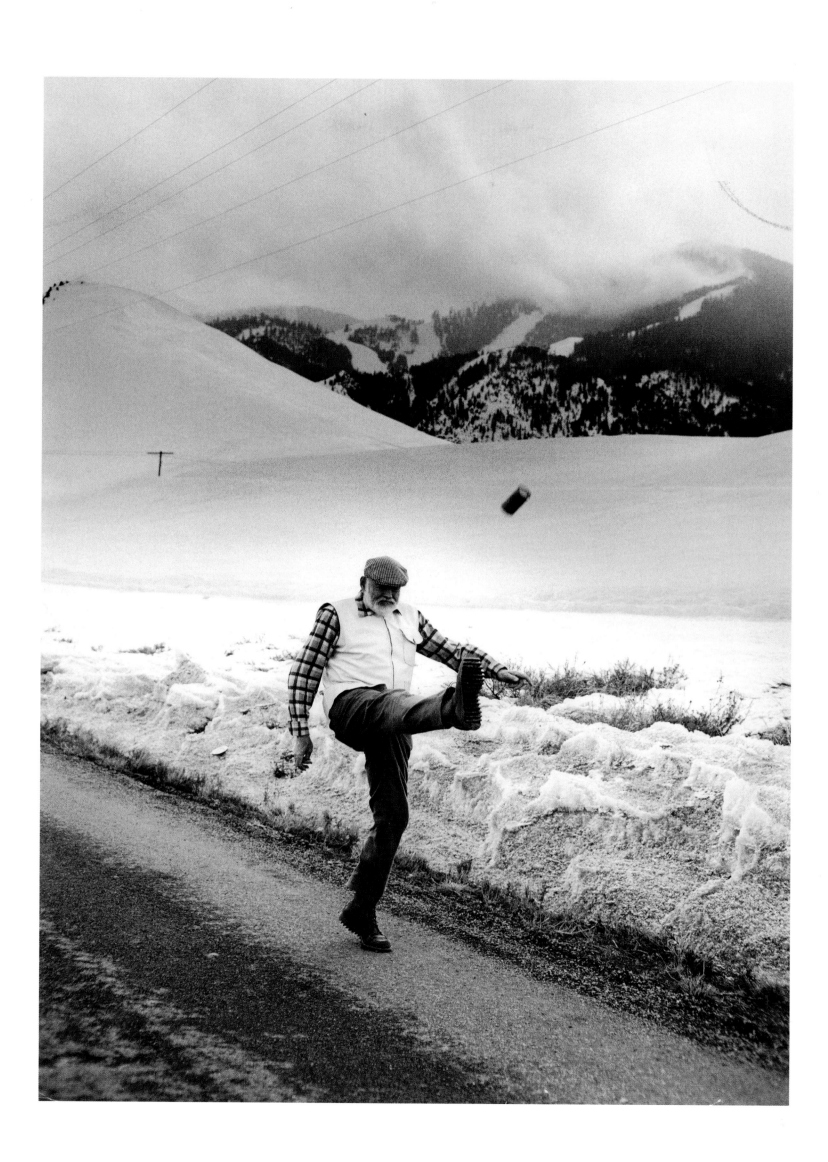

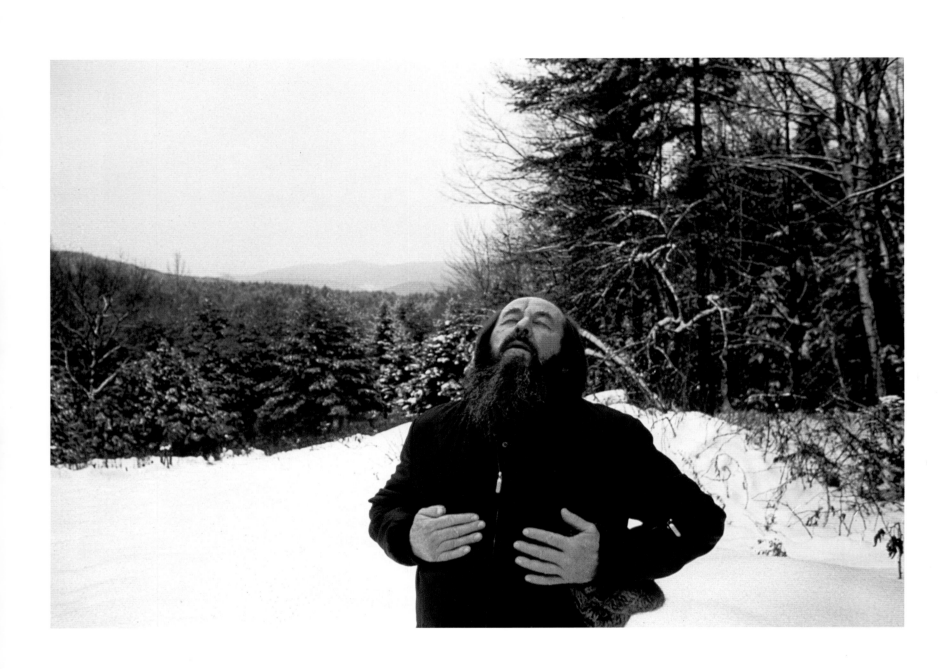

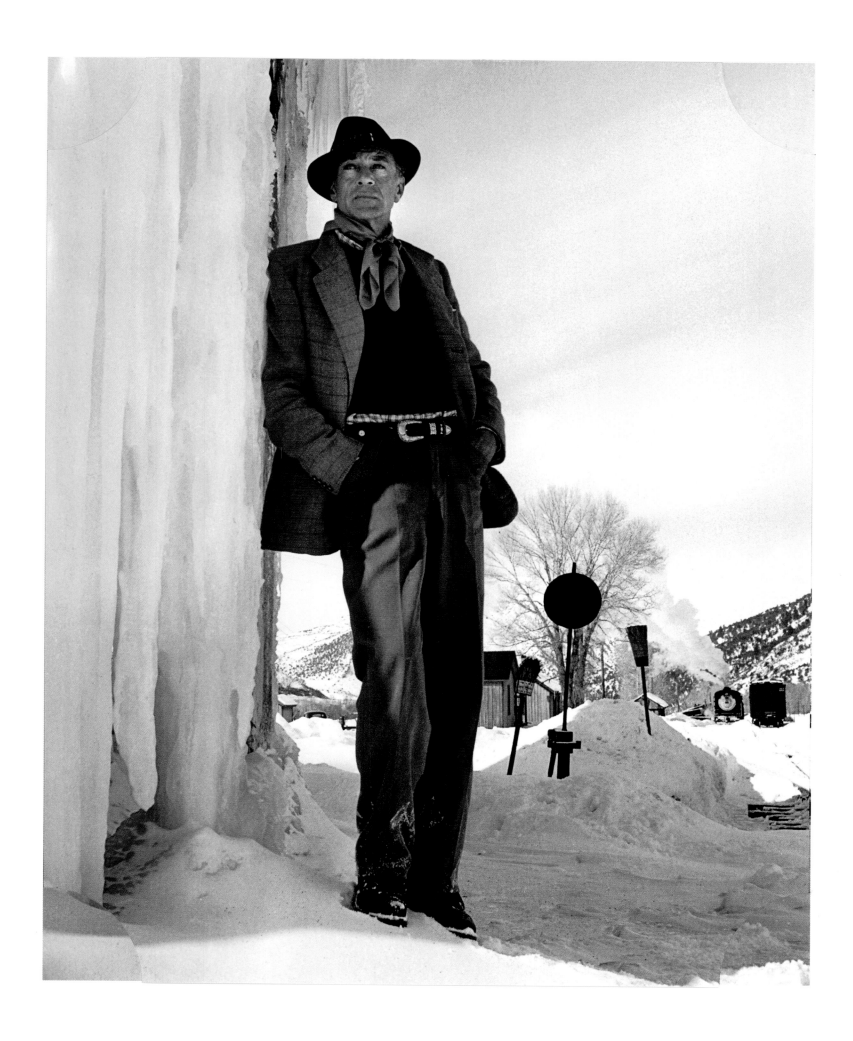

Page 34
**MARLENE DIETRICH, 1952**
The manner in which a portrait photographer gets his or her subject to relax differs, of course, from shooter to shooter. Greene's stylist once recalled, "The way Milton would work, he would bring in the props, turn on the music—it was Stravinsky for Marlene—turn off the phones and bring out the sherry." Greene spun a lot of Stravinsky through the years, as he made hundreds of photographs of Dietrich—one of his favorite subjects, after Monroe. In this 1952 shot, the actress was already in her early fifties; to promote a television special more than two decades later, Dietrich again called on Greene, who made another famous portrait in which the ever-sensual diva appeared to be wearing nothing but a swansdown coat. The sherry worked wonders.
PHOTOGRAPH BY MILTON H. GREENE

Page 35
**ERNEST HEMINGWAY, THE WINTER OF 1958–59**
The assignment (for a magazine other than LIFE) was to shoot Mary Hemingway in her Ketchum, Idaho, kitchen, whipping up dishes made from fish and game brought home by her husband. But photographer Bryson stayed a while and shot both Mary and hubby. Ernest Hemingway was 60 years old when this photo was made, and he told LIFE's editors after it appeared in their pages: "This was the best picture I ever had taken." LIFE enjoyed a long relationship with Hem, dating from 1937 when he wrote captions for a story about the Spanish Civil War. In September 1952, a single issue introduced in its entirety *The Old Man and the Sea,* the work that led to the author's 1954 Nobel Prize.
PHOTOGRAPH BY JOHN BRYSON

Page 36
**ALEXANDER SOLZHENITSYN, 1981**
People who had no desire to become media stars, and who routinely turned down requests for an audience, often made exceptions for LIFE, or for the photographer Harry Benson—or, when stars aligned, both. Recalled Benson of his visit with the reclusive Nobel Prize–winner Solzhenitsyn during the dissident author's years of exile in Vermont: "The first time I saw [him], I thought he looked like the lion in *The Wizard of Oz,* with his mop of hair and red beard." Benson added: "He was not a particularly pleasant man." But the photographer persisted, asking the writer what made him happy, what—if anything—he liked about life in America. Solzhenitsyn allowed that the air was free in the United States, and therefore he liked to breathe. Benson said: Show me.
PHOTOGRAPH BY HARRY BENSON

Page 37
**GARY COOPER, 1949**
One of Hollywood's biggest-ever stars, Cooper was already an old friend of LIFE's (he had first appeared on the magazine's cover in 1940) when, in '49, the editors sent Peter Stackpole to catch up with him yet again. In March they ran a story called "LIFE Visits Gary Cooper," which was fashioned around a family holiday that Coop, his wife, Rocky, and their 11-year-old daughter, Maria, spent in Aspen. Rarely has a movie star's essential personality so clearly shone through in a set of pictures. The native Montanan once said, "Dad was a true westerner, and I take after him," and, in the midst of a perfect setting, all of the photographs reflect the strong, quiet, humble, rugged man that the country's movie-going public—and, indeed, Cooper's Hollywood colleagues—had come to revere.
PHOTOGRAPH BY PETER STACKPOLE

Page 39
**PABLO PICASSO, 1949**
The Albanian native Gjon Mili immigrated to America to study electrical engineering at the Massachusetts Institute of Technology. After working at Westinghouse on photographic applications of lighting techniques, he met in 1937 with M.I.T.'s Harold Edgerton, who had developed stroboscopic light. Mili experimented with the process, and his dazzling pictures in LIFE became famous. An amateur oboe player, Mili had a real appreciation for the performing arts, and over the years, he made many lovely pictures of dancers, musicians and actors. His portrait of the painter Picasso sketching with a penlight at the Madoura Pottery workshop in Vallauris, France, is a masterwork.
PHOTOGRAPH BY GJON MILI

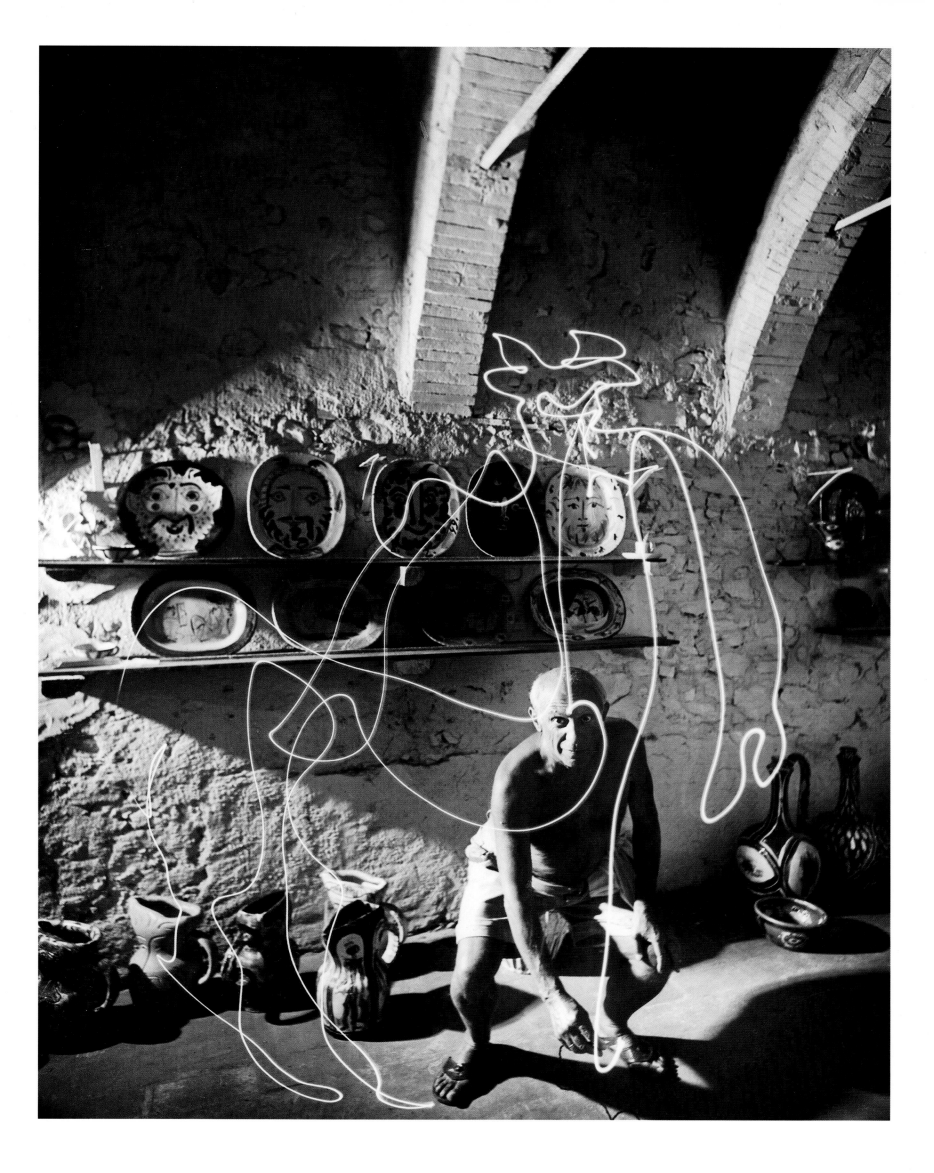

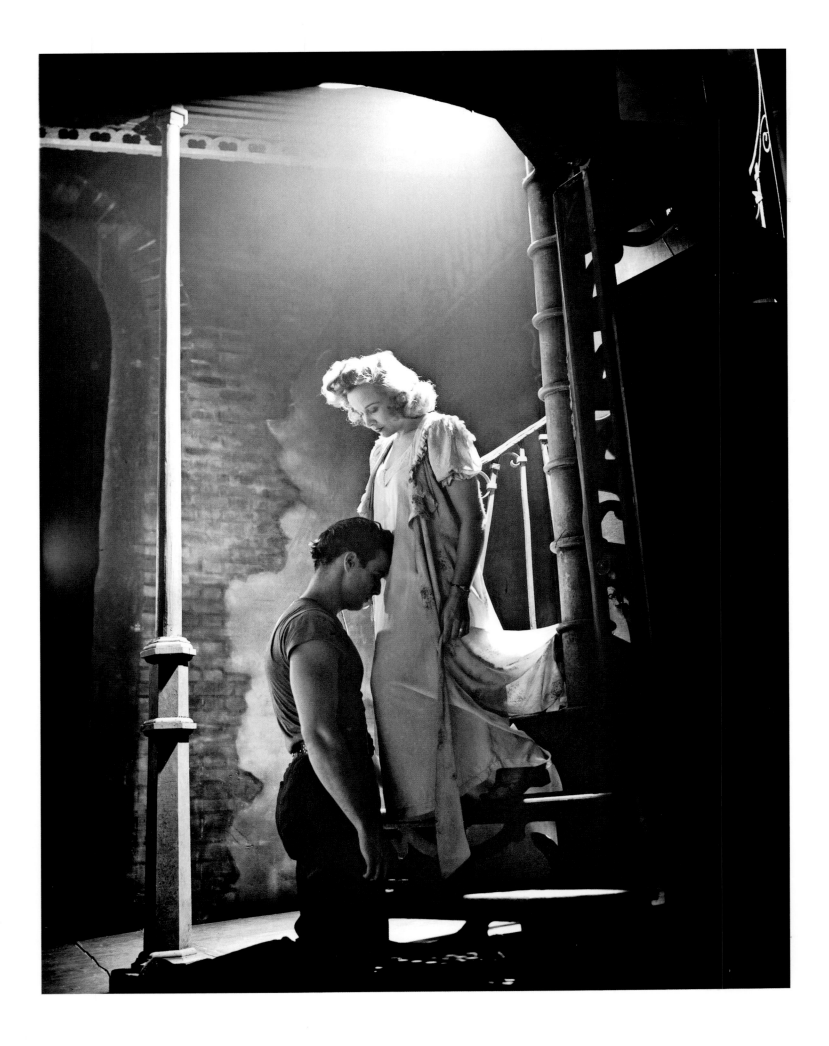

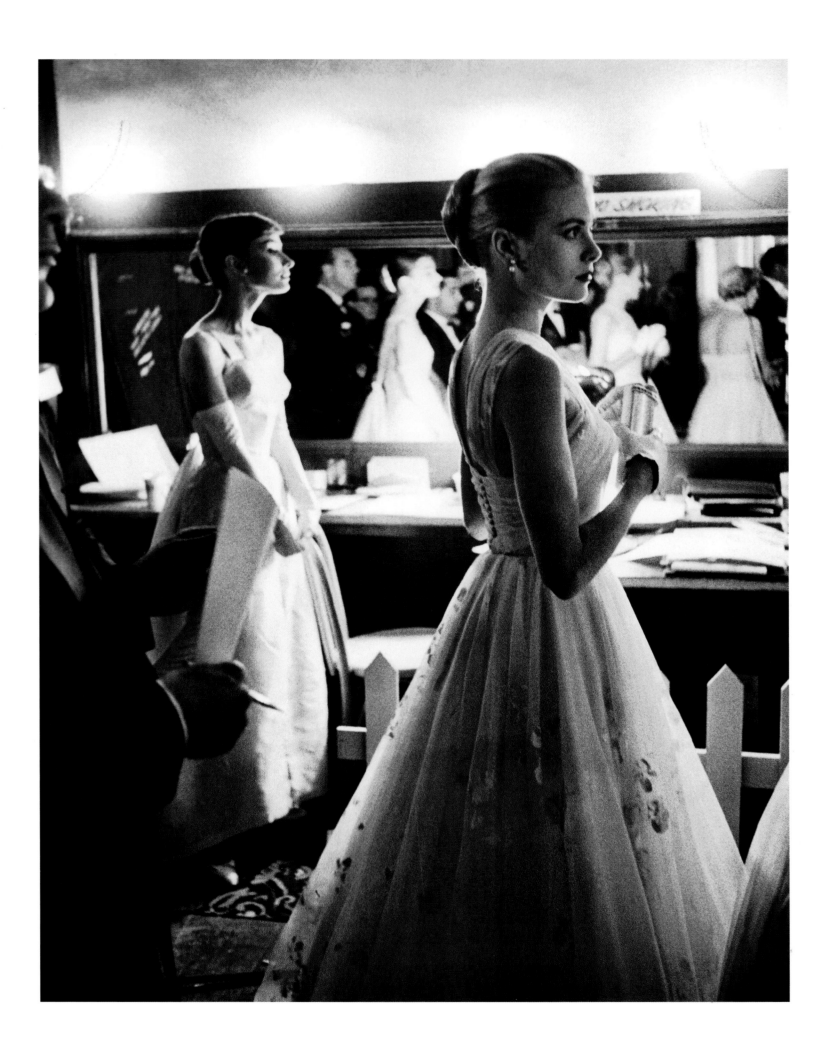

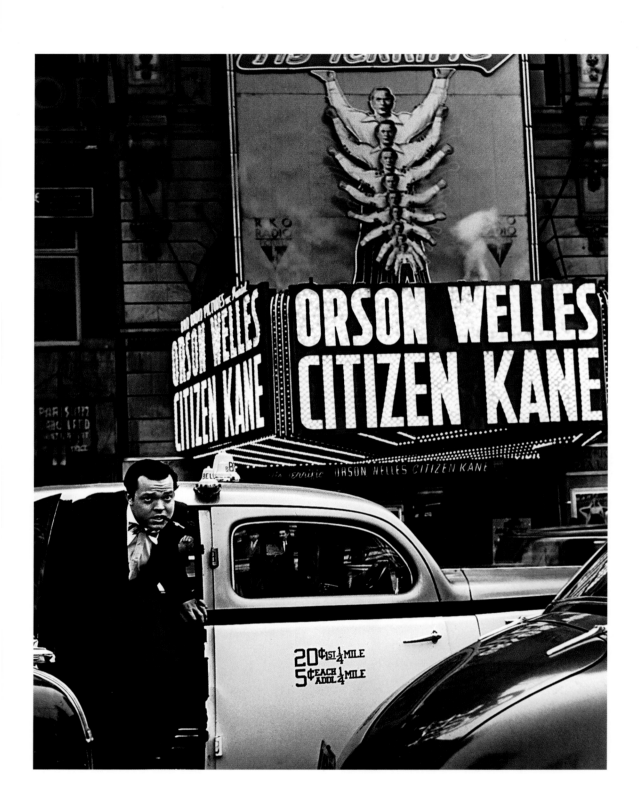

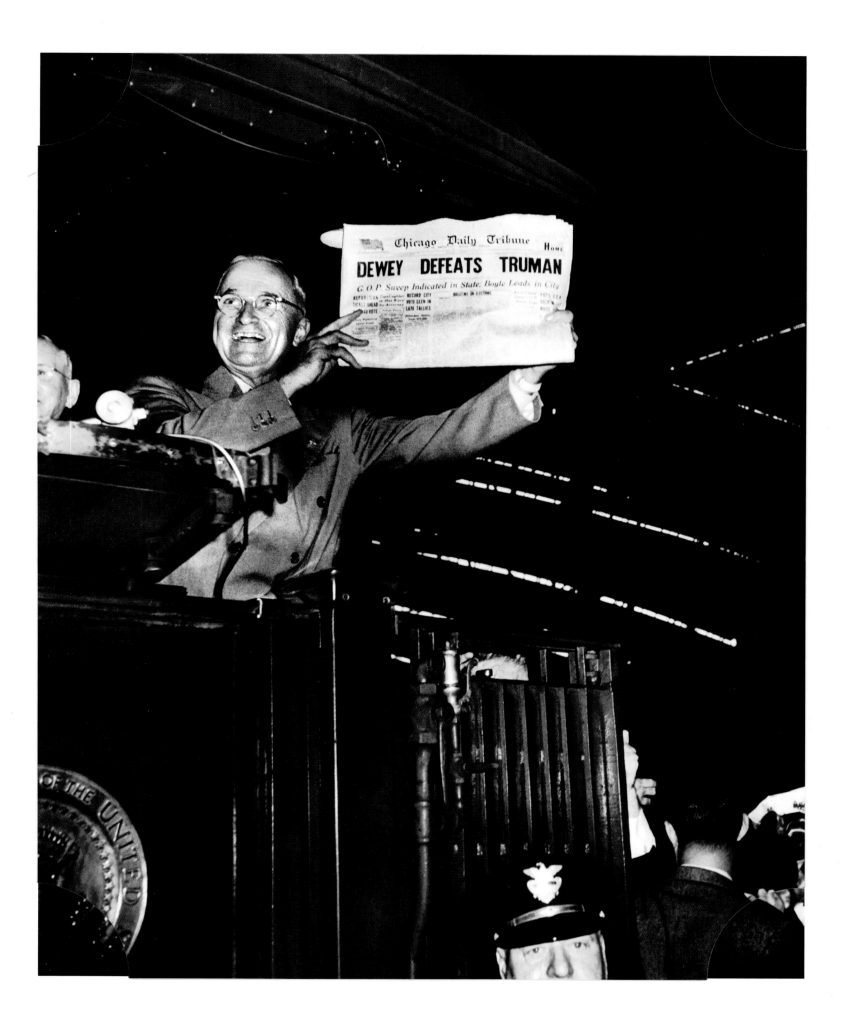

Page 40
**MARLON BRANDO AND KIM HUNTER, 1947**
Producer Irene Mayer Selznick had wanted Margaret Sullavan and John Garfield to play Stella and Stanley Kowalski in the original Broadway production of *A Streetcar Named Desire*. But a hungry young actor named Marlon Brando drove himself from New York City to Cape Cod to personally audition for playwright Tennessee Williams. The legend is that as soon as Williams saw Brando through the screen door of his house, he knew he had found his Stanley. The reading went well, too. As the wife, Kim Hunter was cast, and when she reprised her role in the film version, she won an Oscar as Best Supporting Actress. In 1947 it was simplicity itself for photographer Elisofon to drift down from LIFE's offices to Times Square, where the 23-year-old Brando was creating a nightly sensation, and show the country what all the fuss was about.
PHOTOGRAPH BY ELIOT ELISOFON.

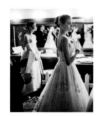

Page 41
**AUDREY HEPBURN AND GRACE KELLY, 1956**
Allan Grant had a talent—and a penchant—for making humorous photographs, and his images often appeared in LIFE's Speaking of Pictures section, a repository for funny or otherwise striking shots. But he could make a purely beautiful photo, too, as he did backstage at the RKO Pantages Theatre in Hollywood on the night of March 21, 1956. The occasion was the Academy Awards, and in this image you can feel the tension—and these two stars weren't even up for Oscars. They were there to present: Kelly gave the award for Best Actor (Ernest Borgnine won for *Marty*), while Hepburn bestowed the statue for Best Film (also for *Marty*). Just by the way, the women got on famously.
PHOTOGRAPH BY ALLAN GRANT

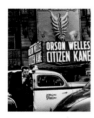

Page 42
**ORSON WELLES, 1941**
In New York City, the boy genius co-writer, director, producer and star of *Citizen Kane* emerged from a cab on a mission to check out ticket sales at one of the relatively few theaters that was showing his masterpiece. The massively influential publisher William Randolph Hearst, seeing the film as a veiled depiction of his own life, had threatened reprisals against movie houses screening *Kane*, and most had fallen in line. Welles was in his mid-twenties when he made his brilliant cinematic debut, and his future seemed boundless. But *Kane* lost money, then Welles's next film, *The Magnificent Ambersons*, was severely edited by the studio and tanked, setting the tone for years of wrangling with producers.
PHOTOGRAPH BY W. EUGENE SMITH

Page 43
**HARRY S TRUMAN, 1948**
It was the very rare—darned near invisible—political pundit who was not predicting that New York Governor Thomas Dewey was destined to roll over the incumbent Harry Truman in the presidential election of 1948. LIFE put Dewey's picture on the cover with the words "The Next President of the United States." The pollsters, too, were in absolute agreement: Gallup, Roper and the others had, from the nominating conventions to the very morning of the vote, been unanimous in predicting a big (5 to 15 percentage points) victory for the Republican. Of course, as we now know and as the editors of the *Chicago Daily Tribune* learned the hard way on Election Day, you should never jump the gun, and you can't always believe what you read. For the record, Truman's margin of victory was 5 percentage points.
PHOTOGRAPH BY W. EUGENE SMITH

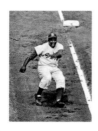

Page 45
**JACKIE ROBINSON, 1955**
Classic sports photos are different: In many instances, they don't fill out until later, the perfect image telling the multilayered story of the whole. Ralph Morse had already made searing images for LIFE during World War II when, in 1955, he stuck with Jackie Robinson during the Brooklyn Dodgers' World Series showdown against their awe-inducing crosstown rivals, the Yankees. Robinson was, of course, the first black player in the major leagues, and he was terrific. Off the field, he played demure. On the field, he shouted the future. Morse caught Robinson rounding third base, and the Dodgers went on to beat the Yanks. A perfect picture suddenly meant more.
PHOTOGRAPH BY RALPH MORSE

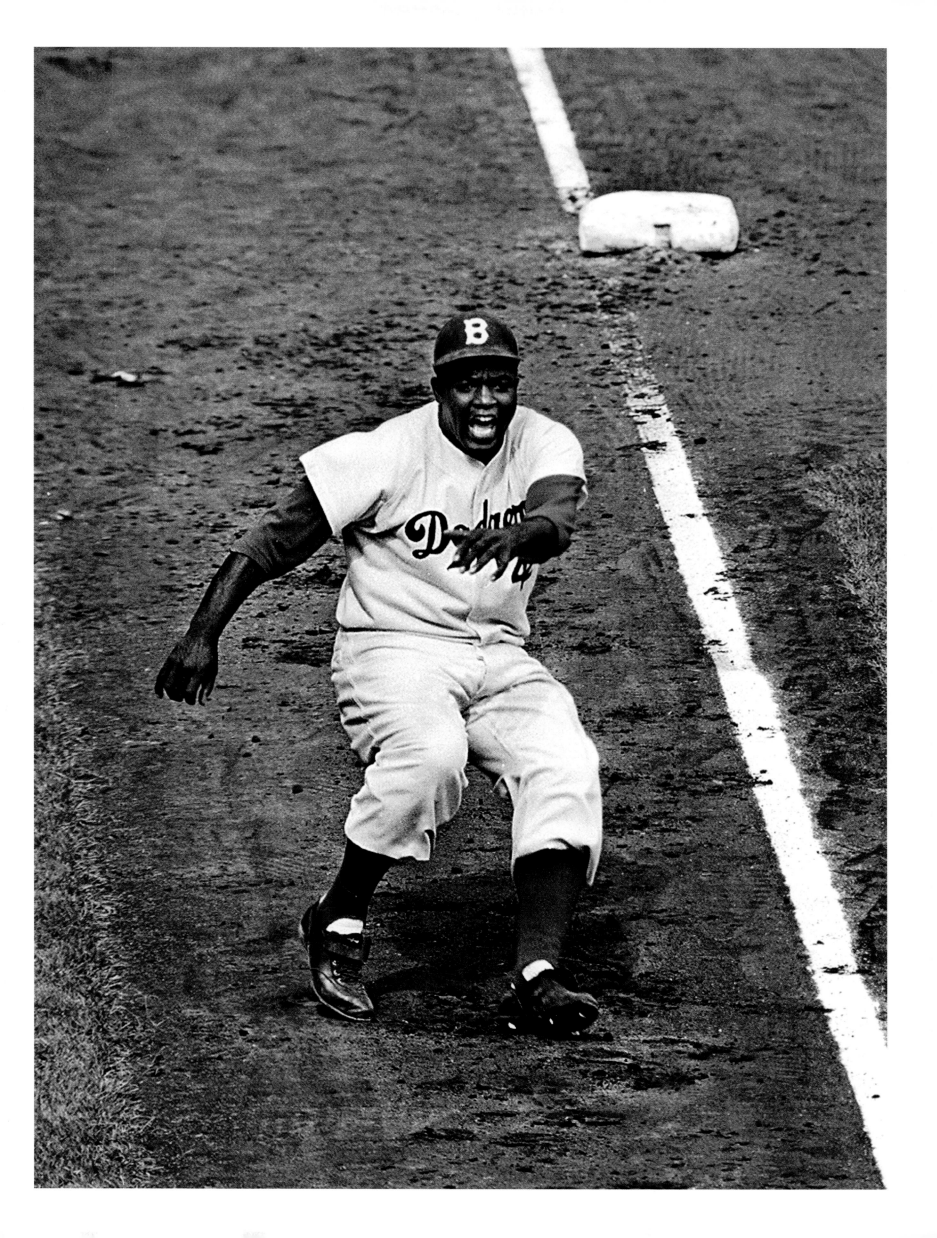

# PLACES
## ...TO SEE THE WORLD...

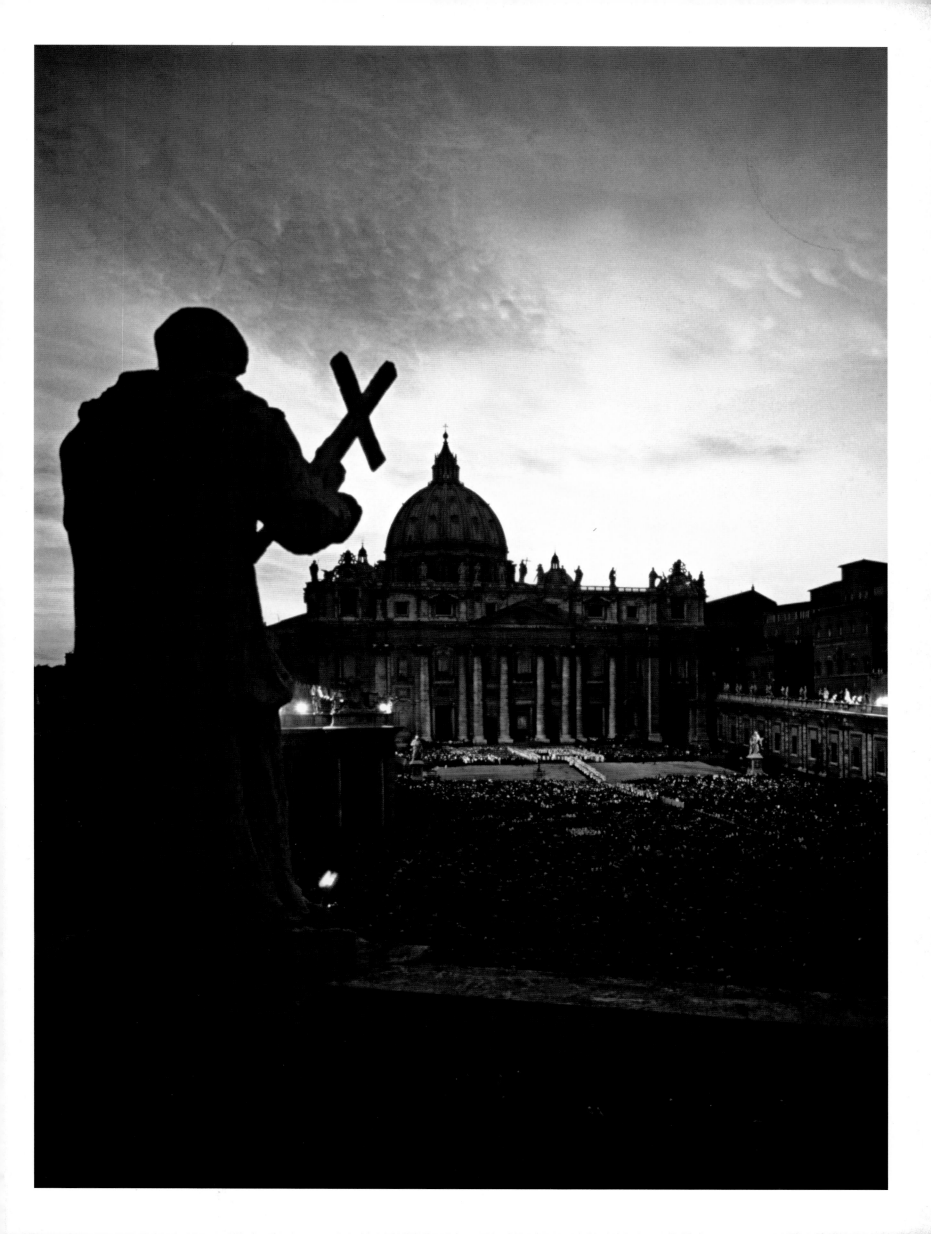

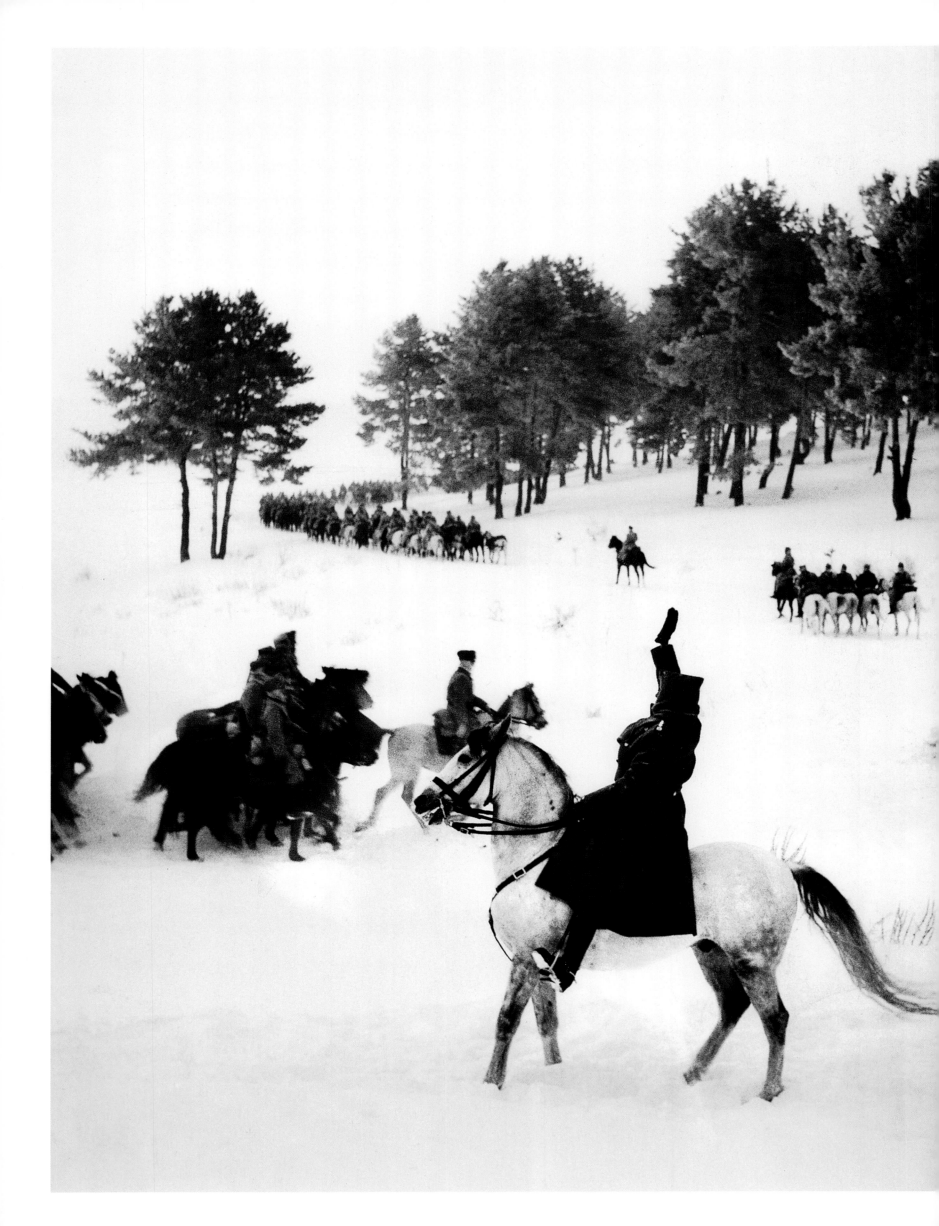

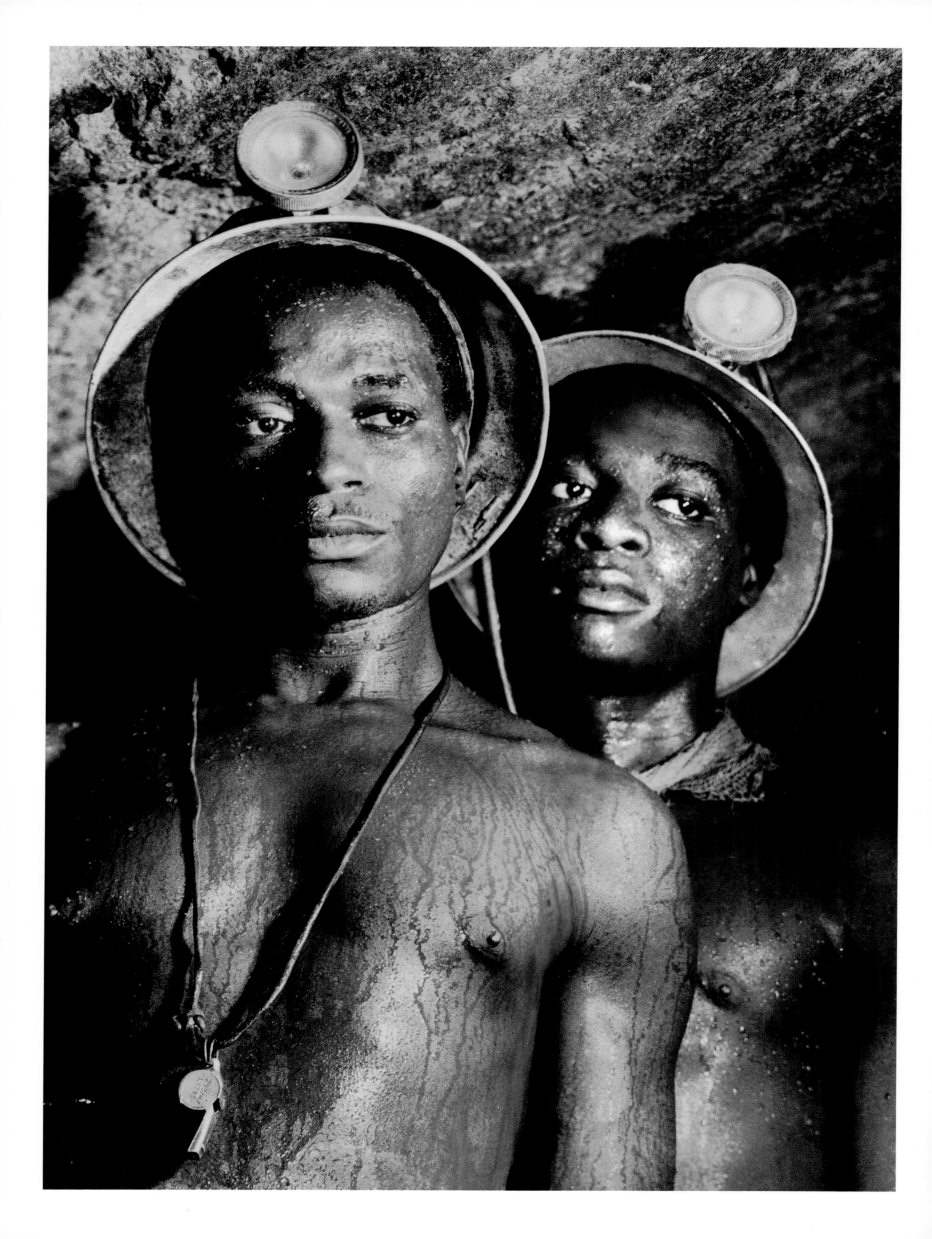

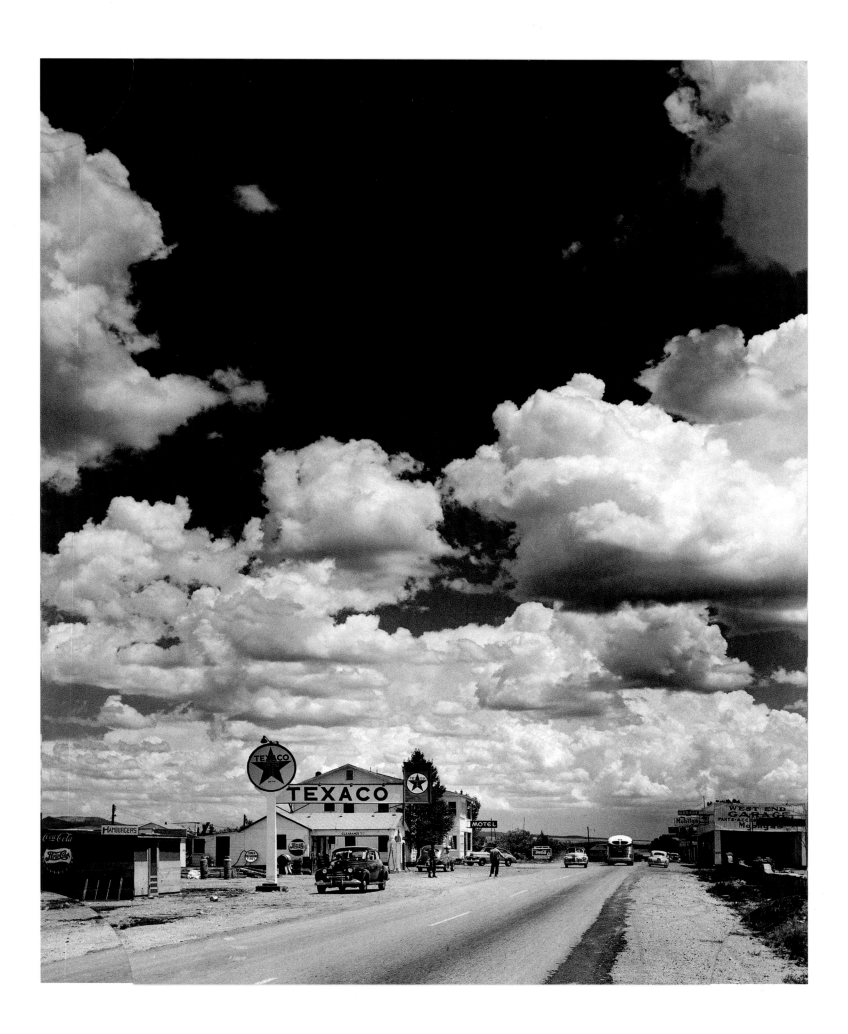

Page 47

**ST. PETER'S SQUARE, 1978**

On August 1, 1978, the world's eyes turned toward the Vatican in Rome as the Catholic faithful pressed toward the steps of St. Peter's Basilica, where a High Mass was said following the investiture of Pope John Paul I. Many photographs were made that day, but one is most special. It was taken by David Lees, a photographer born to British parents stationed in Pisa, Italy. Lees spent his life in Florence (John Paul's predecessor, Paul VI, affectionately called him the "Florentine Englishman") and spent his career showing Italy to the world through the pages of LIFE magazine. Lees was equally deft at rendering a Michelangelo masterwork or a young couple buzzing by the Colosseum on their motor scooter. His love of his adopted homeland permeated his pictures.
PHOTOGRAPH BY DAVID LEES

Page 48

**THE TURKISH CAVALRY, 1949**

For half a millennium Turkish relations with Russia had been generally poor, and the years immediately following World War II were no exception: Stalin wanted to build military bases on Turkish land, but was thwarted in his efforts when the U.S. strongly backed Turkey. The photographer David Douglas Duncan, a Marine veteran who had been on the USS *Missouri* to record Japan's surrender in 1945, spent a decade after the war as a LIFE photographer based in the Middle East. For one assignment he captured—strikingly—the Turkish Cavalry being led on maneuvers near the Soviet border by Brigadier Kara Avni Mizrak.
PHOTOGRAPH BY DAVID DOUGLAS DUNCAN

Page 50

**SERVITUDE IN SOUTH AFRICA, 1950**

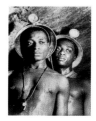

Of the four original staff photographers for LIFE, one—Bourke-White—was a woman, and she was as intrepid as any shooter who ever worked for the magazine. She had already covered want in America and war abroad when she was asked to travel to Johannesburg to report on the government's harsh treatment of South African natives. She received grudging permission to photograph gold miners working in a dangerous situation two miles underground; while shooting, Bourke-White nearly fainted and was taken to the edge of the shaft to be revived. Appalled that the miners were forced to spend endless days in such a dreadful place, she made sure to complete her work as a witness for the wider world.
PHOTOGRAPH BY MARGARET BOURKE-WHITE

Page 51

**ROUTE 66, 1947**

Many of LIFE's photographers were known for their images of people, but Andreas Feininger was a profound exception. His concerns were basically with things—ships, cityscapes, dramatic vistas—and his images were always as strong as they were technically excellent and routinely inspiring. One day on U.S. Highway 66 outside Seligman, Ariz., he saw a gas station, a few cars, a couple of men and a dramatic sky, and he captured the American West.
PHOTOGRAPH BY ANDREAS FEININGER

Page 53

**"PREMIERE AT LA SCALA, MILAN," 1934**

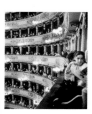

"I see pictures all the time," Eisenstaedt once said. He saw a picture this night, as an audience awaited an opening night performance at the famed La Scala opera house in Milan, Italy. Eisie was looking about and shooting—as always—when "suddenly I saw a lovely young society girl sitting next to an empty box. From that box, I took another picture, with the girl in the foreground. For years and years, this has been one of my prize photographs. Without the girl I would not have had a memorable picture."
PHOTOGRAPH BY ALFRED EISENSTAEDT

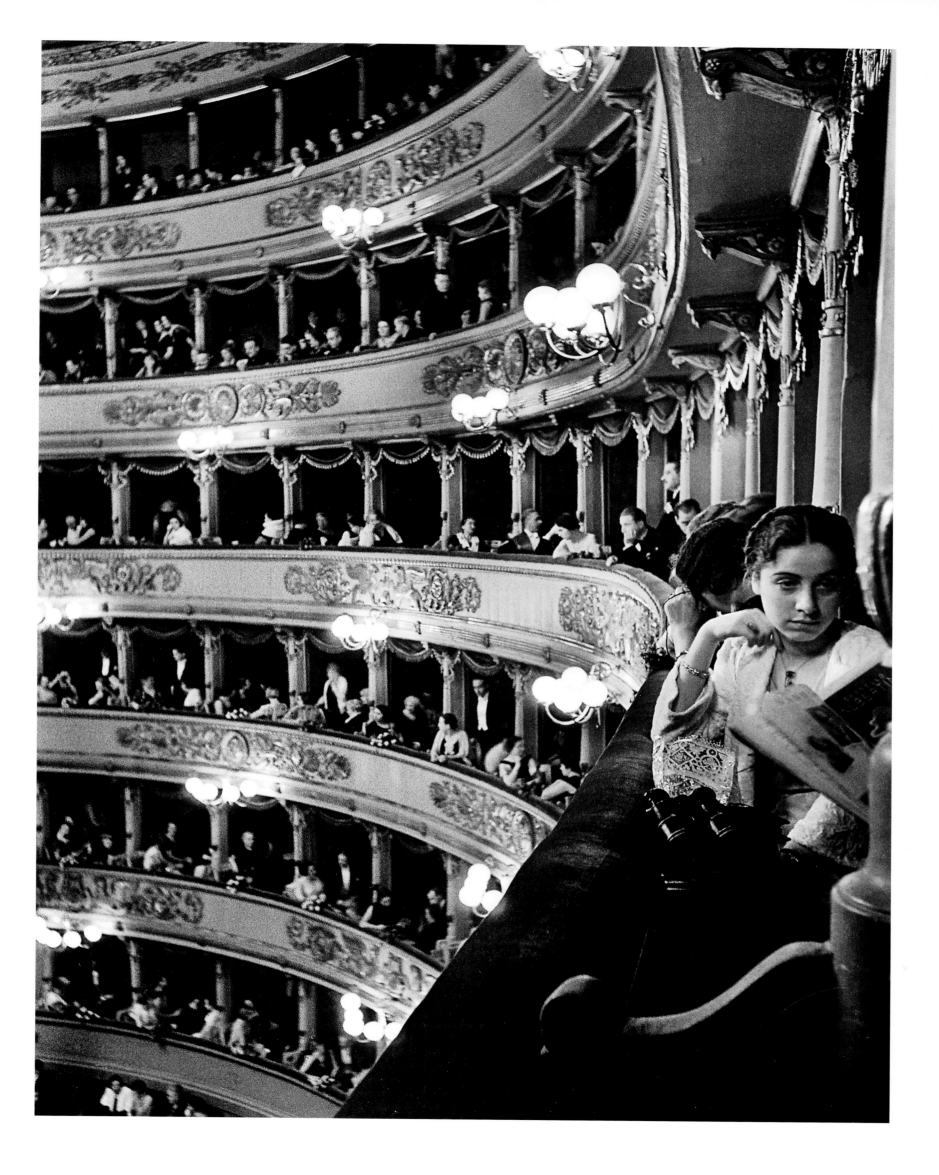

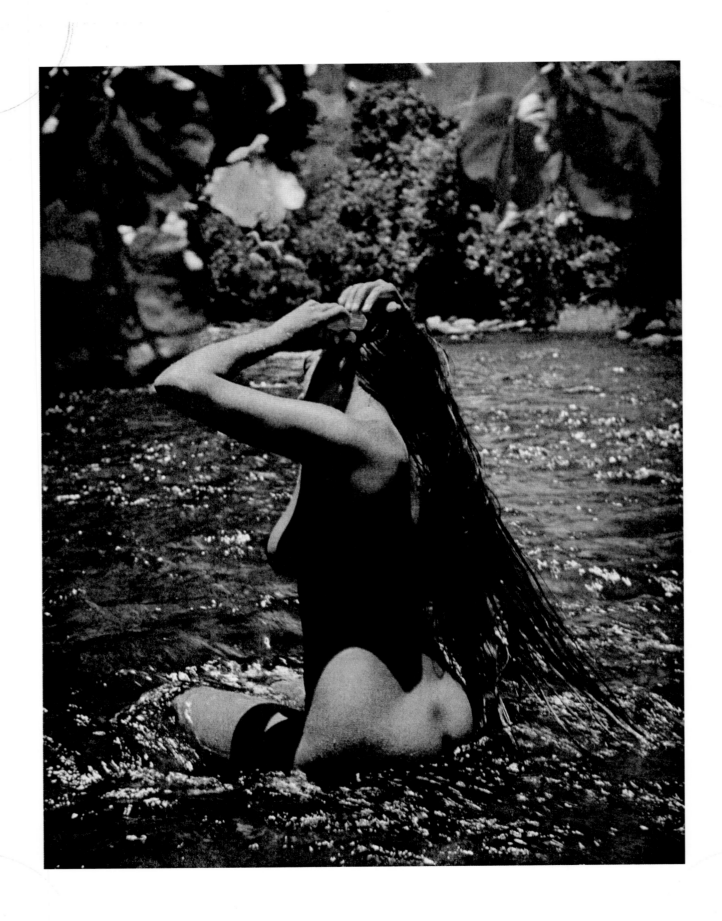

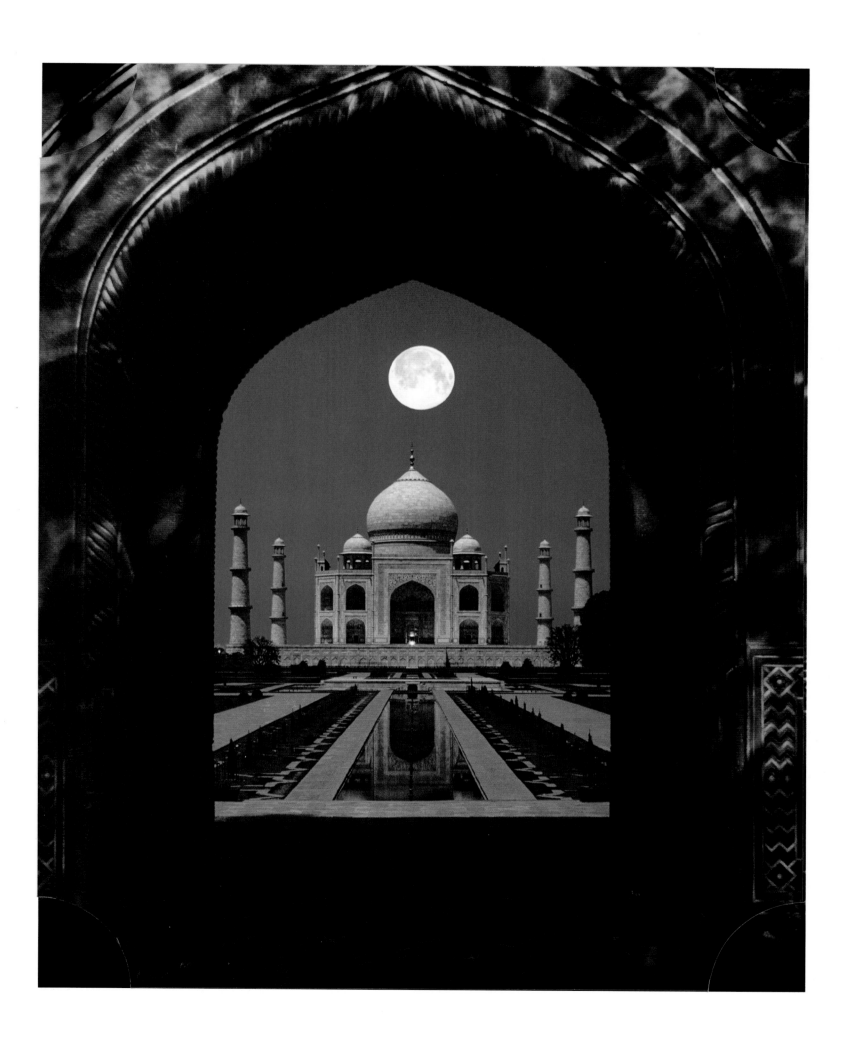

Page 54
**TAHITI, 1954**
Eliot Elisofon took up photography in college, became a successful commercial shooter, then forsook that career to join LIFE. He was one of the magazine's platoon of photographers in World War II; once, leaving North Africa, his plane crashed and burned the trousers right off him. Said war correspondent Ernie Pyle: "Elisofon was afraid like the rest of us. Yet he made himself go right into the teeth of danger. I never knew a more intense worker." Eliot's work in the decades after the war was just as intense but much more pleasurable, as was evidenced in his January 24, 1955, story with the cover line "Storied Isles of Romance in the South Seas." In 2005, this image reappeared as cover art on the single "Waiting for the Sirens' Call" by the post-punk band New Order.
PHOTOGRAPH BY ELIOT ELISOFON

Page 55
**THE TAJ MAHAL, 1967**
As will become clear later in this book, Larry Burrows was one of the master war photographers. But as was the case with Eliot Elisofon and so many others who worked for LIFE, he was simply a great photographer, able to render any scene or situation wonderfully. Even as he was building his astonishing photographic document of the Vietnam War that is, inevitably, his principal legacy, he was flying off to New Guinea to make marvelous pictures of crested Goura pigeons in Nondugl Aviary (page 118), to East Pakistan to movingly cover the devastating 1970 cyclone, or to India where, outside Agra, he saw a full moon over the Taj Mahal.
PHOTOGRAPH BY LARRY BURROWS

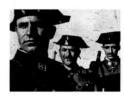

Page 57
**THE LAW IN SPAIN, 1951**
Fellow LIFE staff photographer Gordon Parks once said that W. Eugene Smith possessed "a wonderful sense of humanity." In 1951, about halfway between Madrid and the Portuguese border, Smith wandered off the main road into an ancient village called Deleitosa. The name means "Delightful," but for a community of 2,300 peasants facing daily deprivations caused by Francisco Franco's reign, that meaning no longer applied. In one of his many famous photo essays, "Spanish Village," Smith captured manifold aspects of the human condition. Not all such essays can be successfully excerpted, but this image of Franco's stern Guardia Civil, feared mightily by the villagers, stands strongly on its own.
PHOTOGRAPH BY W. EUGENE SMITH

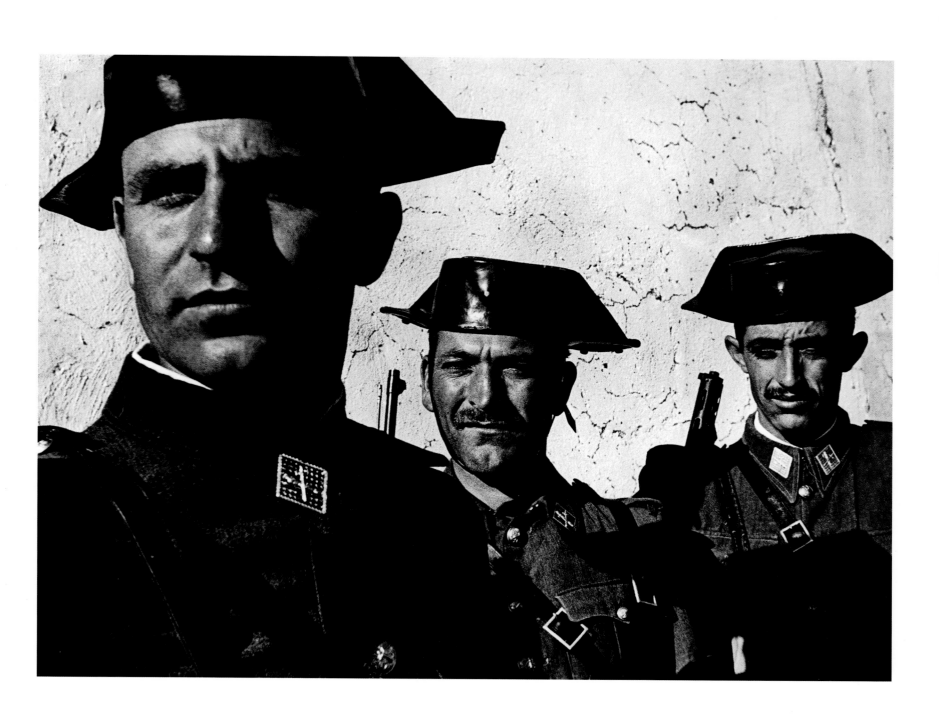

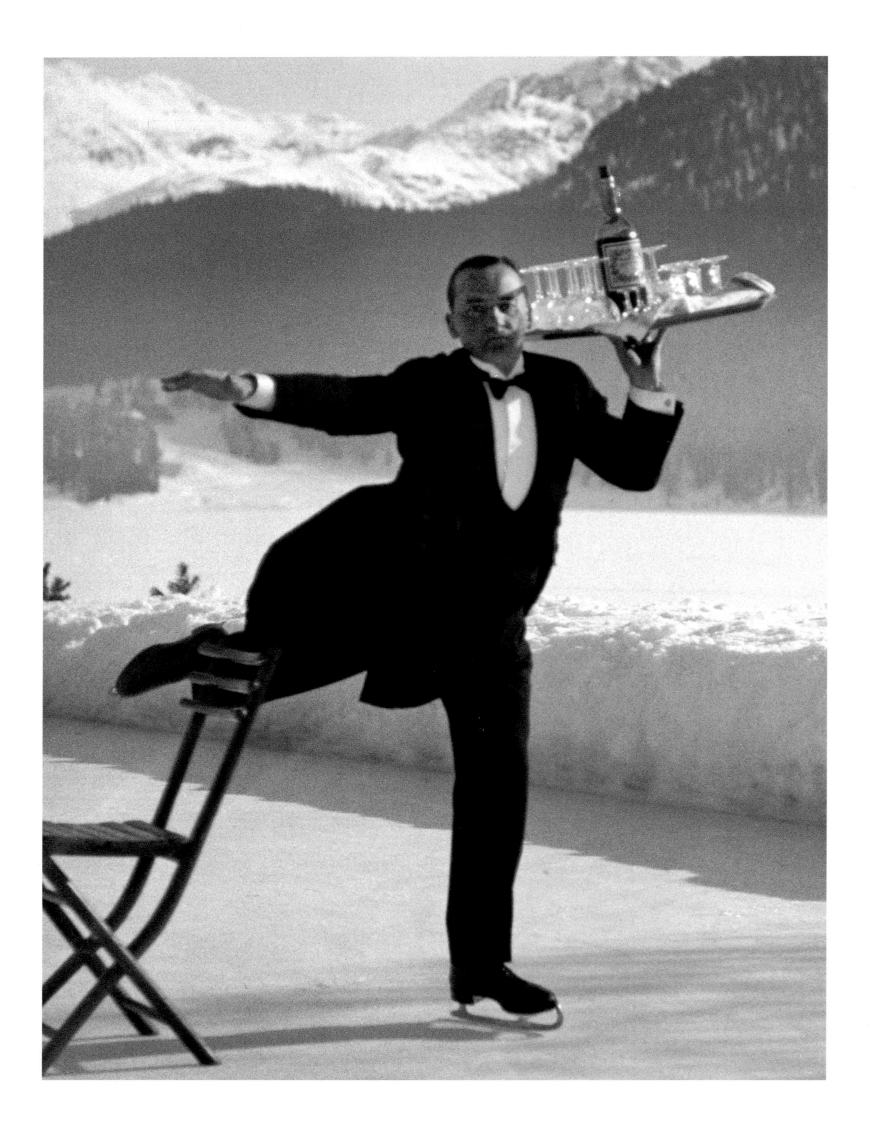

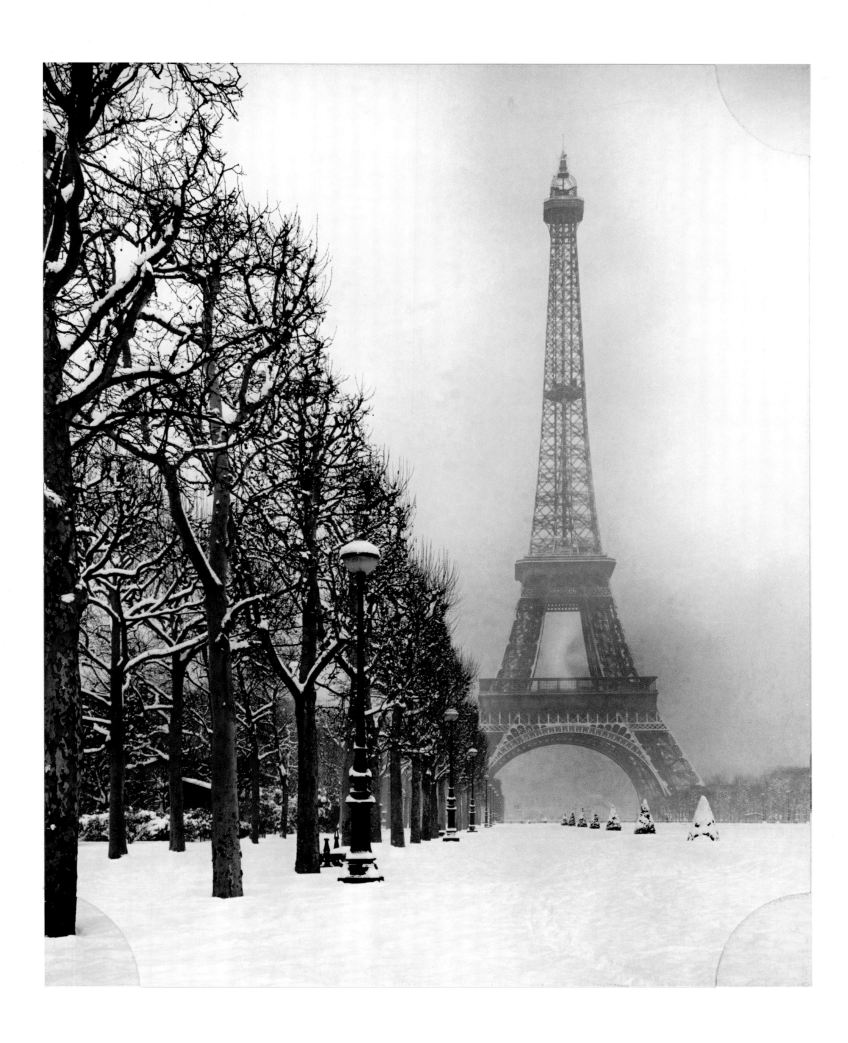

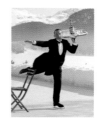

Page 58
**"ICE SKATING WAITER, ST. MORITZ," 1932**
Some iconic pictures taken by LIFE's famous photographers were created even before the magazine was born, though they came to be associated with LIFE after appearing in the weekly's pages and in retrospective books. Alfred Eisenstaedt was taking pictures throughout Europe in the 1920s and early '30s before emigrating to America in 1935. Among the earliest of his renowned images is this one, made at the ice rink of the legendary Grand Hotel in St. Moritz, Switzerland. "I did one smashing picture of the skating headwaiter," Eisenstaedt recalled later. "To be sure the picture was sharp, I put a chair on the ice and asked the waiter to skate by it. I had a Miroflex camera and focused on the chair."
PHOTOGRAPH BY ALFRED EISENSTAEDT

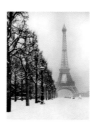

Page 59
**THE EIFFEL TOWER, 1948**
It was said of Dmitri Kessel, "He is an international human being," a telling reference to a man who lived well and long (1902 to 1995), in many places and with many interests. He grew up in comfort in the Ukraine, but saw his tidy life swept away during the Bolshevik Revolution; Dmitri was drafted into the army at age 16, and that service doubtless informed his later photography of World War II. After escaping the Russian Revolution, he arrived in America in 1923 and began to concentrate on photography. He was capable of shooting hard, eruptive news photos but also gorgeous architectural photography, notably of churches and cathedrals. His home base eventually became Paris, where one foggy winter day he made a signature image of its signature tower.
PHOTOGRAPH BY DMITRI KESSEL

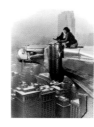

Page 61
**THE CHRYSLER BUILDING, CIRCA 1935**
In 1930, six years before signing on at LIFE, Margaret Bourke-White leased a studio in New York City's sexy new Deco darling, the Chrysler Building, which had been completed only that May (and for a brief time was the world's tallest building). She took striking pictures of the building's majestic spire, and, while situated atop its 61st-floor gargoyles, this woman once known as Maggie the Indestructible cast her eye—and lens—over all of Gotham and made fantastic cityscapes. This particular photo, as famous as any of the Chrysler shots that Bourke-White took, shows the photographer at her precarious perch, readying her camera. This portrait of the artist as a young daredevil was taken by Bourke-White's assistant.
PHOTOGRAPH BY OSCAR GRAUBNER

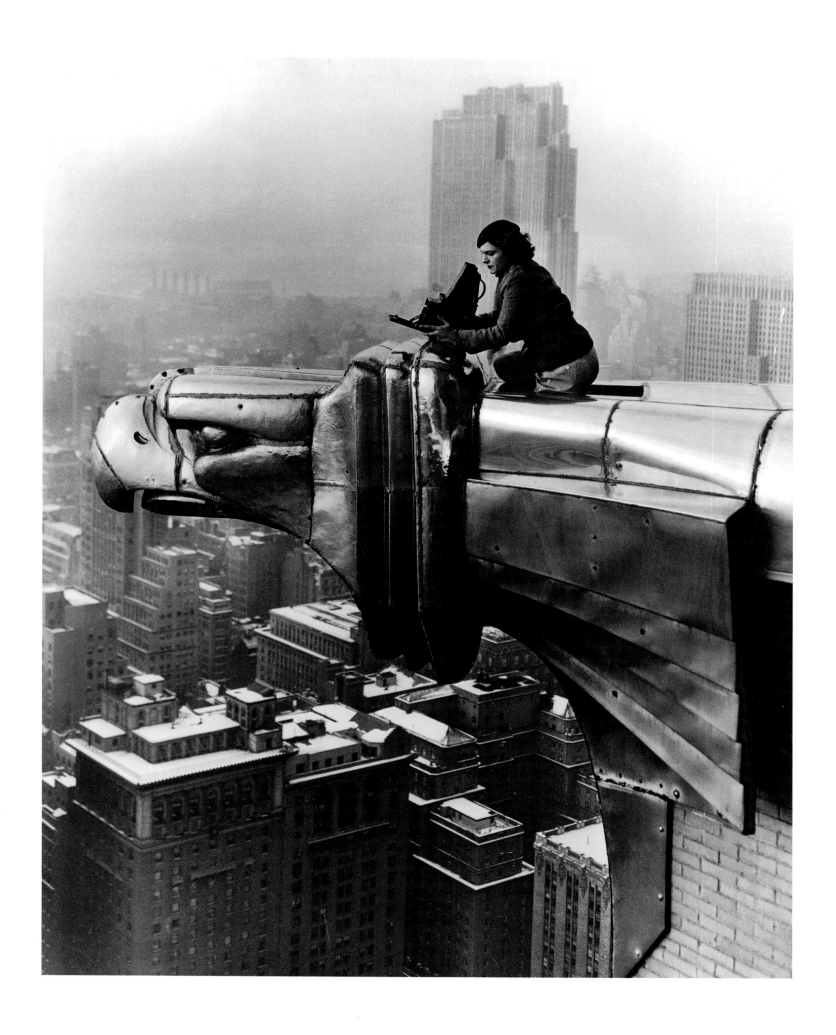

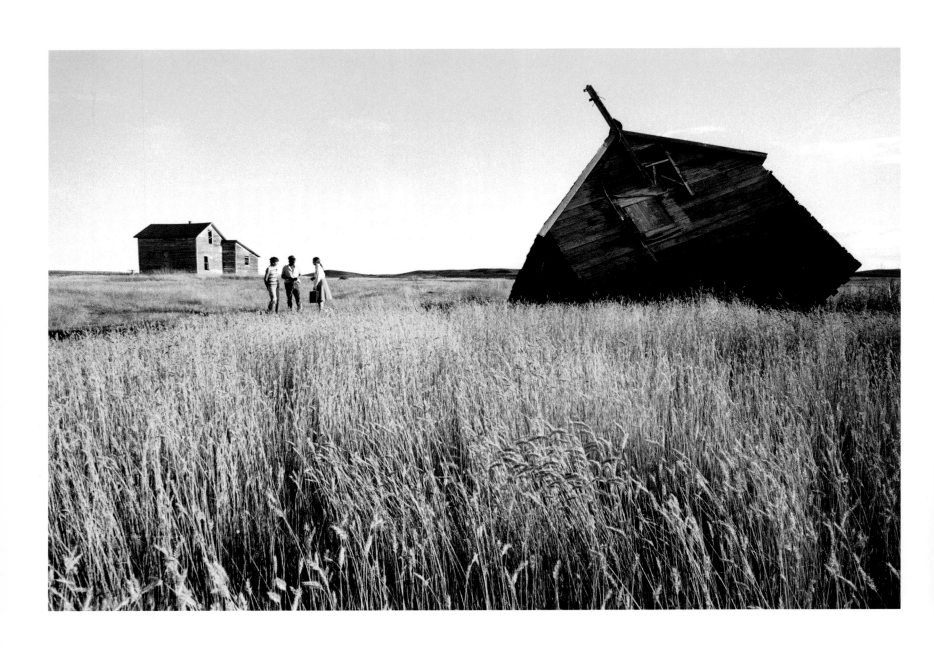

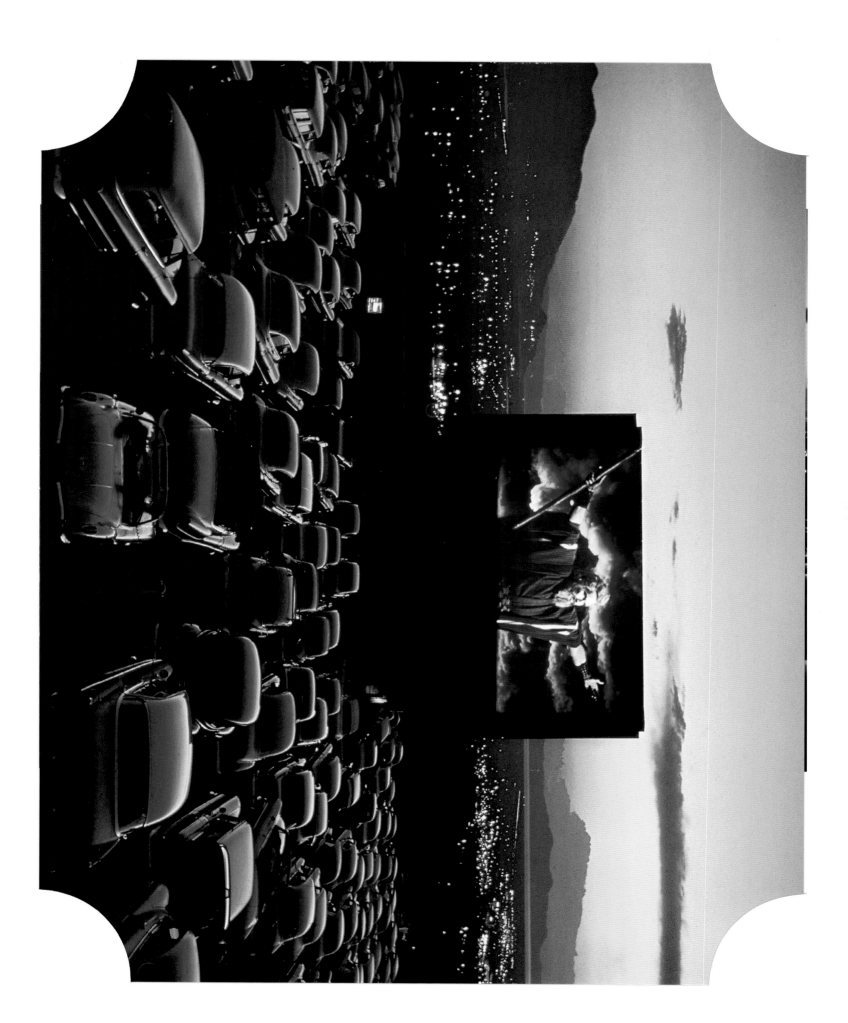

Page 62
**"GOING UNDER," 1982**
Bumper harvests for two years straight had driven down the price of wheat, and for the first time since the Great Depression the farmers of North Dakota had experienced back-to-back years where the cost of producing a bushel outweighed what the farmer could charge for it. Of 8,558 North Dakota farms in hock to the Farmers Home Administration, more than a fifth were delinquent and 17 had been referred to the U.S. Attorney for foreclosure. Such were the conditions when LIFE sent Grey Villet west to tell the tale in pictures. The opening spread of his story featured this photograph of the activist lawyer Sarah Vogel, a native North Dakotan and friend of the farmers, conferring with Lois and Randy Oster on their acreage. The building says much, as does the damnably rich field of wheat.
PHOTOGRAPH BY GREY VILLET

Page 63
**AT THE DRIVE-IN, 1958**
It is, at the very least, an interesting footnote that what are arguably the two greatest photographs ever taken of people watching movies—both of which are LIFE Classics—were executed by the same man. The technologically deft J.R. Eyerman made the famous picture of a Hollywood audience watching a 3-D movie in 1952 (in this book, it is another framable print—on page 125), and, six years later, in Salt Lake City, he captured a sea of sedans all but kneeling in the presence of Charlton Heston, larger than life on the drive-in screen during a showing of Cecil B. DeMille's *The Ten Commandments*. The sunset and the hills beyond are properly biblical and add to Eyerman's Wagnerian composition.
PHOTOGRAPH BY J.R. EYERMAN

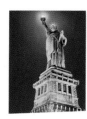

Page 65
**THE STATUE OF LIBERTY, 1939**
Another iconic Big Apple structure, one even more storied than the Chrysler Building, is Lady Liberty (formal name, "Liberty Enlightening the World"), proudly standing 151 feet tall in New York Harbor, hard by the former immigration center on Ellis Island. This gift from the people of France has been commemorated in photographs by untold millions of tourists and professionals through the years—including, in a well-known picture of visitors waving from its crown, by Margaret Bourke-White—but few have captured the symbolic power of the statue as staff photographer Gehr did. LIFE's editors were so taken with the image they ran it as the cover twice: on the Memorial Day issues of both 1939 and '40.
PHOTOGRAPH BY HERBERT GEHR

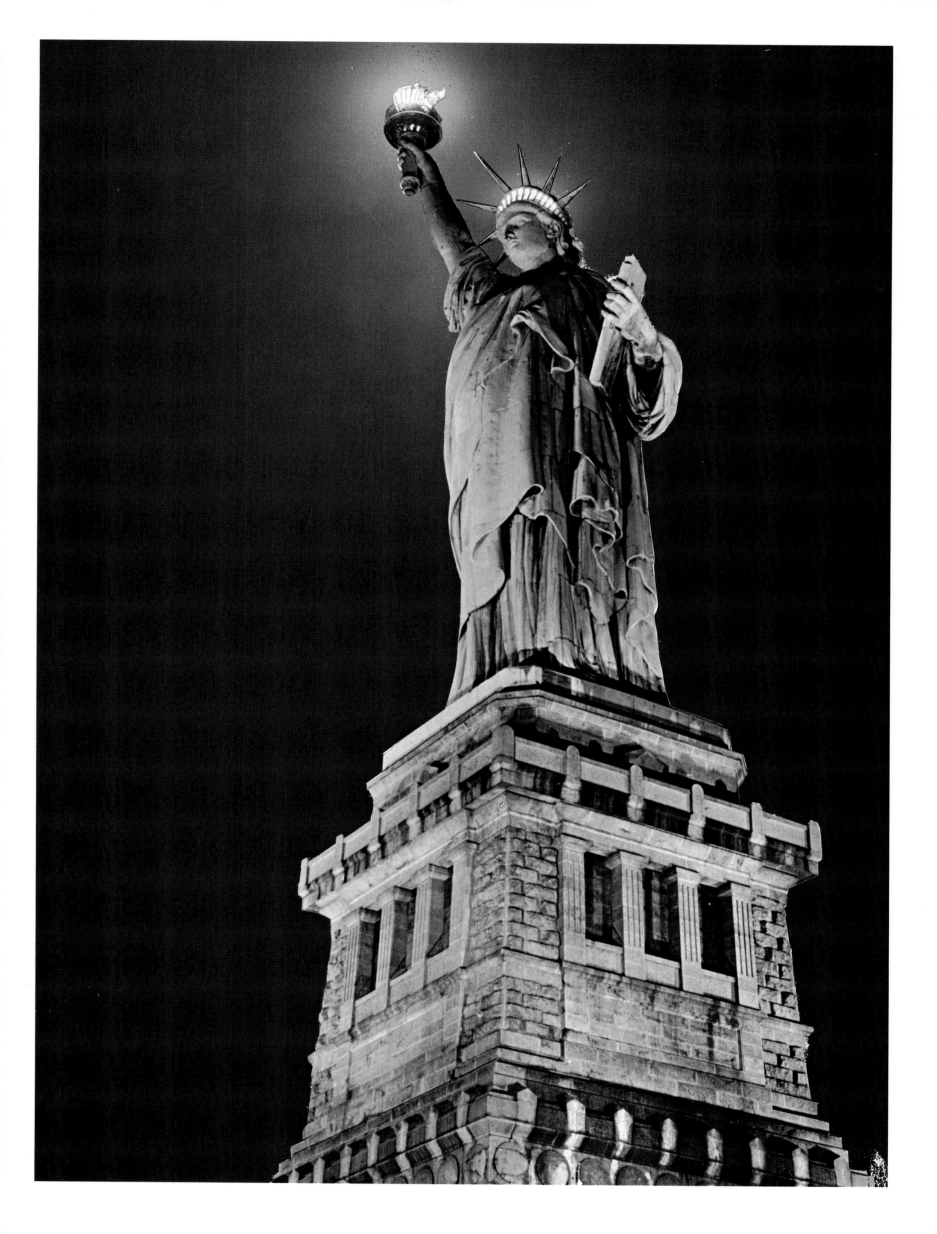

# MOMENTS

. . . TO EYEWITNESS GREAT EVENTS . . .
TO SEE STRANGE THINGS . . .

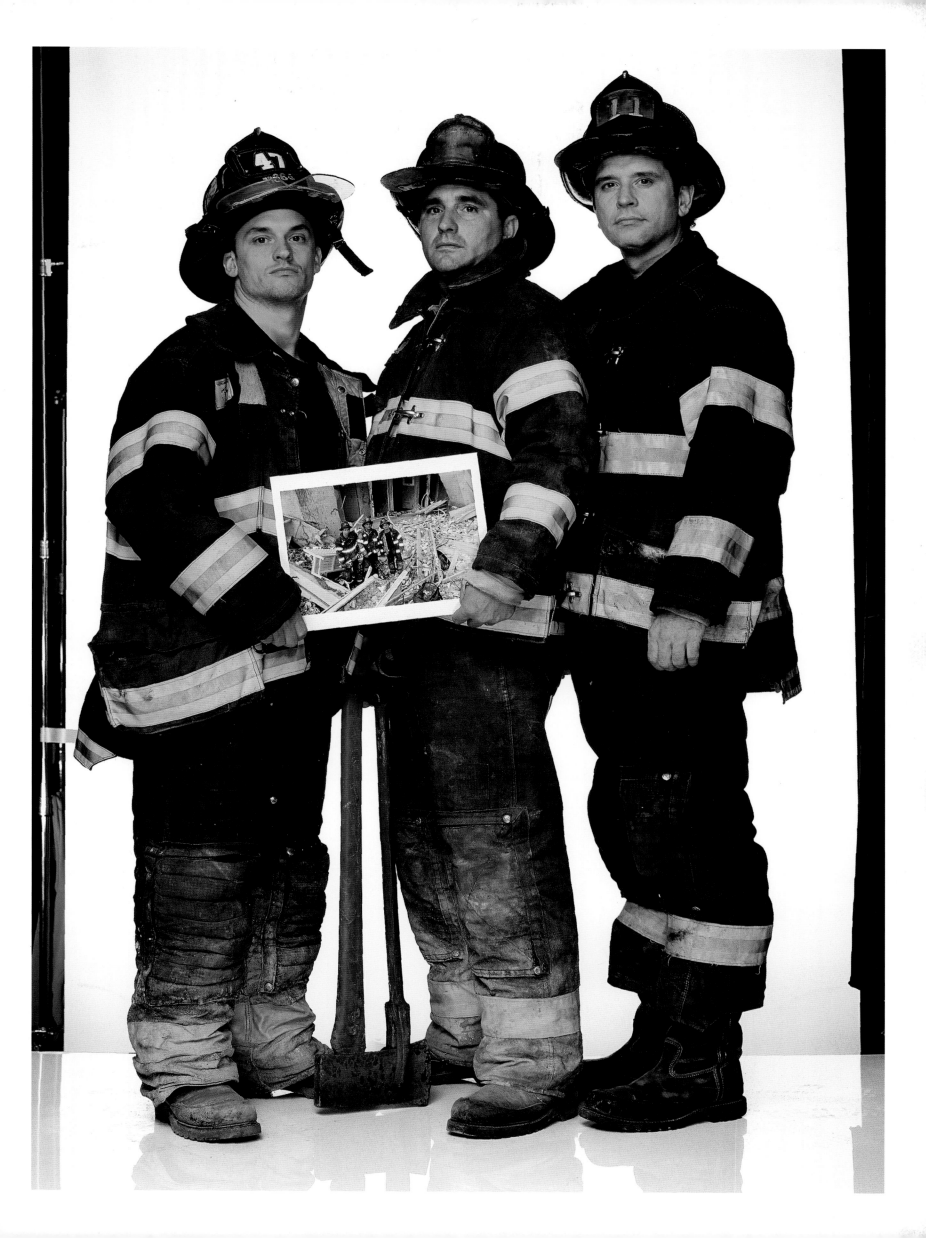

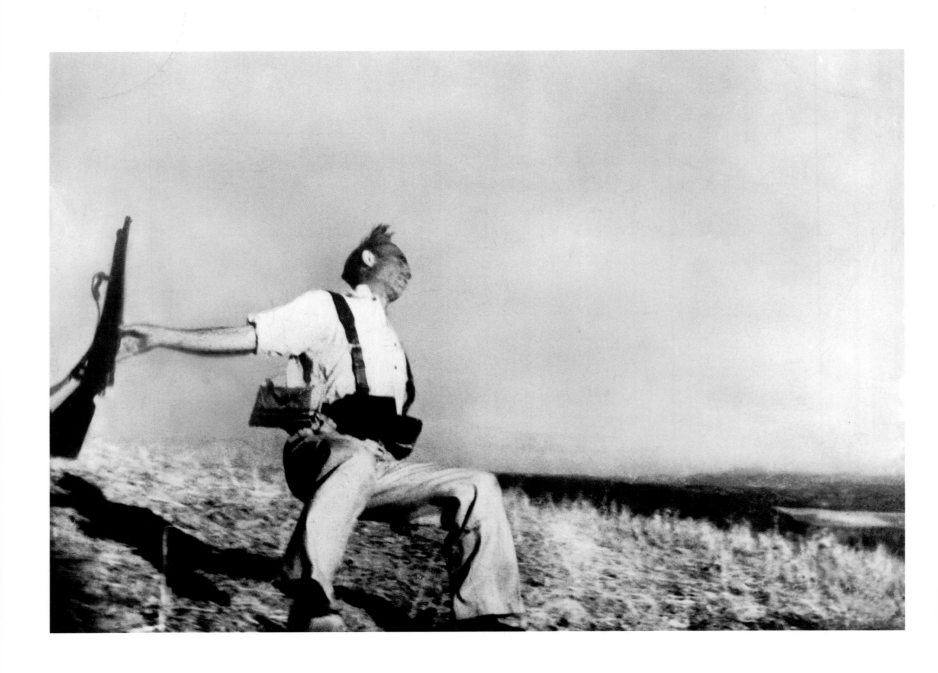

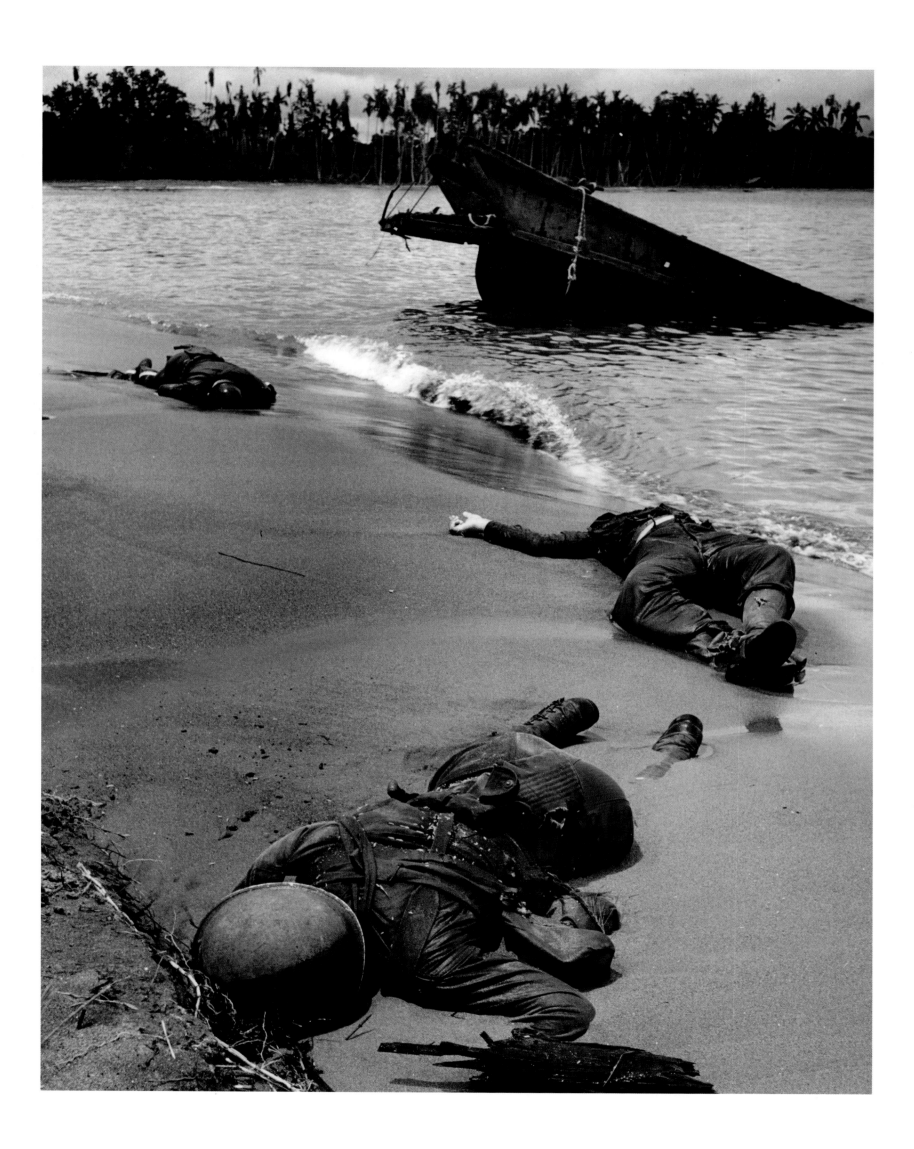

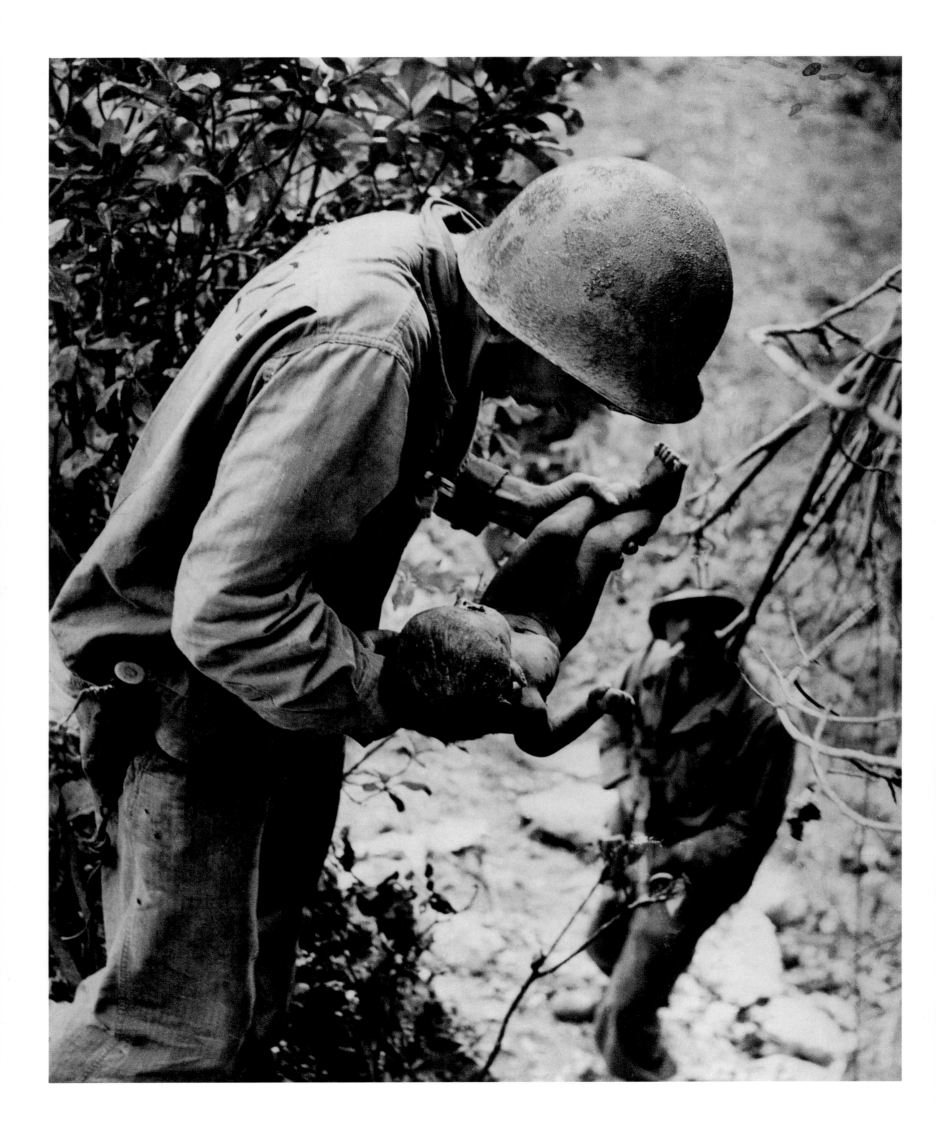

Page 67
**"FACES OF GROUND ZERO," 2001**
After the attacks of September 11, Joe McNally, LIFE's last staff photographer, embarked on a project in a studio only blocks from Ground Zero: To make portraits of men, women and children involved in the tragedy. Police, firefighters, survivors, widows—everyone, including the mayor—came before McNally's camera. Several of the images first appeared in the LIFE book *One Nation*, and an exhibit of larger-than-life versions of the portraits debuted in New York's Grand Central Terminal and then toured other cities. In this picture are the fire-fighting Gleason brothers. Patrick (center) was working when the alarm came in. Richard (left), who was off-duty, and Peter, who was retired, geared up to join in the effort.
PHOTOGRAPH BY JOE MCNALLY

Page 68
**FALLING SOLDIER, 1936**
The official title of this, perhaps the most famous war photograph of all time, is "Loyalist Militiaman at the Moment of Death, Cerro Muriano, September 5, 1936." The photographer, the mysterious, dashing Robert Capa, once said, "If your pictures aren't good enough, you're not close enough." He was certainly close enough at this climactic moment, as a loyalist soldier of the Spanish Republic greeted death with open arms.
PHOTOGRAPH BY ROBERT CAPA

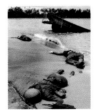

Page 69
**"THREE DEAD AMERICANS," 1943**
The accomplished crime and sports photographer George Strock joined LIFE and almost immediately went off to war in the Pacific. Strock documented, among other battles, the one at Buna in Papua New Guinea, which claimed more than 3,000 Allied lives. At the time in the U.S., government censors had been enforcing a ban on images depicting American dead. LIFE raised the point with Washington, and FDR himself decided the public was growing complacent and should see the dire reality. This image from Buna Beach shook the nation awake.
PHOTOGRAPH BY GEORGE STROCK

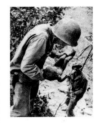

Page 70
**ALSO IN THE PACIFIC THEATER, 1944**
In 1944 Gene Smith was on the front lines as the United States set off on its island-hopping offensive against Japan. He took memorable battle pictures on Iwo Jima, in particular, and photographed U.S. Marines and Japanese POWs on that island, Okinawa and Guam. Here, on Saipan, Smith made one of his most famous photographs, of a Marine lieutenant cradling a half-dead Micronesian baby who had been found in a cave. In a 1945 tribute to their 21 war photographers, LIFE's editors wrote: "Finally, on Okinawa, the averages caught up with Smith. A Japanese shell fragment hit him in the face, tore through his cheek and mouth." That ended Smith's war, though he would eventually recover.
PHOTOGRAPH BY W. EUGENE SMITH

Page 71
**D-DAY, OMAHA BEACH, 1944**
Capa was with the first wave of Allied soldiers to hit Omaha Beach on June 6, 1944. He shot four rolls of film. A photo assistant in London, however, wrecked all but 11 images. Fortunately, the handful that survived were more than enough to limn the massive assault, and when this soon-to-be-famous picture ran in LIFE a week later, folks at home had a real sense of the perils of that longest day. Capa shared the fears and fatigue of the men he accompanied. During one campaign, he kept repeating to himself, "I want to walk in the California sunshine and wear white shoes and white trousers." He was killed in 1954 when he stepped on a land mine while covering war—this time in Southeast Asia—for LIFE.
PHOTOGRAPH BY ROBERT CAPA

Page 73
**BUCHENWALD, 1945**
The distance that Bourke-White traveled from the masterly but clean industrial photography she crafted for *Fortune* magazine in the early 1930s to the shattering human documents she forged at the Nazi concentration camps in 1945 is immeasurable. "I saw and photographed the piles of naked, lifeless bodies, the human skeletons in furnaces, the living skeletons who would die the next day," she said. "Using the camera was almost a relief. It interposed a slight barrier between myself and the horror in front of me."
PHOTOGRAPH BY MARGARET BOURKE-WHITE

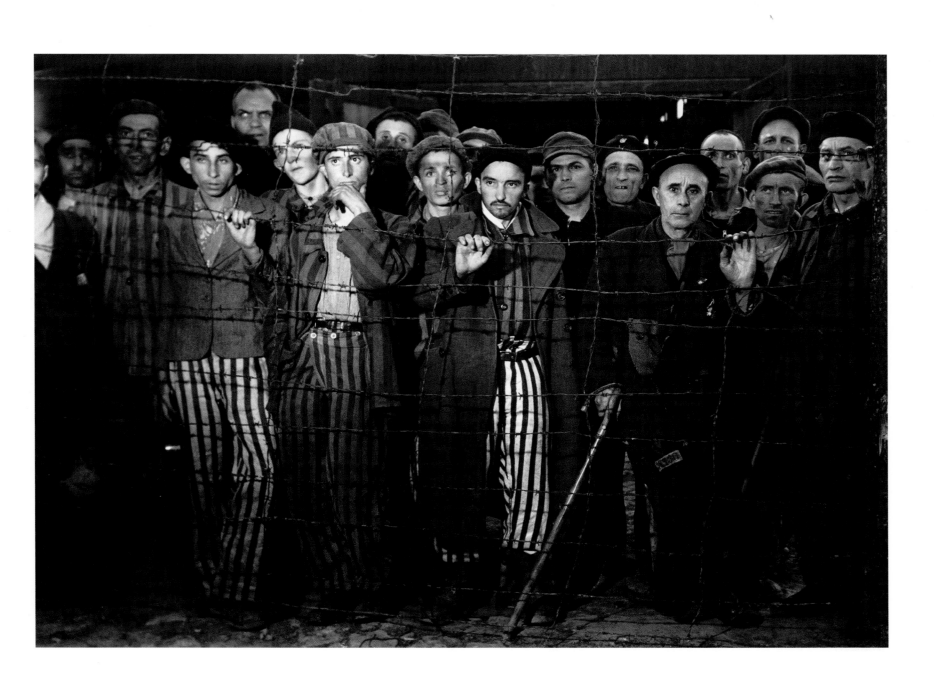

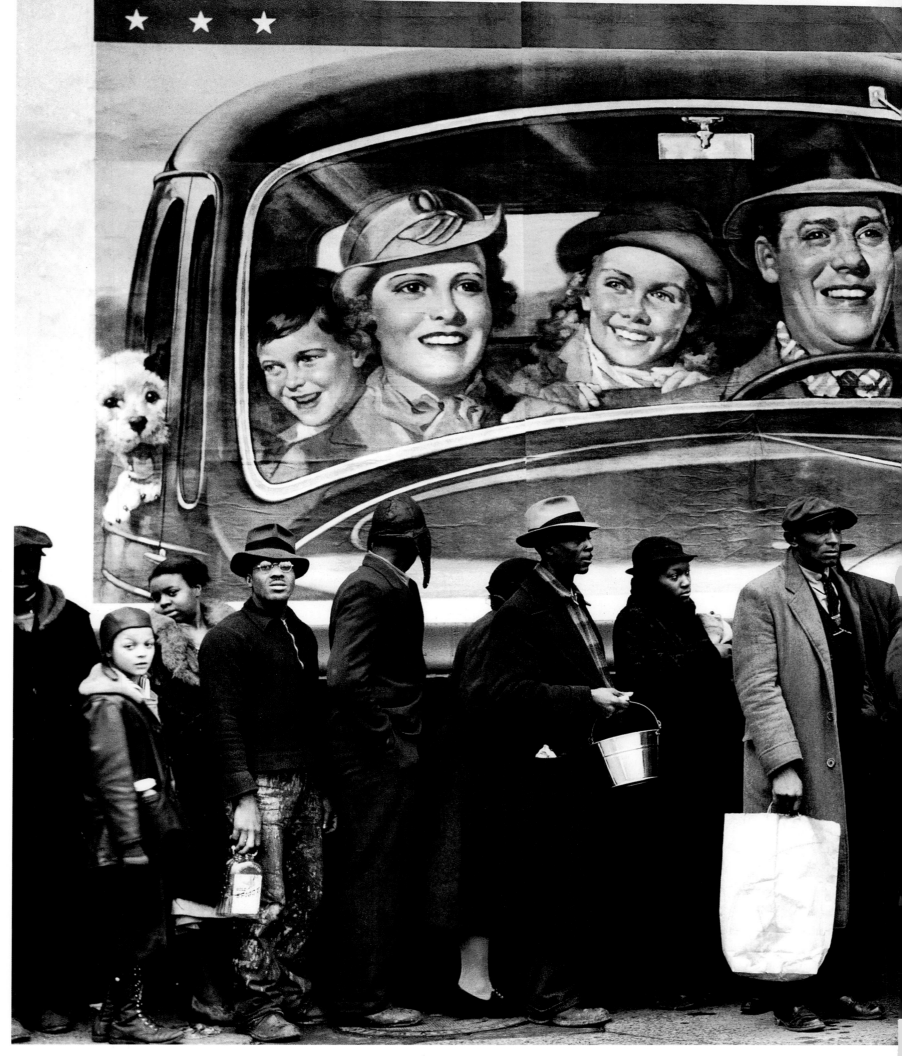

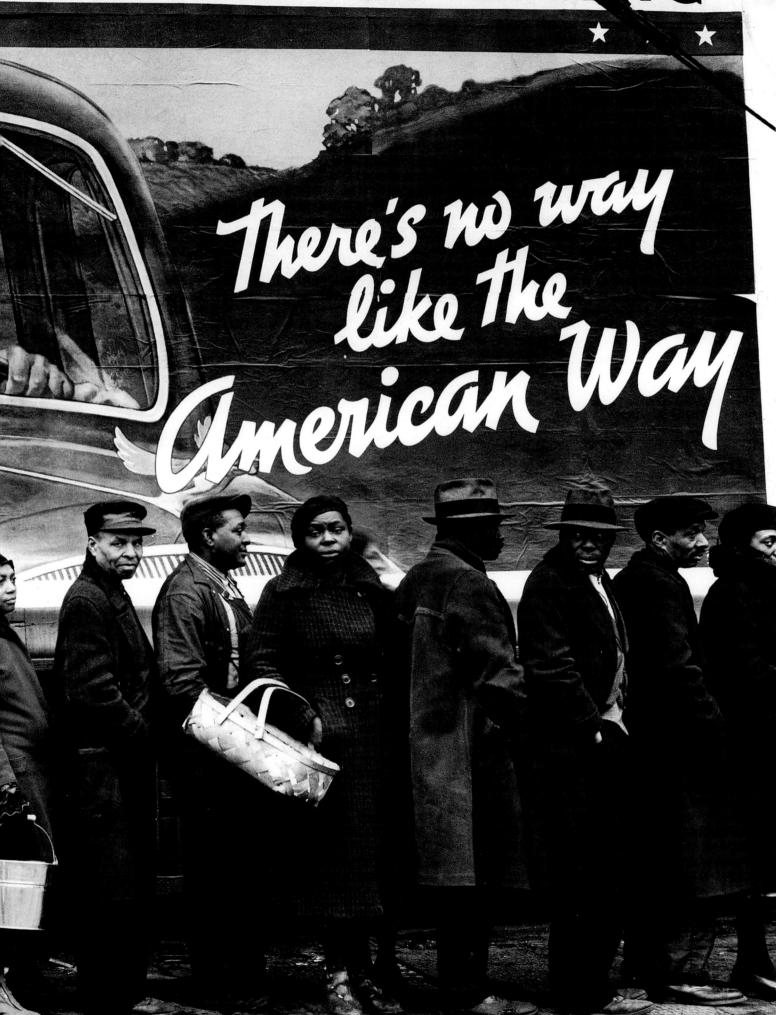

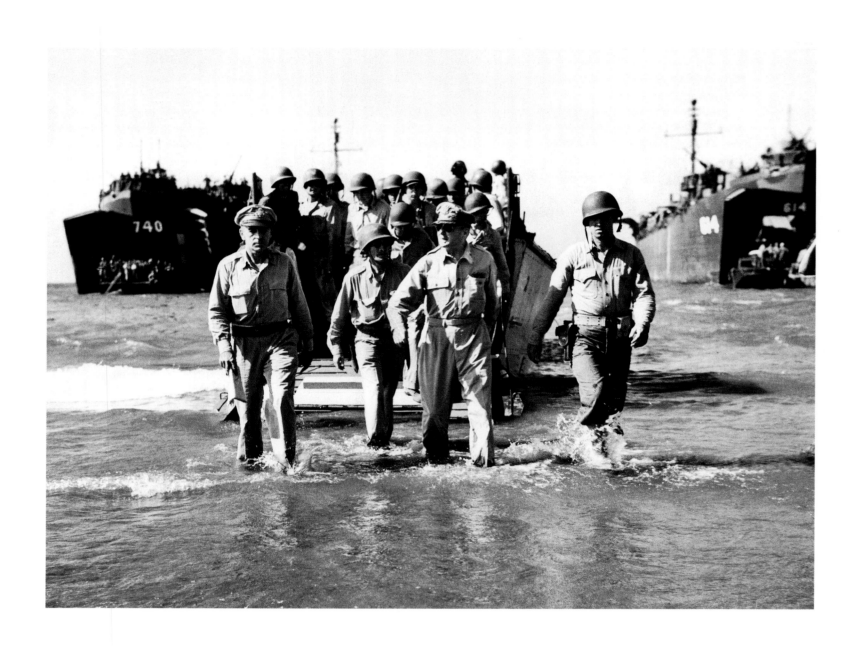

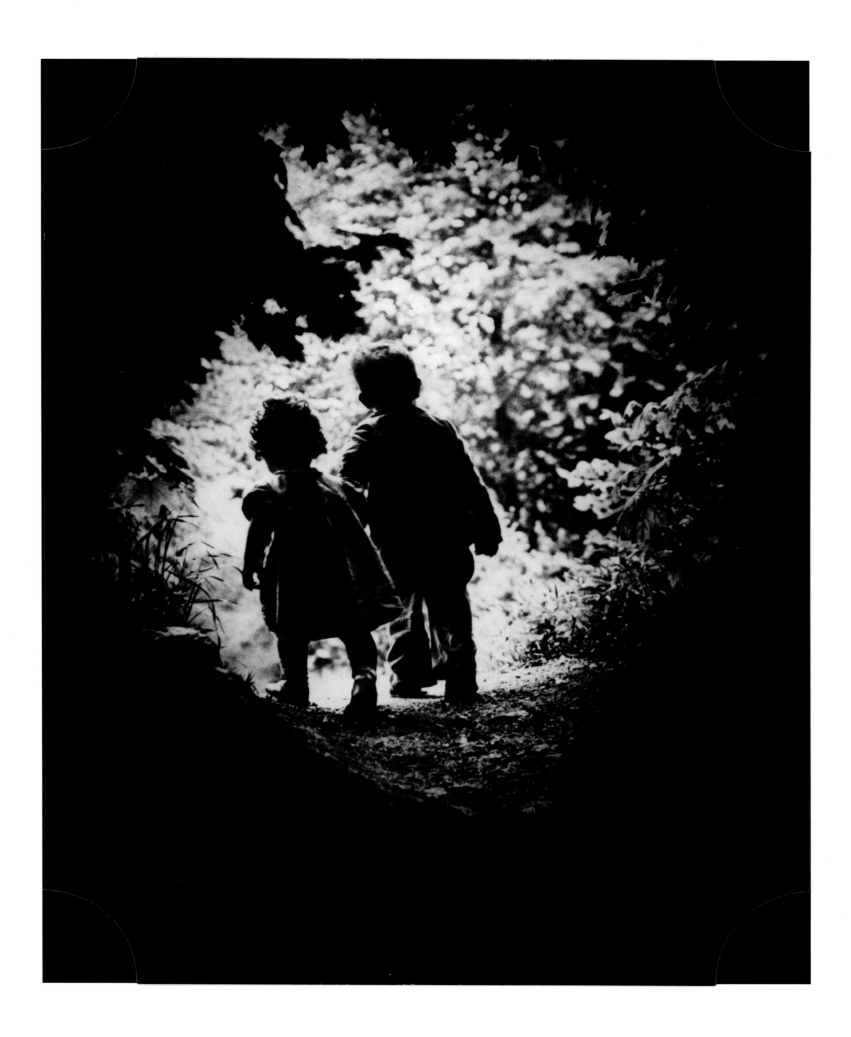

Page 74
**THE AMERICAN WAY, 1937**
Victims of the Louisville Flood wearily assembled in front of an image that might as well have been from another world; they were in line to receive food and clothing from a Red Cross relief station. The juxtaposition with the billboard is, clearly, nothing short of surreal—but it took a keen eye to see the picture whole. Bourke-White later said that when LIFE's founder and Time Inc.'s chief, Henry Luce, saw the difference between her flood photos and those from the news services, he realized that his photographers deserved credit lines.
PHOTOGRAPH BY MARGARET BOURKE-WHITE

Page 76
**MACARTHUR COMES ASHORE, 1945**
General Douglas MacArthur and photographer Carl Mydans both experienced jarring twists of fate in World War II's Pacific Theater before arriving at this moment. MacArthur was driven from the Philippines by the Japanese in March 1942, declaring emphatically, "I shall return." Two months earlier, Mydans, covering the war for LIFE, had been taken prisoner in Manila; he was held for nearly two years before being repatriated in a POW exchange. MacArthur made good on his pledge in October of '44. This photo, taken during American landings at Lingayen Gulf in the Philippines, is invariably used to commemorate "the return." However, it was actually taken three months later, at a different beach than that of the original landing. The general apparently preferred his commanding mien in this version.
PHOTOGRAPH BY CARL MYDANS

Page 77
**"THE WALK TO PARADISE GARDEN," 1946**
Gene Smith, as we have learned, was badly wounded in 1945 on Okinawa. He couldn't pick up a camera again until May 1946. "The day I again tried for the first time to make a photograph, I could barely load the roll of film into the camera. Yet I was determined that the first photograph would be a contrast to the war photographs and that it would speak an affirmation of life." In "The Walk to Paradise Garden," we watch as Smith's daughter and son make their way from a shrouded place into a world of light behind their suburban New York home. Paradise, at least for a time, is regained.
PHOTOGRAPH BY W. EUGENE SMITH

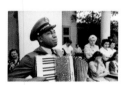

Page 79
**AMONG THE MOURNERS, 1945**
President Franklin Delano Roosevelt's death in April 1945 was a terrible blow to America—we lost a man who had led us out of the Great Depression and guided us through the Second World War. Here, in Warm Springs, Ga., where the President had been scheduled to attend a barbecue on the day he died, Chief Petty Officer Graham Jackson plays "Going Home" as FDR's body is borne past. "I heard this accordion start to play behind me," photographer Ed Clark later remembered. He turned around and saw Jackson's face. "I thought to myself, 'My God, what a picture.'"
PHOTOGRAPH BY EDWARD CLARK

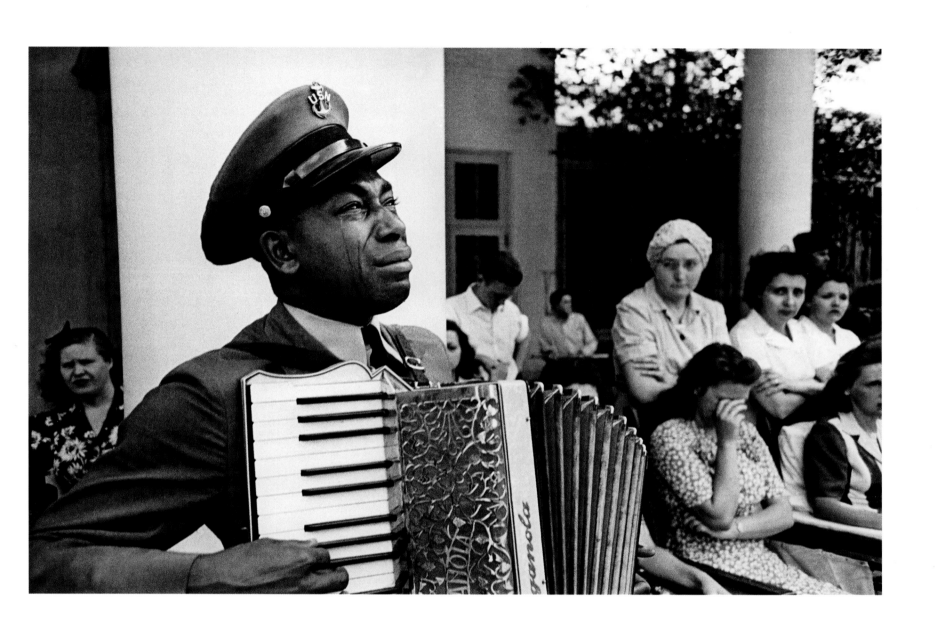

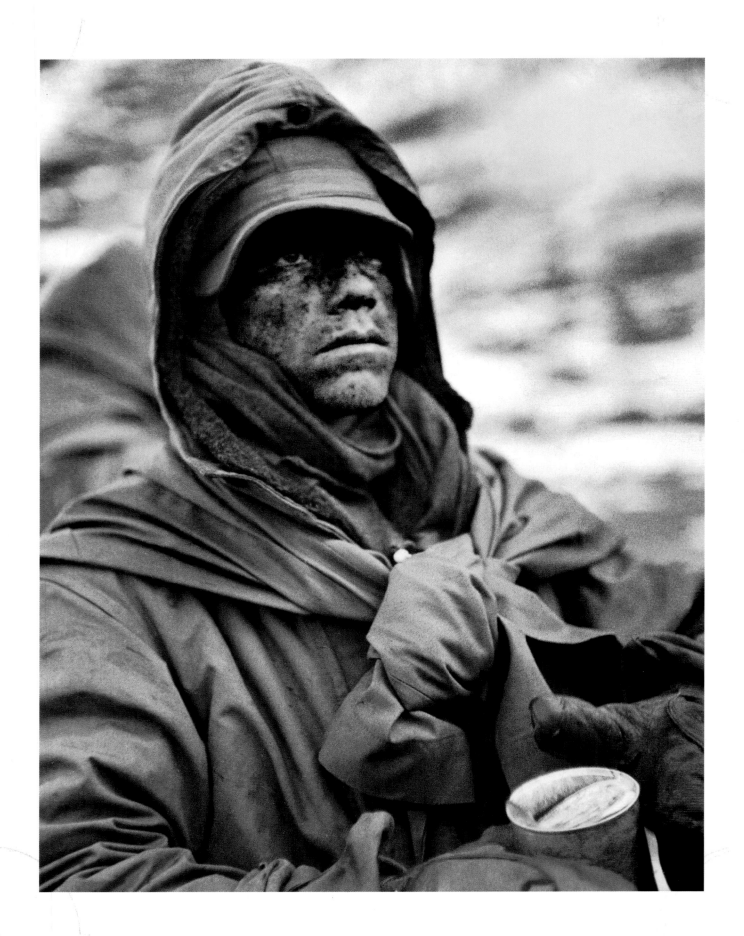

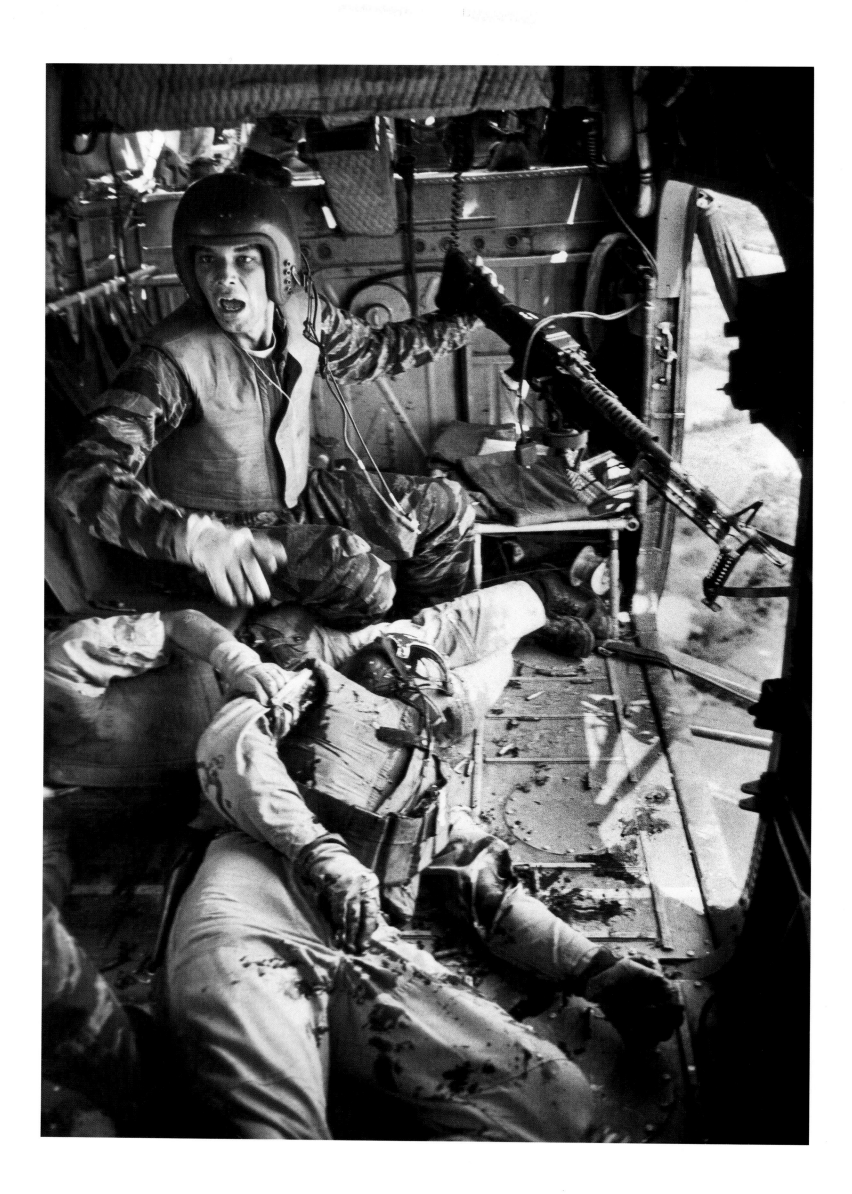

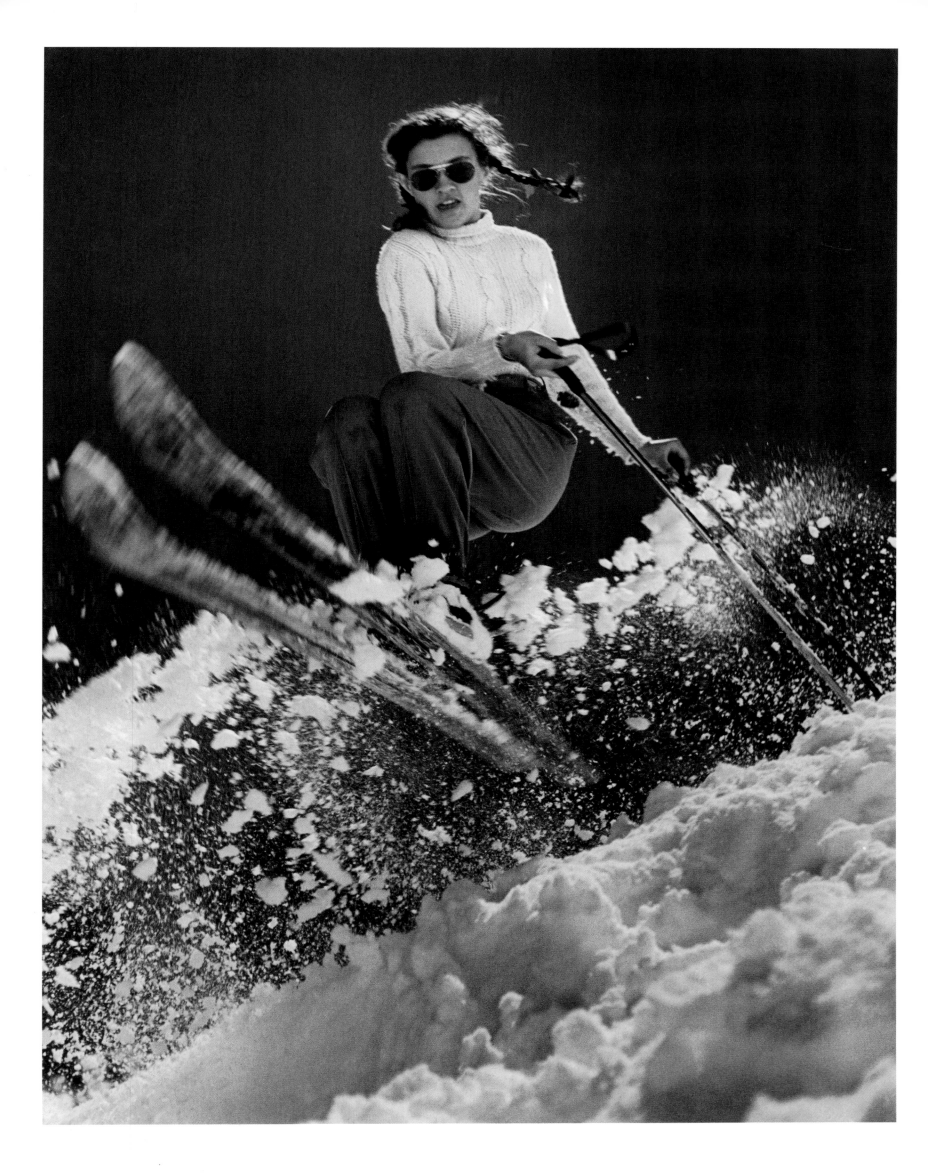

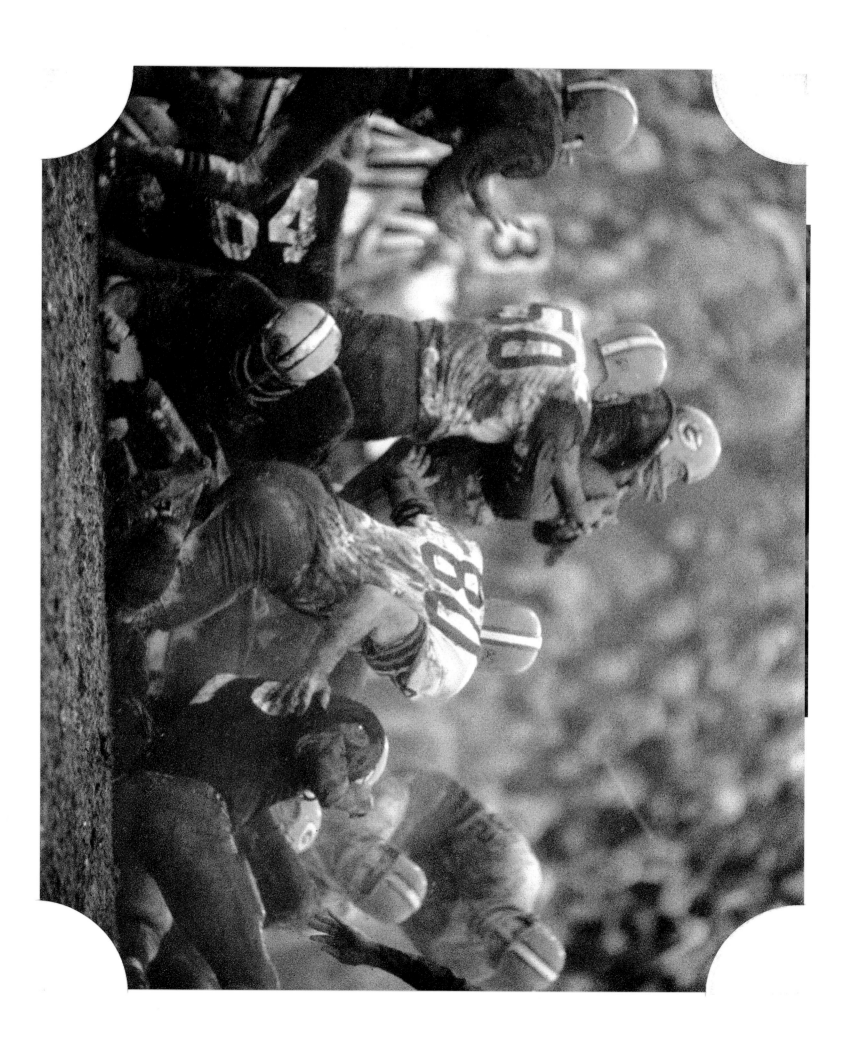

Page 80

**THE WAR IN KOREA, 1950**

Only five years earlier Americans were fighting a brutal war in Asia, and now, in 1950 it was time to go back—this time to Korea, to take on the North Koreans and the Chinese. David Douglas Duncan, the World War II veteran who had stayed on for LIFE in the Middle East, became the signature photographer of the Korean conflict. In this photograph, a U.S. Marine shows the strain of fighting against heavy odds, with minimal rations and in the cold of December, during a long retreat from the Changjin Reservoir along a route nicknamed "Nightmare Alley."

PHOTOGRAPH BY DAVID DOUGLAS DUNCAN

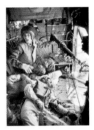

Page 81

**ABOARD YANKEE PAPA 13, 1965**

What Duncan was to Korea, Larry Burrows was to Vietnam, and his masterpiece photo essay from that war was "One Ride with Yankee Papa 13." That was the name of a Marine helicopter whose crew was given the job of ferrying a battalion of Vietnamese infantry to an isolated area 20 miles away. That area was a rendezvous point for enemy Vietcong forces, and by day's end disaster had laid its cruel hand on several very young men. In this picture, crew chief Lance Cpl. James C. Farley, his machine gun jammed, returns to base with two wounded comrades.

PHOTOGRAPH BY LARRY BURROWS

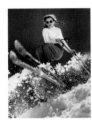

Page 82

**ANDREA MEAD LAWRENCE, 1947**

It can still be said more than 60 years later that she is the greatest-ever U.S. ski racer. Lawrence, of Rutland, Vt., was only 15 years old when she flashed past George Silk's camera in 1947 during practice sessions for the next year's Winter Olympics. Although she didn't take home any medals at St. Moritz, four years later, at Oslo, she became the first American skier ever to win two gold medals in a single Olympics—she took the slalom and giant slalom—and remains today the only one to turn the trick. Silk's sports photography from just after World War II is evidence that today's technological advancement, while fine, has done nothing to add excitement to a well-made picture.

PHOTOGRAPH BY GEORGE SILK

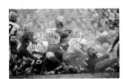

Page 83

**NFL CHAMPIONSHIP GAME, 1966**

As did his LIFE colleague Silk, Arthur Rickerby chronicled the Pacific Theater in World War II, then returned to civilian life to cover a variety of topics, principal among them sports. His photography helped bring pro football, with all of its attendant strategy, speed and violence, into national prominence. In this picture, Vince Costello of the Cleveland Browns has put Jim Taylor of the Green Bay Packers in a bear hug during play on muddy Lambeau Field in Wisconsin. The Pack, under legendary coach Vince Lombardi, would eventually emerge victorious, 23–12, thus gaining its ninth NFL title overall. As for Rickerby, his pictures of other subjects would eventually hang in the Museum of Modern Art in New York City, but he would still be remembered as "the sports guy."

PHOTOGRAPH BY ARTHUR RICKERBY

Page 85

**SHASTRI'S FUNERAL, 1966**

Lal Bahadur Shastri, the third prime minister of independent India, was a revered figure. Upon hearing a speech by Gandhi as a boy, he dedicated his life to serving his homeland, and later spent years in prison for his activities with the freedom movement. Once India gained its independence from Great Britain in 1947, Shastri became a statesman. Upon becoming prime minister in 1964, he promised to fight for "freedom and prosperity for all and the maintenance of world peace and friendship with all nations." Within two years, Shastri was dead of a heart attack at age 61, and India was plunged into mourning. Larry Burrows traveled to New Delhi and, in a single famous image, told the story of a serene but strong man and a nation's grief.

PHOTOGRAPH BY LARRY BURROWS

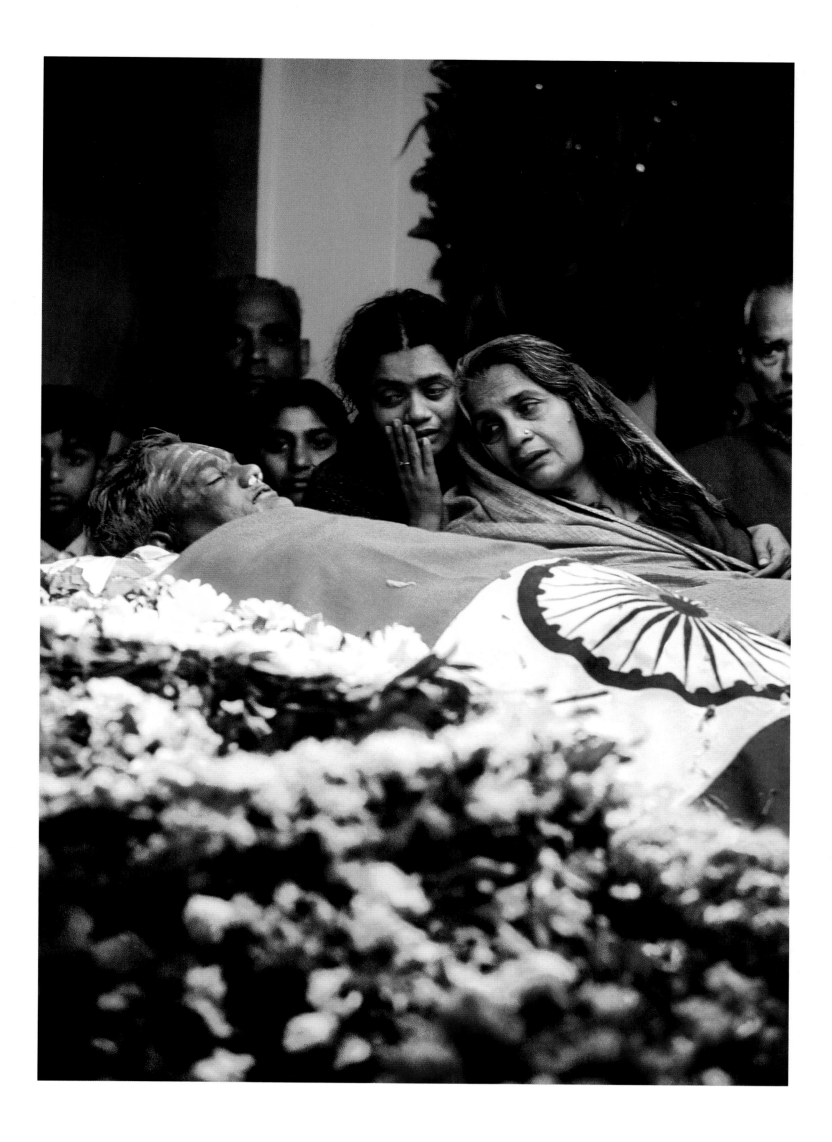

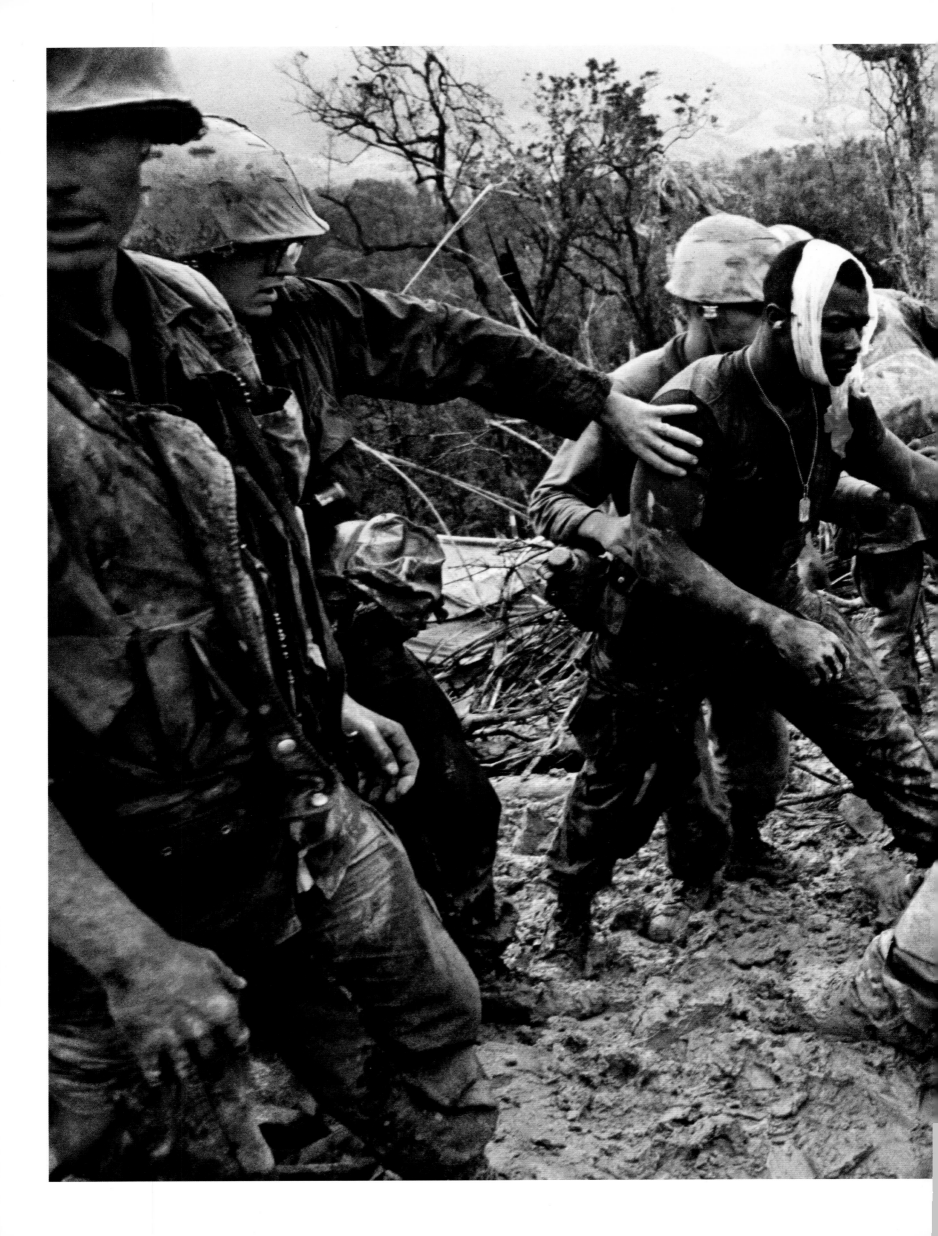

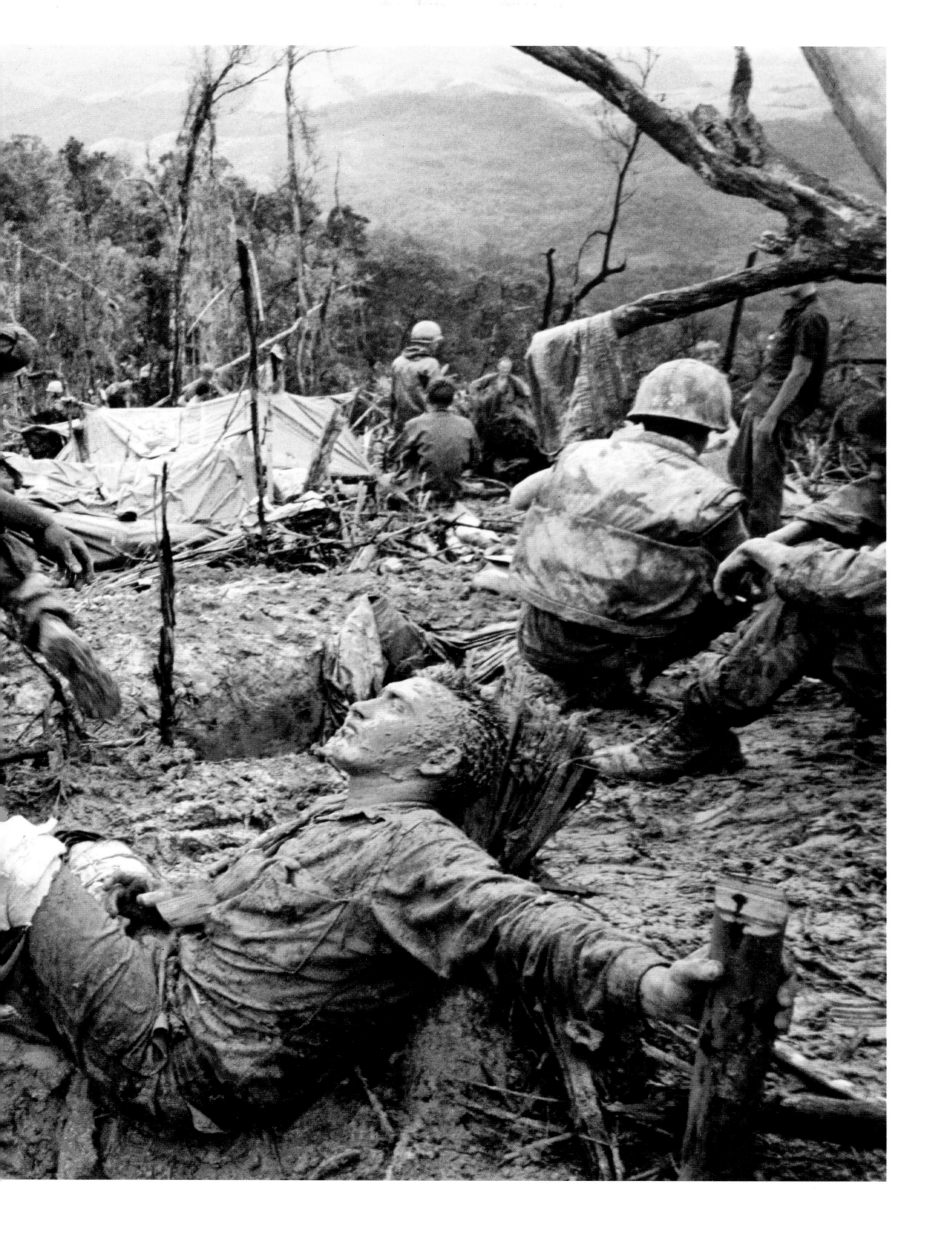

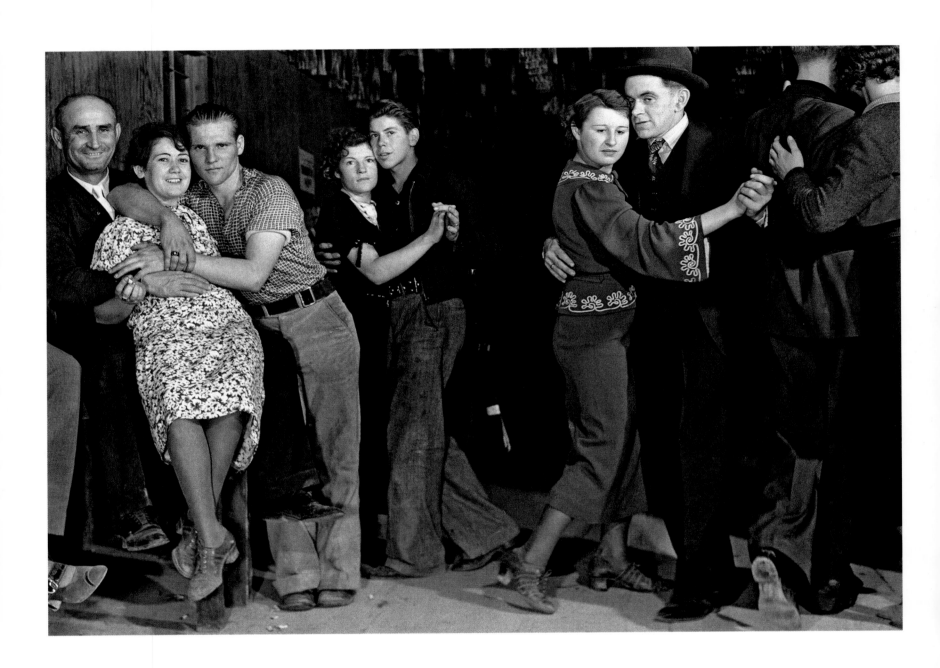

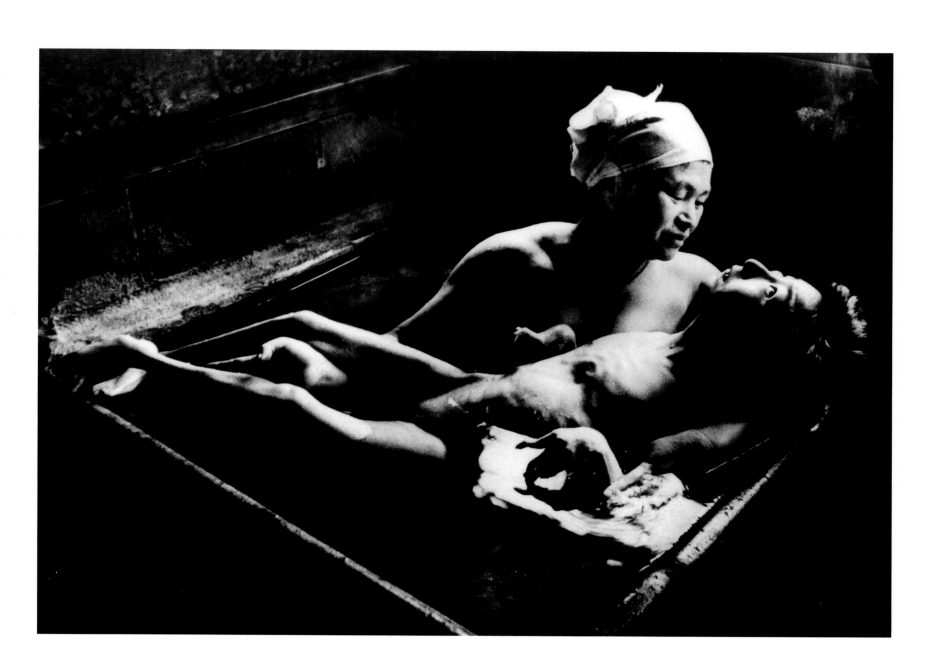

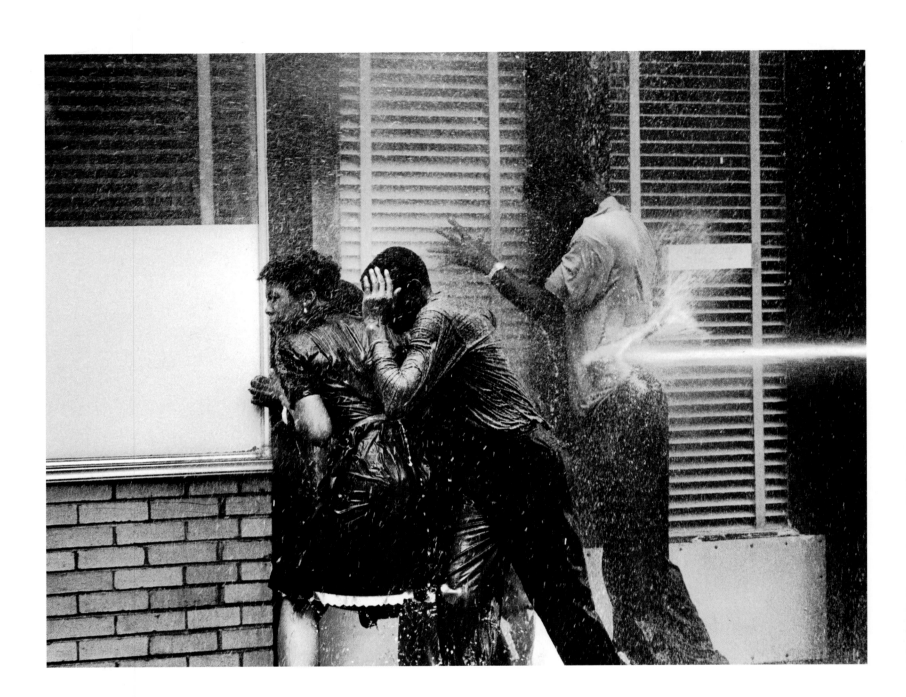

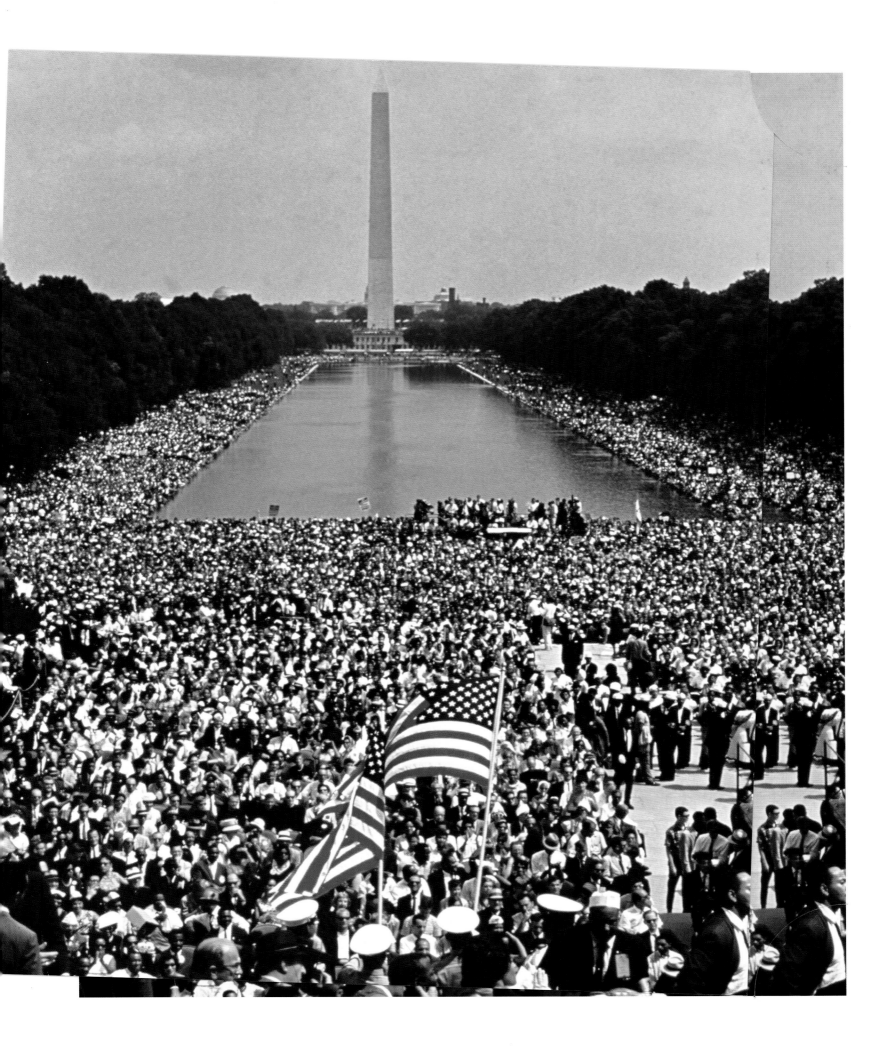

Page 86
**"REACHING OUT," 1966**
Casualties ran heavy on October 5, 1966, when a company of Marines was caught in an ambush on Mutter's Ridge in South Vietnam. In this famous photograph, which was untitled by Burrows but has come to be called "Reaching Out," Gunnery Sergeant Jeremiah Purdie has just arrived at a first-aid station and, despite his own wounds, seems more concerned with a fellow stricken soldier. Burrows himself went about his work with a sense of duty: "I can't afford the luxury of thinking about what would happen to me." He covered the war for nine years before he died when the helicopter in which he was traveling was shot down over Laos in 1971.
PHOTOGRAPH BY LARRY BURROWS

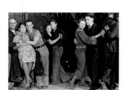

Page 88
**"FRANKLIN ROOSEVELT'S WILD WEST," 1936**
The first feature in the inaugural issue of LIFE brought into focus a work-relief project in northeastern Montana that was designed by FDR's planners to bring jobs to the unemployed. The Fort Peck Dam project—the dam itself was featured on the cover in another Bourke-White shot that in turn became a U.S. first-class postage stamp in 1998—spurred the establishment of a half dozen shantytowns, with names such as New Deal and Delano Heights. Like the wild and woolly boomtowns of yore, these communities had wide-open saloons, a red-light district and bad men with guns. The caption for this photo read: "Taxi dancers lope all night in scuffed and dusty shoes for a nickel a song."
PHOTOGRAPH BY MARGARET BOURKE-WHITE

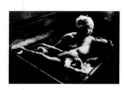

Page 89
**"TOMOKO UEMURA IN HER BATH," 1971**
It has been called photojournalism's "Pietà." In 1971, Smith and his wife, photographer Aileen, moved to Minamata, Japan, a coastal fishing village that had been riddled with disease after a chemical company dumped mercury into the water, poisoning much of that water and the food supply. In this picture, Tomoko, who was born blind, mute and with deformed limbs, is bathed by her mother. Many regard this beautiful, painful image as the first photograph to awaken the world to ecological abuse.
PHOTOGRAPH BY W. EUGENE SMITH

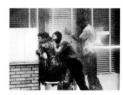

Page 90
**THE CIVIL RIGHTS MOVEMENT, 1963**
For a long time, Birmingham, Ala., had been considered one of the toughest, most volatile places in the American South, as a sizable black population and a dominant white class frequently joined in overt hostility. By 1963, Birmingham had become a touchstone of the black civil rights movement, and nonviolent demonstrators led by Rev. Martin Luther King Jr. were met with police commissioner Bull Connor's police dogs and fire hoses. Several photographers covered the movement for LIFE, principal among them Charles Moore, and pictures such as this one spurred nationwide revulsion. Said President Kennedy: "Bull Connor has done as much for civil rights as Abraham Lincoln."
PHOTOGRAPH BY CHARLES MOORE

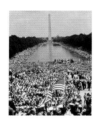

Page 91
**THE MARCH ON WASHINGTON, 1963**
In the centennial year of the Emancipation Proclamation, a quarter of a million Americans gathered to participate in the monumental March on Washington for jobs and freedom. "I have a dream my four little children will one day live in a nation where they will not be judged by the color of their skin but by the content of their character," said Rev. King in his stirring address to the largest mass-protest meeting in the nation's history. "I have a dream today!" Paul Schutzer, a passionate photographer, captured the day for LIFE. Four years later, at age 37, he rushed to Israel to cover the Six-Day War and was killed when the half-track in which he was riding was struck by a shell.
PHOTOGRAPH BY PAUL SCHUTZER

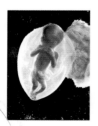

Page 93
**IN THE WOMB, 1965**
Lennart Nilsson began his long fascination with the secrets of life as a boy, collecting plant specimens at age five in his native Sweden. When he was in his late twenties, he saw two-month-old fetuses in laboratory bottles: "In the same second, I knew I would concentrate on the early development of the human," he said. In 1965, LIFE published a piece that was a dozen years in the making, "Drama of Life Before Birth," which included this picture of a living eighteen-week-old fetus and placenta. It became one of the magazine's most famous stories.
PHOTOGRAPH BY LENNART NILSSON

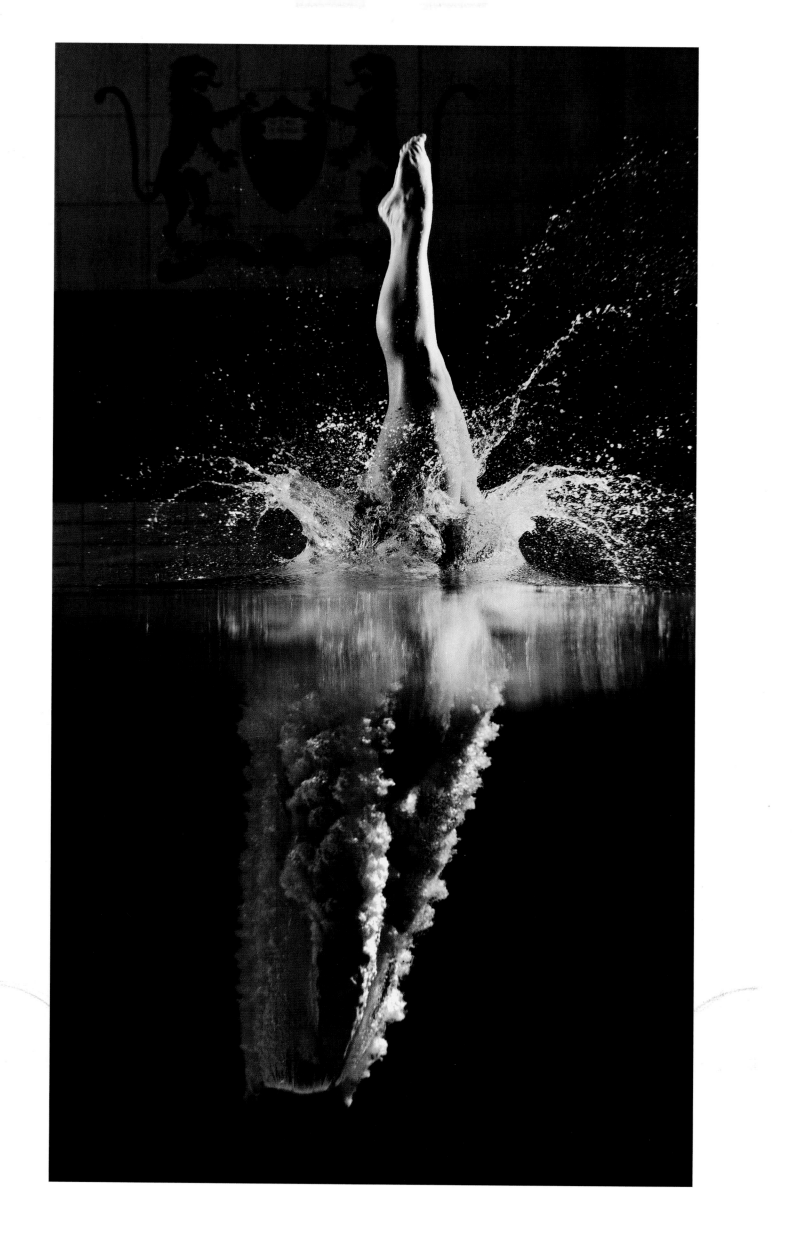

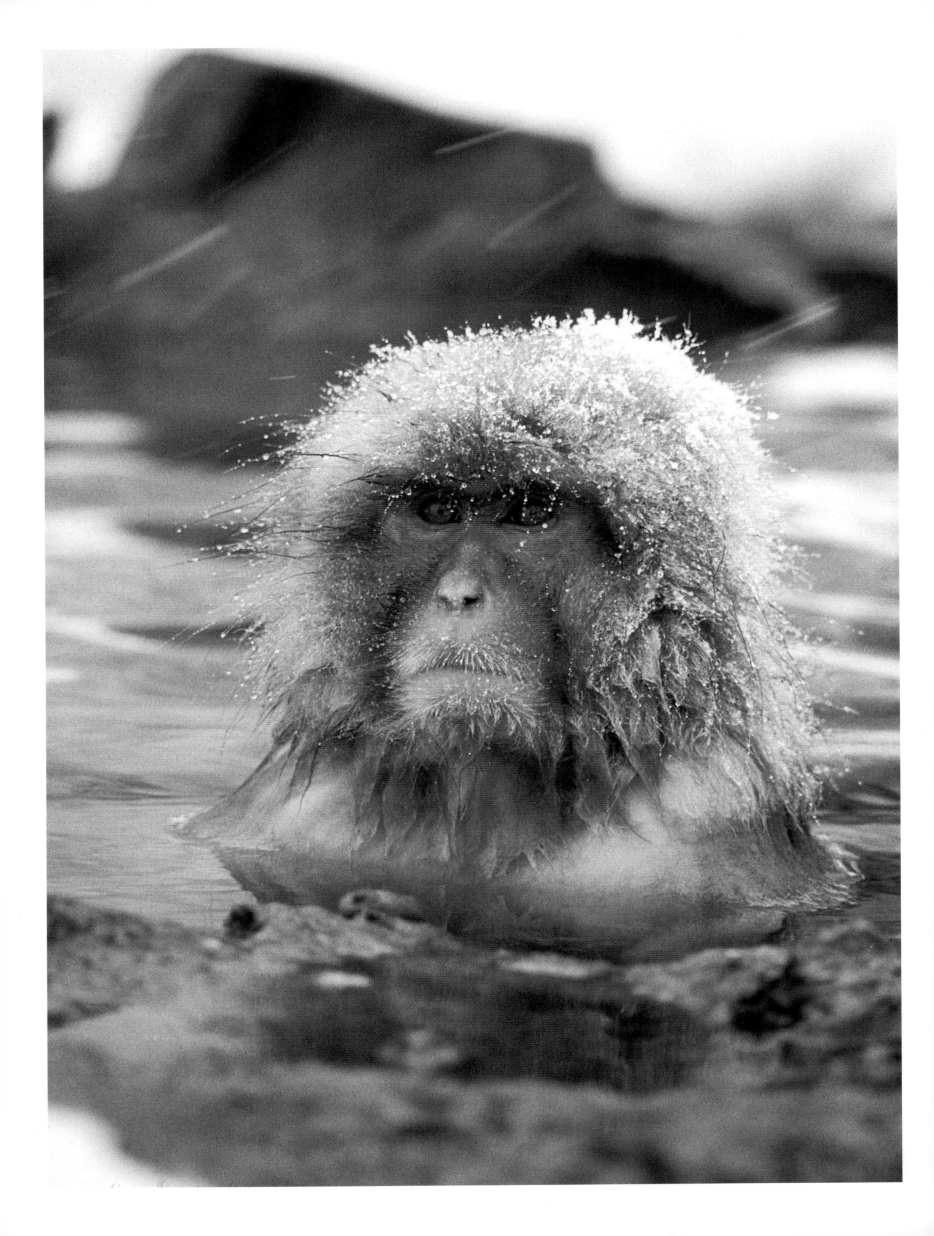

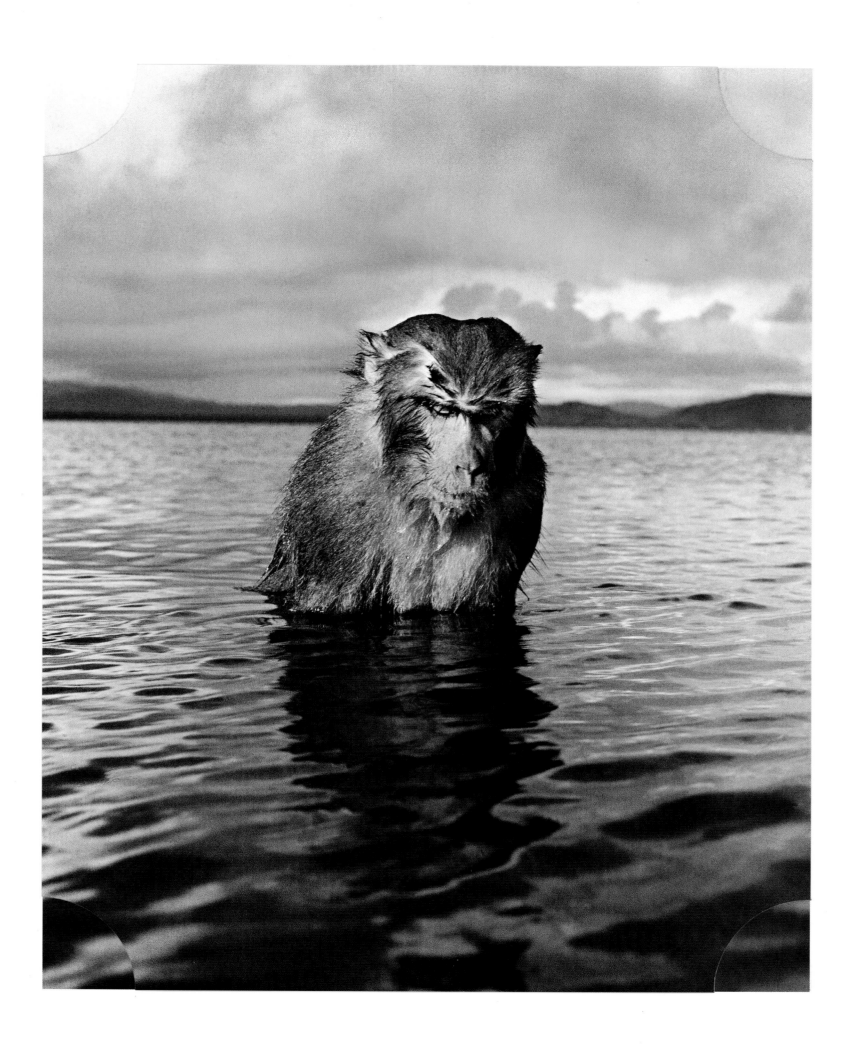

Page 94
**PHOTOGRAPHER, 1951**
The photographer in question was Dennis Stock, and the photographer of the photographer was the wizardly Andreas Feininger. "Realism and superrealism are what I am after," Feininger once said. "This world is full of things the eye doesn't see. The camera can see more, and often 10 times better." Here, it saw patterns, shadows—and somewhere, lurking, a man. Feininger made this portrait of Stock because Stock had won LIFE's 1951 Young Photographer contest. The aspirant shooter would go on to make iconic photographs of the movie star James Dean.
PHOTOGRAPH BY ANDREAS FEININGER

Page 95
**DIVER, 1962**
Sports photographers are often asked to cover an event, to capture the decisive play—the goal as it is scored, the homer as it is hit. That was not George Silk's assignment nor his goal in this instance; he was out to create something abstract and artistic, using sport as the vehicle. He traveled to Princeton University's Dillon Gym pool in New Jersey, and asked to have the water level lowered so that his camera, which was aimed through a trainer's observation window, could capture action half in and half out of the water. He set up six flash units to record the athlete's entry, knowing he had to trigger them at the exact moment. Then he asked 14-year-old national diving champion Kathy Flicker to do her stuff on the springboard. *Et voilà!*
PHOTOGRAPH BY GEORGE SILK

Page 96
**SNOW MONKEY, 1970**
Japanese macaques, also known as snow monkeys, are important figures in Buddhist mythology; it is believed they are the inspiration of the saying "See no evil, hear no evil, speak no evil." They are very smart animals, the only ones besides humans and raccoons known to wash food before eating it. The macaques live far north in the mountains around Honshu, where winter temperatures can drop to zero. They are seen by man mostly when, as with the fellow in this picture, they leave their forests to visit hot springs in Shiga Kogen.
PHOTOGRAPH BY CO RENTMEESTER

Page 97
**RHESUS MONKEY, 1939**
"I call him the monkey on my back," said Hansel Mieth, who had nothing but unpleasant memories about this, her most famous photograph. After Mieth had extensively photographed a rhesus monkey colony on Santiago Island off Puerto Rico, she was furious that LIFE's editors ran only one picture: a sullen, runaway rhesus she had pursued into the water. A picture that had been created as part of a scientific article had been turned by her bosses into a novelty photograph. And then—in the worst possible scenario—the novelty photo became immensely popular, even famous, all but overwhelming Mieth's tremendous portfolio, which included moving photography of war victims and children with polio.
PHOTOGRAPH BY HANSEL MIETH

Page 99
**LION, 1965**
Having already photographed everything from war to food stories, John Dominis, in 1965, undertook two seminal photo essays on very different kinds of cats: the big ones of Africa, and Frank Sinatra. Ol' Blue Eyes came first, and the experience of hanging with the singer for three months, tracking a subject among his own kind, helped the stalwart Dominis when he traveled to the bush. Cheetahs, tigers, leopards and lions were the stars of his series in LIFE, which instantly riveted the nation and brought Dominis laurels.
PHOTOGRAPH BY JOHN DOMINIS

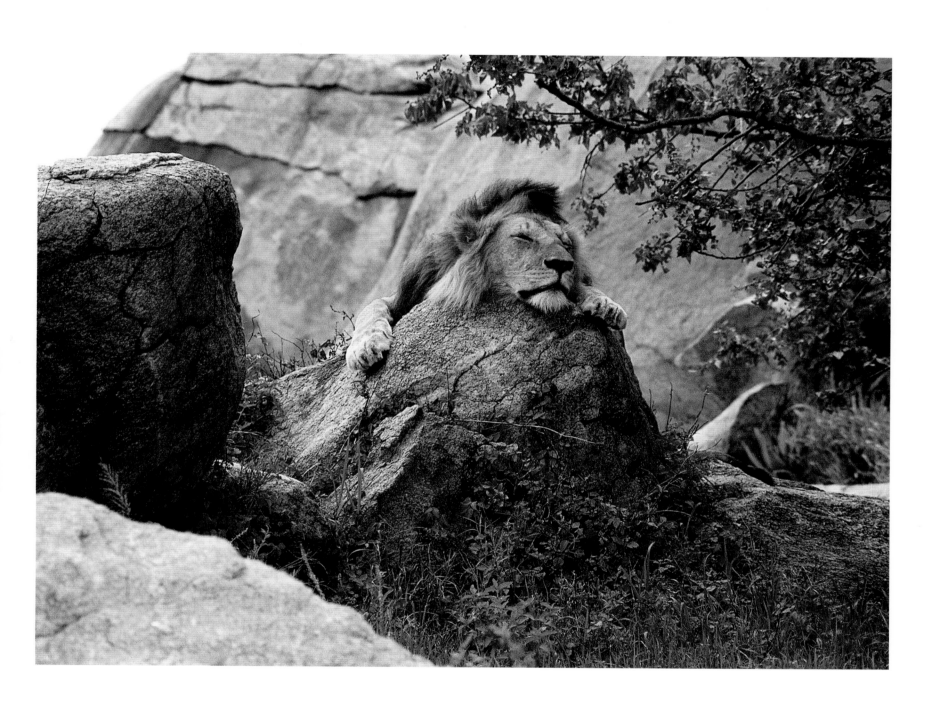

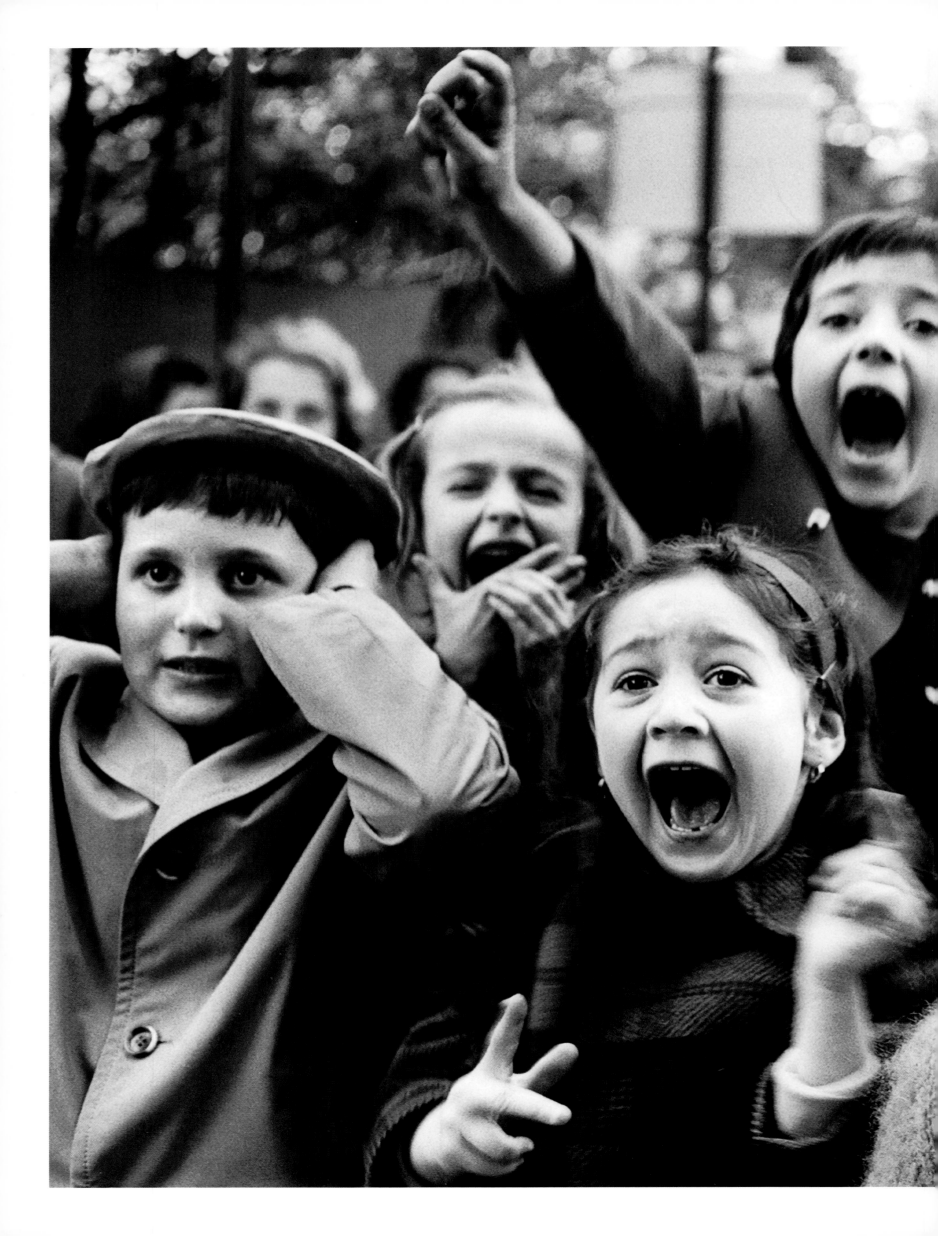

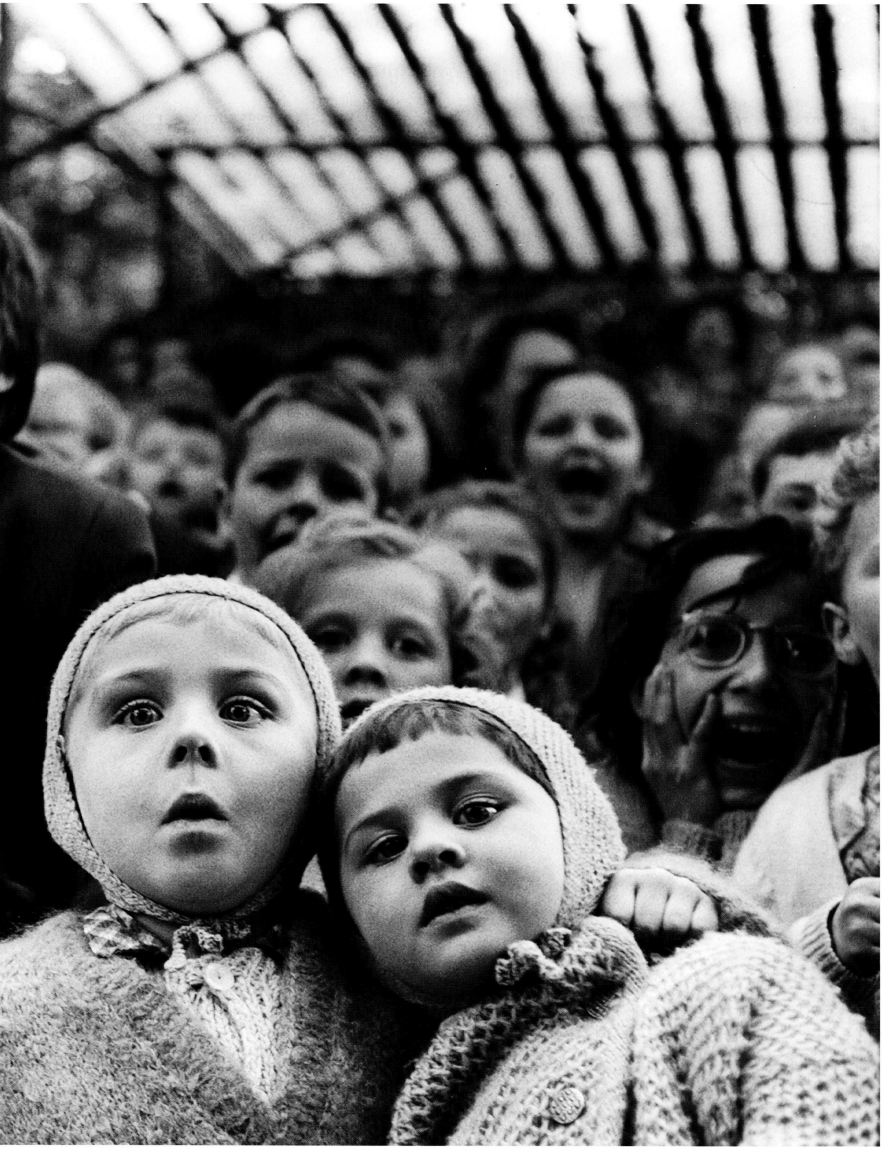

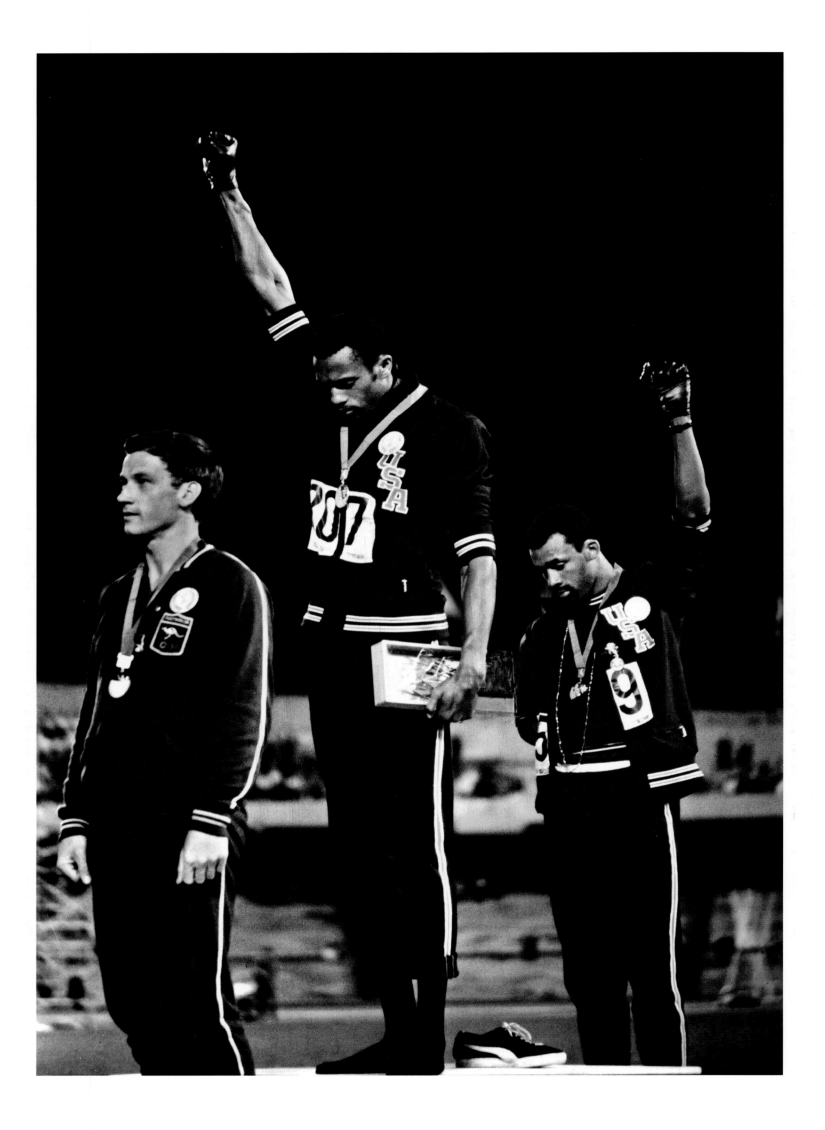

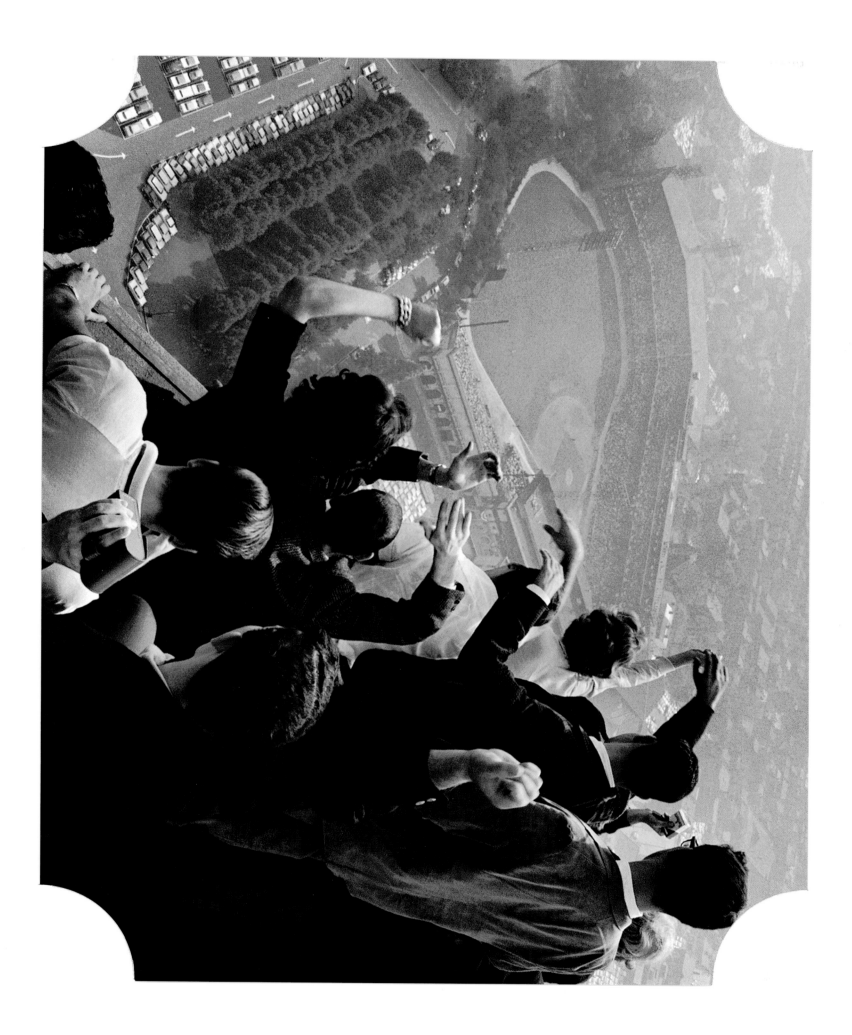

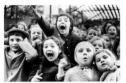

Page 100
**"CHILDREN AT A PUPPET THEATRE," 1963**
Pulling the right strings like a master puppeteer, Alfred Eisenstaedt was a master of delight—an instinctive delighter. At the Guignol puppet show in the Tuileries park in Paris, he knew, during a performance of "Saint George and the Dragon," to turn away from the marionettes and focus on the children. "It took a long time to get the angle I liked," he said later. Three frames on his contact sheet are brilliant, "but the best picture is the one I took at the climax of the action. It carries all the excitement of the children screaming, 'The dragon is slain!' Very often this sort of thing is only a momentary vision. My brain does not register, only my eyes and finger react. *Click*."
PHOTOGRAPH BY ALFRED EISENSTAEDT

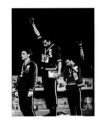

Page 102
**BLACK POWER SALUTE, 1968**
The Olympics have long been—and remain—a stage for political propaganda or protest. Adolf Hitler wanted to introduce the world to his strong, gleaming Third Reich with the Berlin Games of 1936, and in 2008 we saw demonstrations for everything from a Free Tibet to a cleaner environment directed at Beijing. In 1968 the American sprinters Tommie Smith (center) and John Carlos, having won the gold and bronze medals in the 200-meter dash, expressed their solidarity with the Black Power movement back home. It's worth noting that the Australian Peter Norman, who finished second, also donned a human rights badge on the podium in support of Smith and Carlos.
PHOTOGRAPH BY JOHN DOMINIS

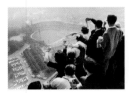

Page 103
**HIGH ABOVE FORBES FIELD, 1960**
When recalling the 1960 World Series, in which the Pittsburgh Pirates beat the New York Yankees four games to three to claim their first title in 35 years, many fans bring up Chuck Thompson's radio call of the final play: baseball's first-ever series-ending home run. "There's a swing and a high fly ball going deep to left, this may do it! . . . Over the fence, home run, the Pirates win! Ladies and gentleman, Bill Mazeroski has just hit a one-nothing pitch over the left-field wall to win the 1960 World Series!" The classic photograph to emerge from that series wasn't even taken in the ballpark, but from atop the Cathedral of Learning at the University of Pittsburgh, where students got a bird's-eye view of the action and George Silk got an altogether unique sports photo.
PHOTOGRAPH BY GEORGE SILK

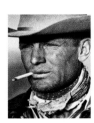

Page 105
**COWBOY, 1949**
Clarence Hailey Long was foreman of the JA Ranch on the Texas panhandle when LIFE's Leonard McCombe visited. In the story accompanying this iconic cover photograph, the magazine's editors described a cowboy as "one of the most purely functional human beings the world has ever developed." Across the country from Long's ranch, in New York City, advertising exec Leo Burnett was looking for a way to reinvent Philip Morris's Marlboro cigarette brand, which was then pitched at the women's market. He seized upon this image in dreaming up the uber-masculine Marlboro Man. In a 2006 book, *The 101 Most Influential People Who Never Lived*, the Marlboro Man, who fronted one of the most successful ad campaigns ever, came out Number One. Never lived? Tell it to C.H. Long.
PHOTOGRAPH BY LEONARD MCCOMBE

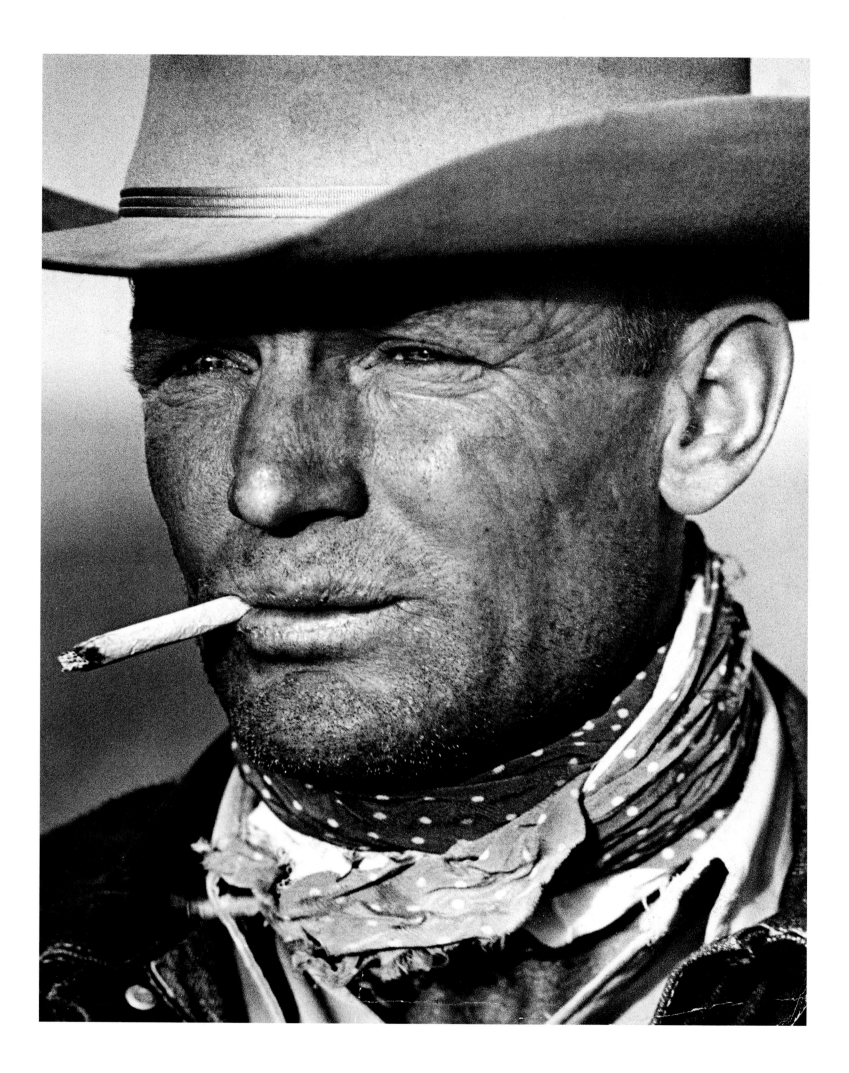

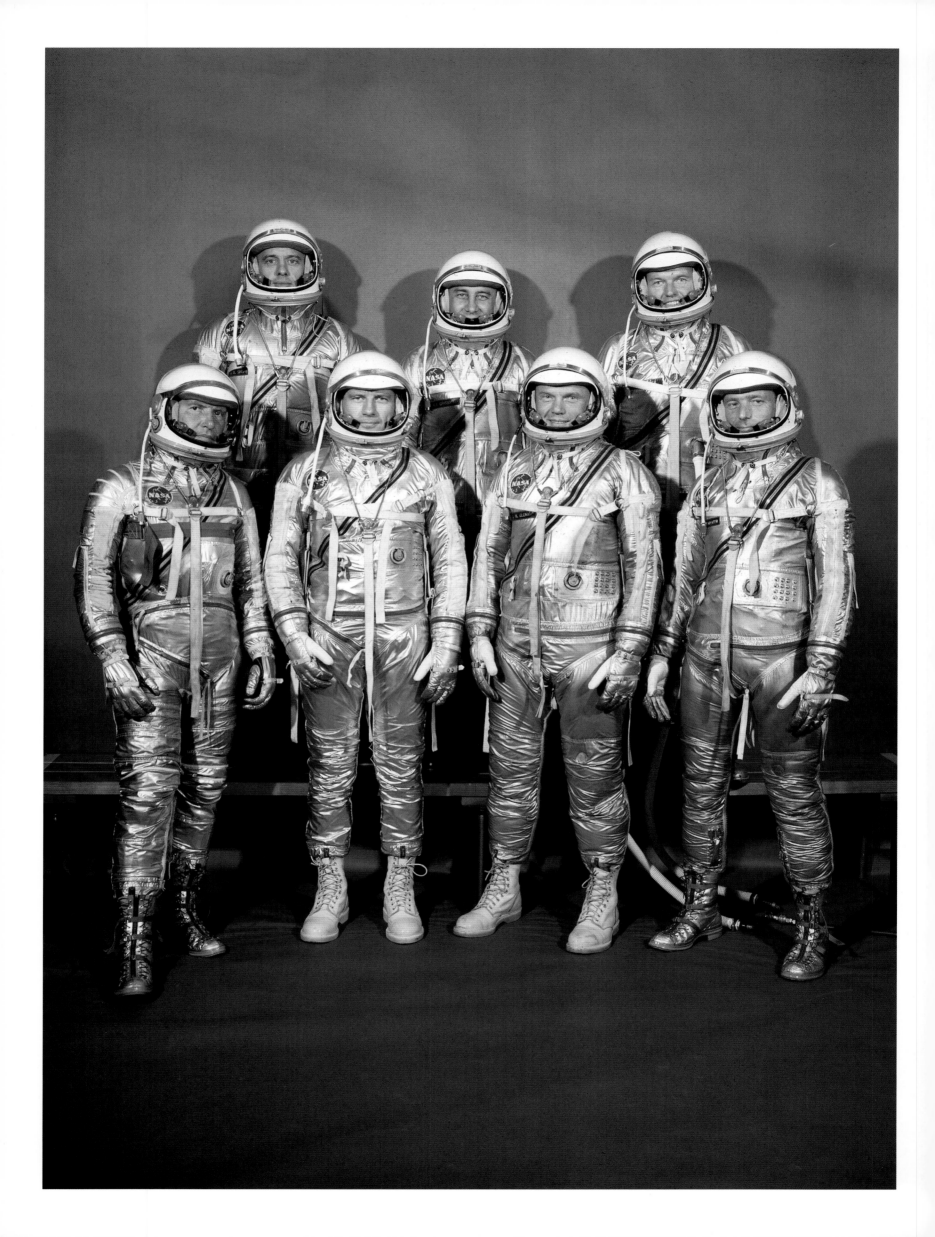

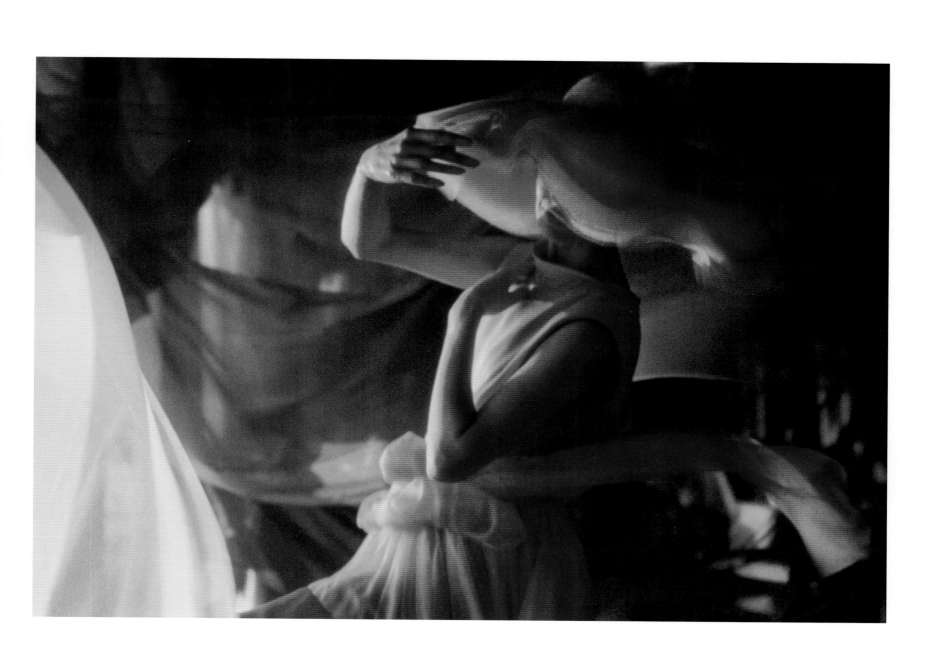

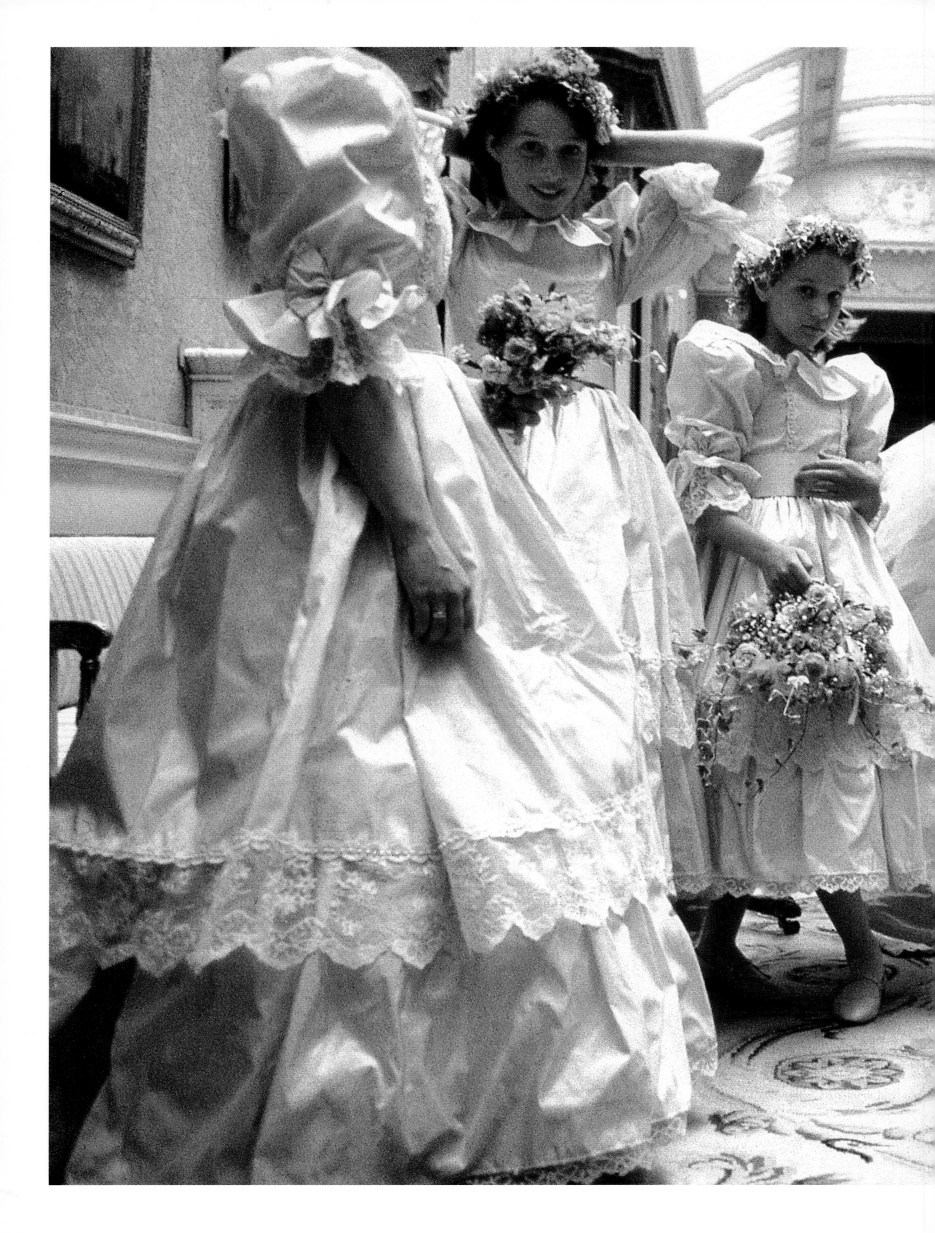

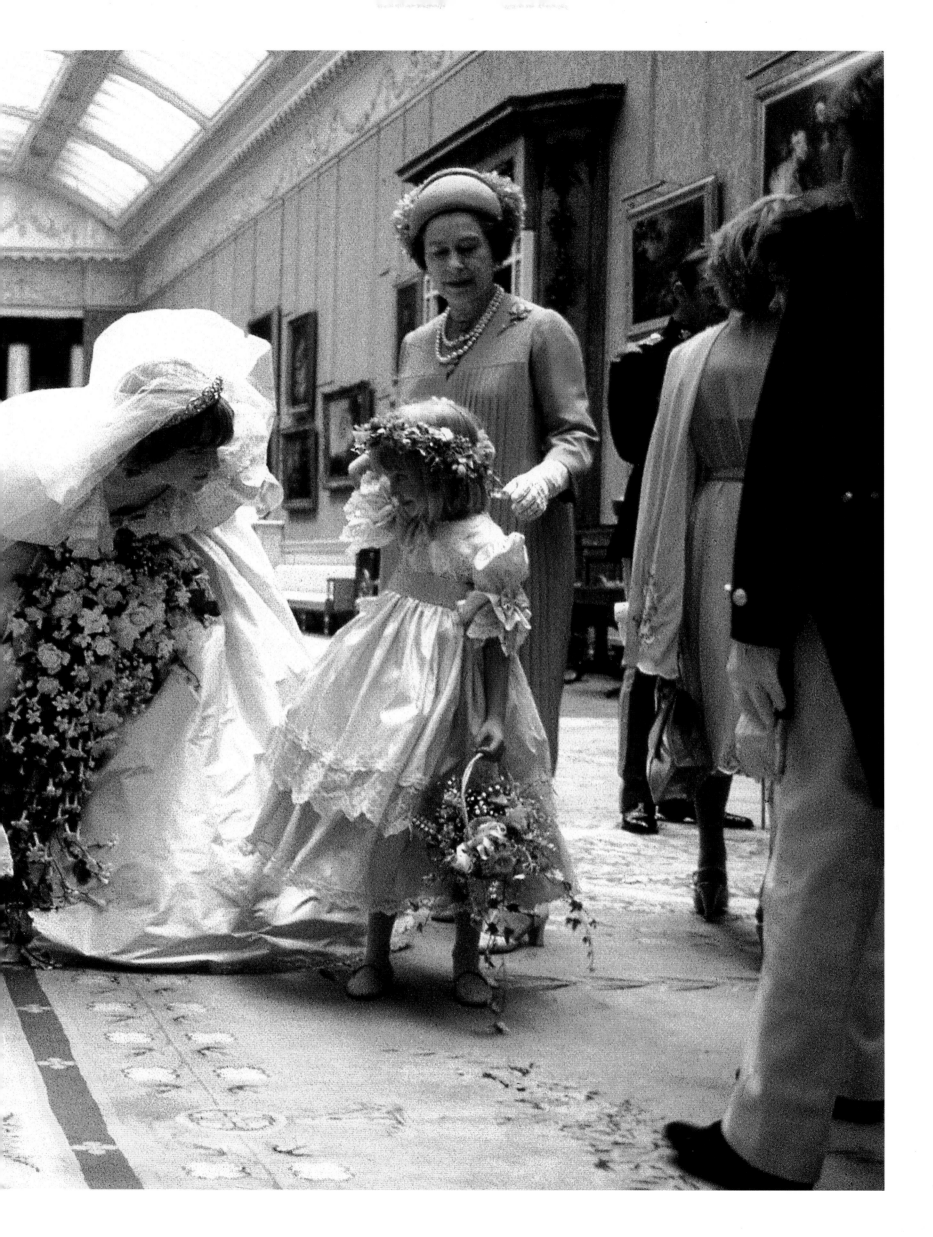

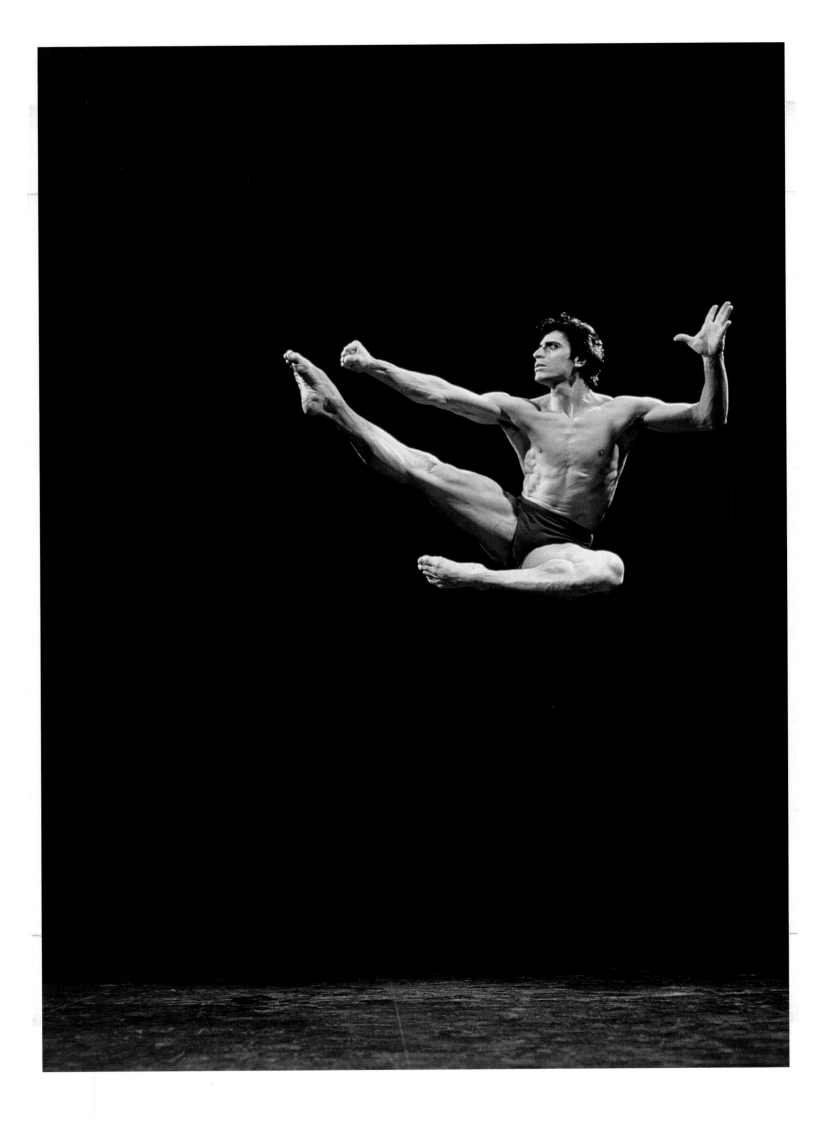

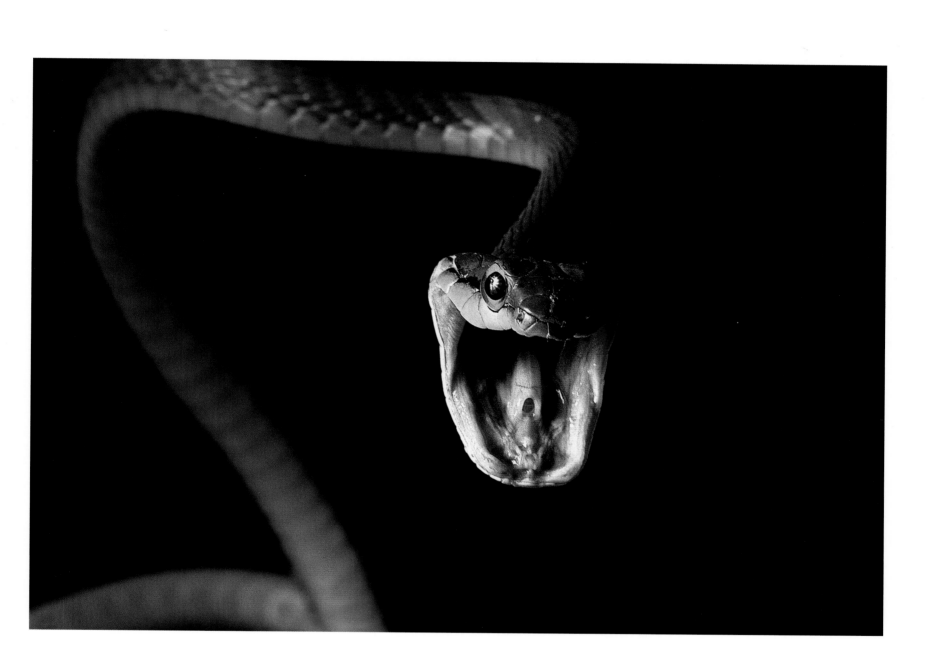

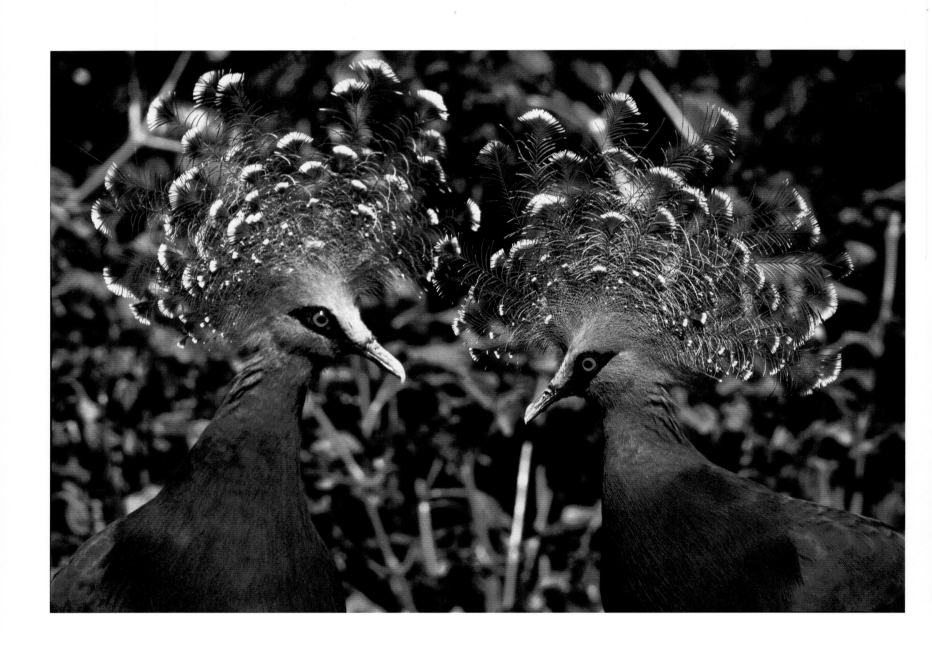

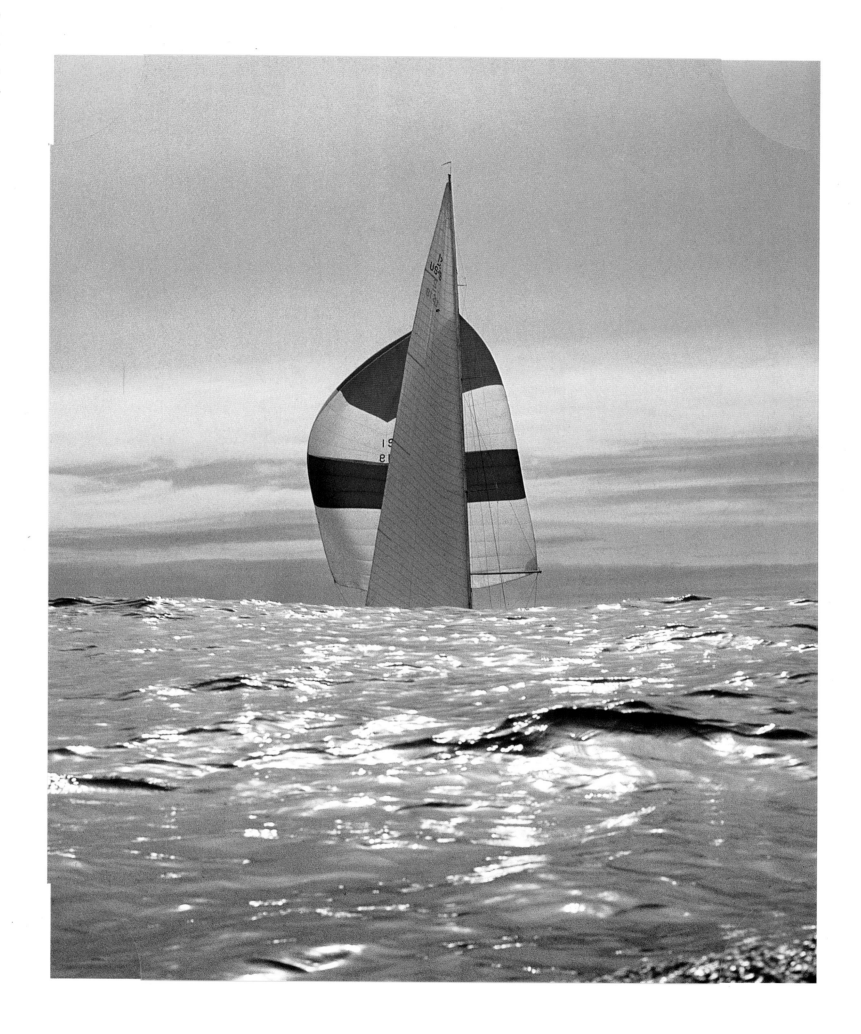

Page 118
**PIGEONS, 1966**
Yes, they're pigeons, but no ordinary pigeons: They're crested Gouras, photographed by Burrows at the Nondugl Aviary in New Guinea during one of his sorties out of harm's way in the years he was covering the Vietnam War. Burrows had, clearly, a tremendous appreciation of color. Earlier in his career, the Englishman had been one of LIFE's chief color copyists, lugging half a dozen cases of bulky equipment around Europe in order to photograph paintings, old buildings and objets d'art. "What he loved to do best," *Time* Saigon bureau chief Frank McCulloch once recalled, "was to study the paintings of the old masters, and then try to capture all their richness and subtlety on film." He succeeded wondrously, becoming a master in his own right.
PHOTOGRAPH BY LARRY BURROWS

Page 119
**AMERICA'S CUP, 1962**
A native New Zealander, George Silk joined the Australian Army as a photographer in World War II. Captured by Rommel's troops in North Africa, he escaped and finished the war as a LIFE photographer in the Pacific. Then, as we have already seen in his study of the diver and his picture from on high in Pittsburgh, he moved on to fun and games: sports, of which he became a master chronicler. He developed new technological approaches to picture-taking and was renowned for being able to immerse a viewer in the action. Here, you are on the water as the yacht *Nefertiti* competes in the America's Cup trials. The boat lost, but there's a happy postscript: Restored, she still races in the seas off Newport, R.I.
PHOTOGRAPH BY GEORGE SILK

Page 121
**"AMERICAN GOTHIC," 1942**
Gordon Parks felt that he was often acting as a crusader, waging a battle with his words and pictures. Early on, in 1942, he moved to Washington, D.C., upon joining the Farm Security Administration. In the nation's capital, he was struck by the racism that afflicted the city. Ella Watson was a charwoman there, and Parks began talking to her. "She told me about how her father had been lynched. How her daughter died at childbirth. How she was bringing up two kids on a salary fit for half a person." Realizing his camera could be a weapon, Parks produced "my first professional photograph"—an instant classic.
PHOTOGRAPH BY GORDON PARKS

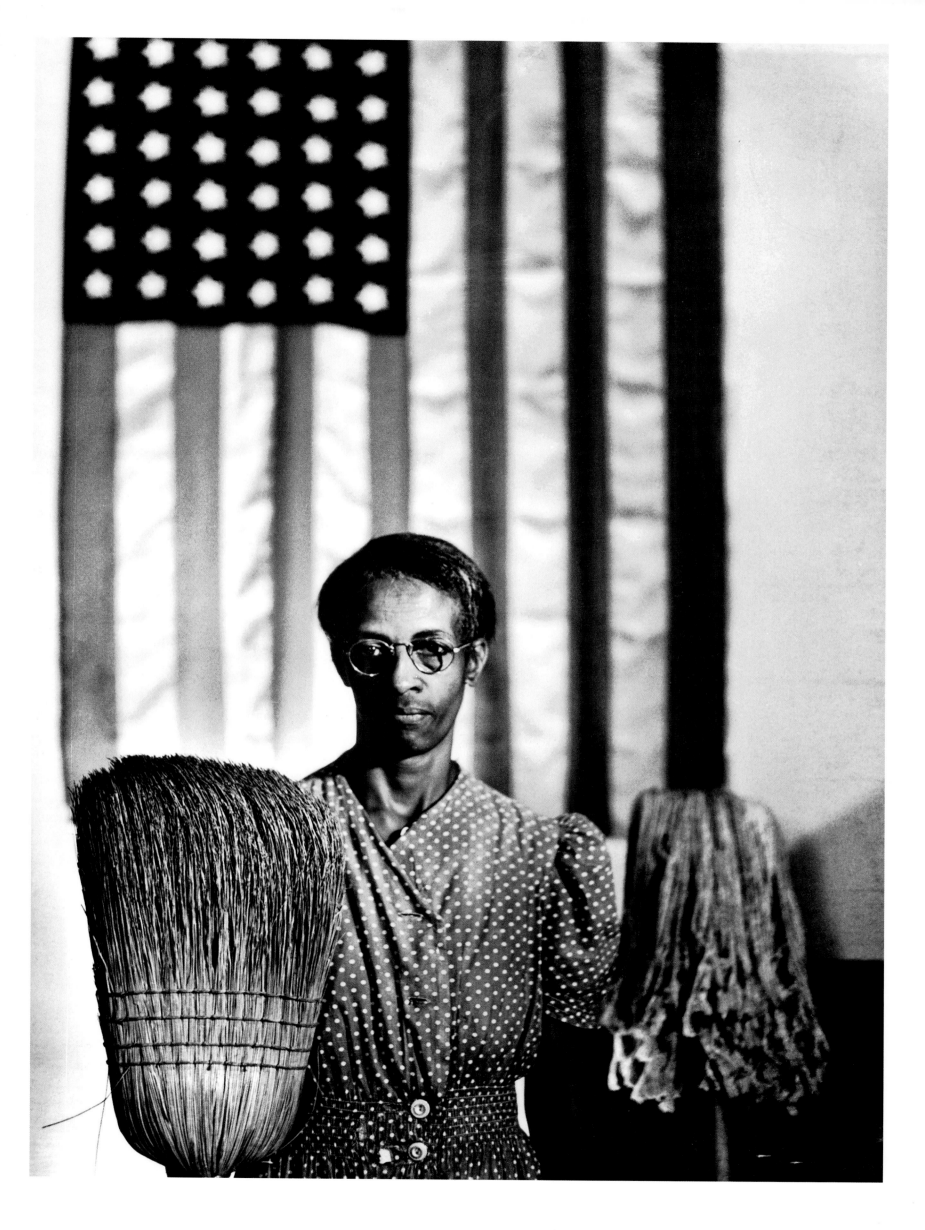

# THE SUNNY SIDE OF LIFE

... TO SEE AND TAKE PLEASURE IN SEEING...

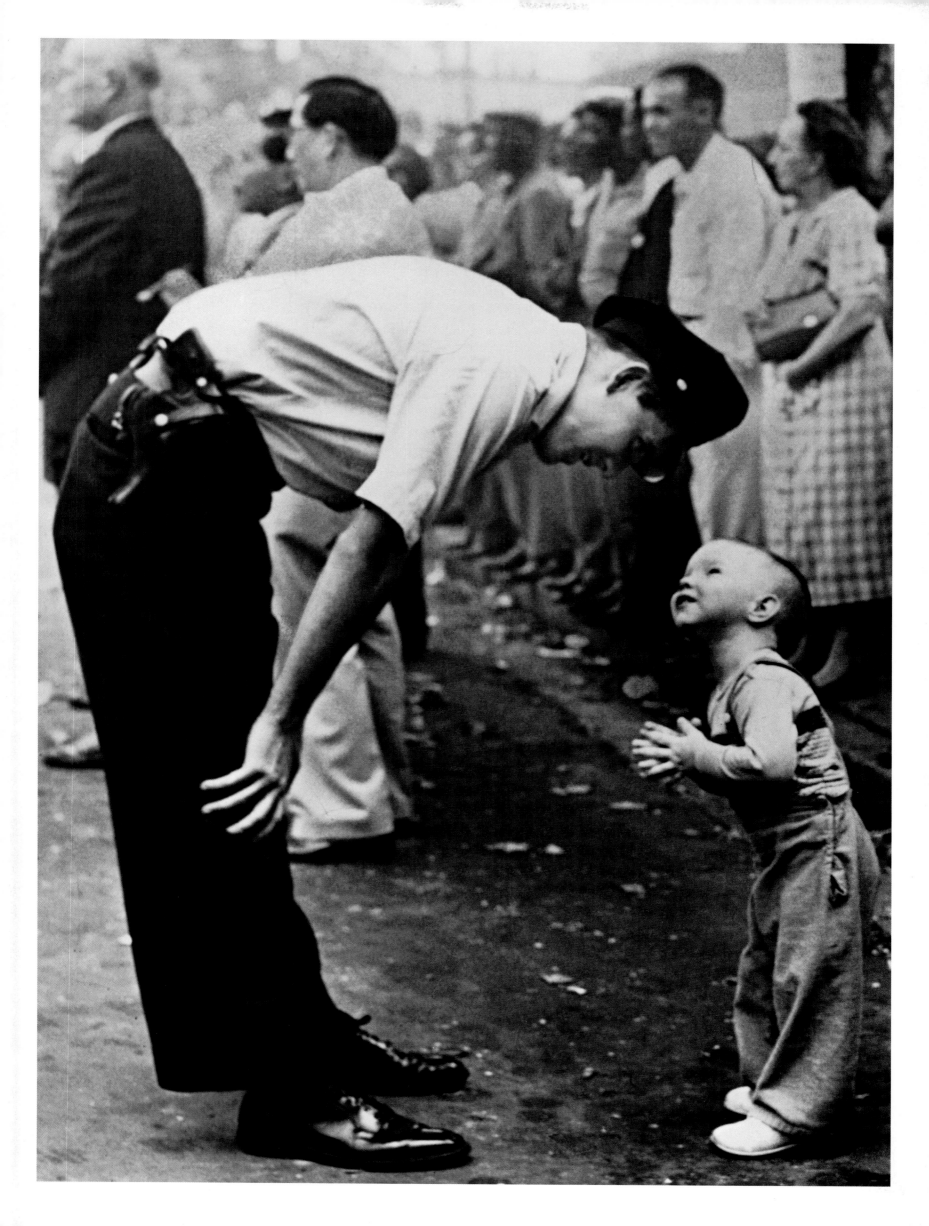

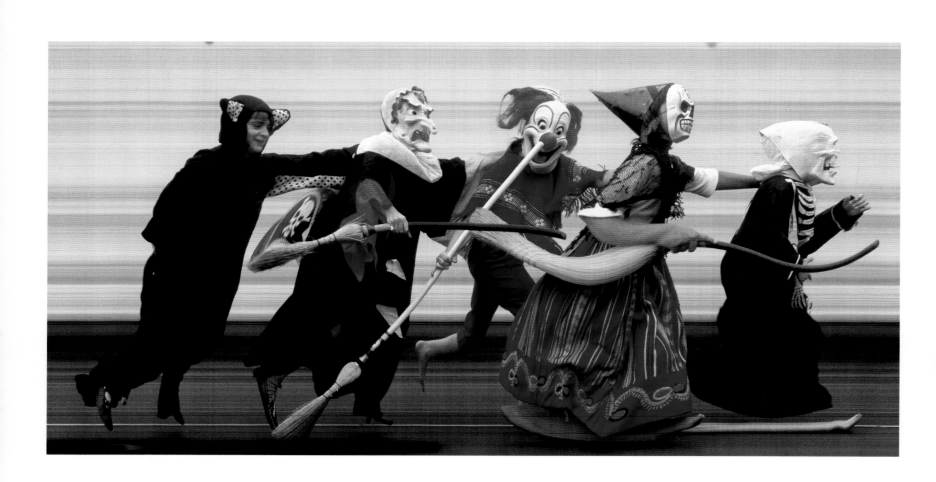

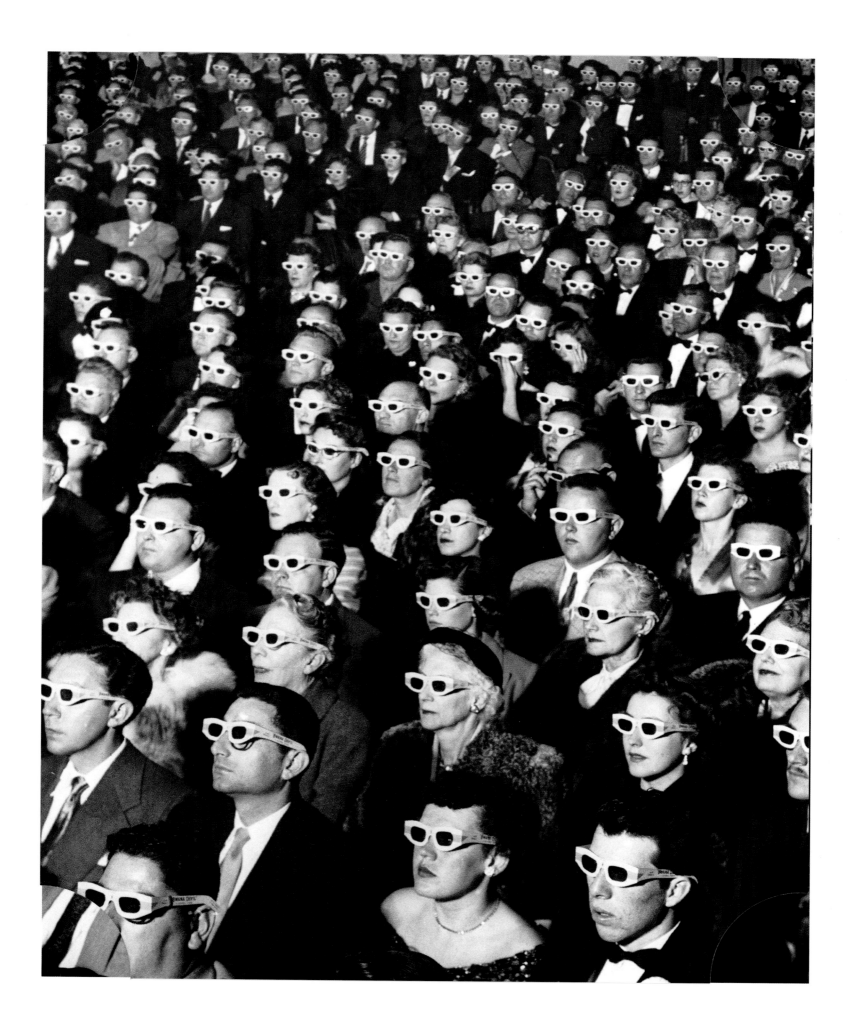

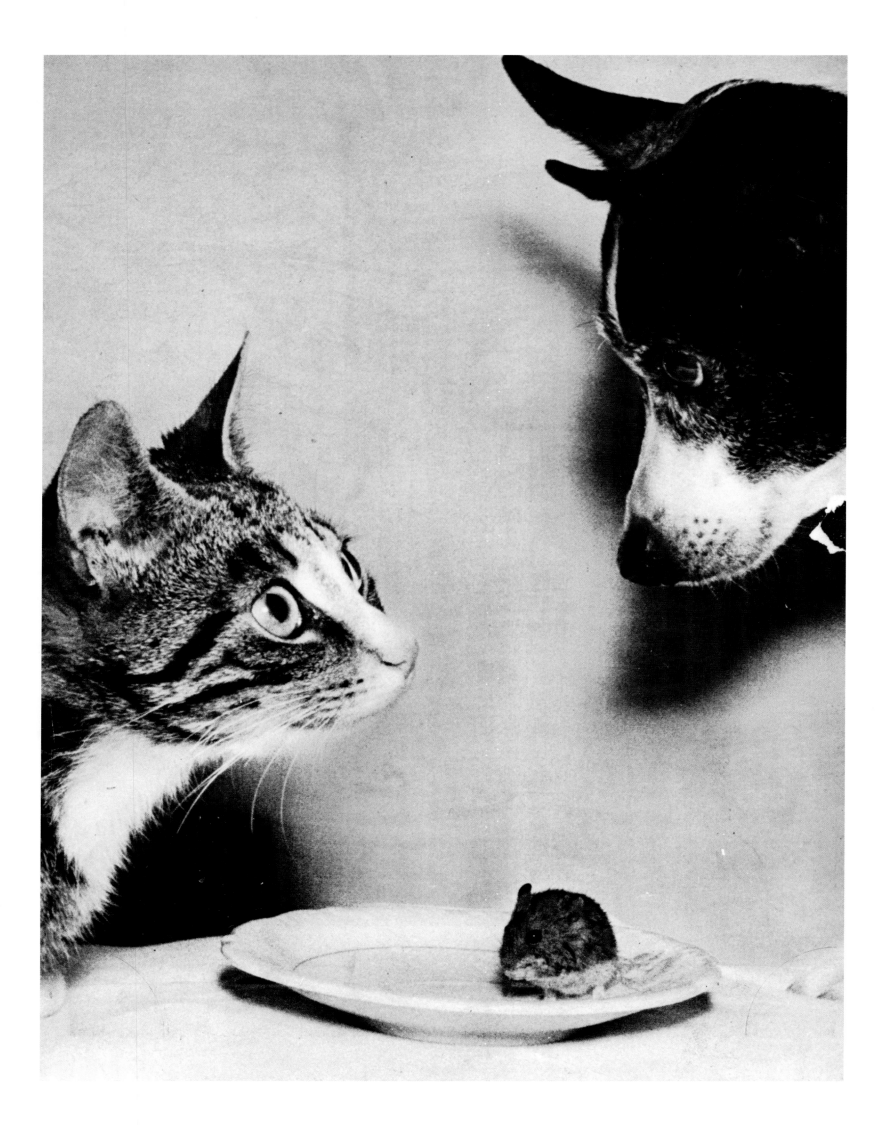

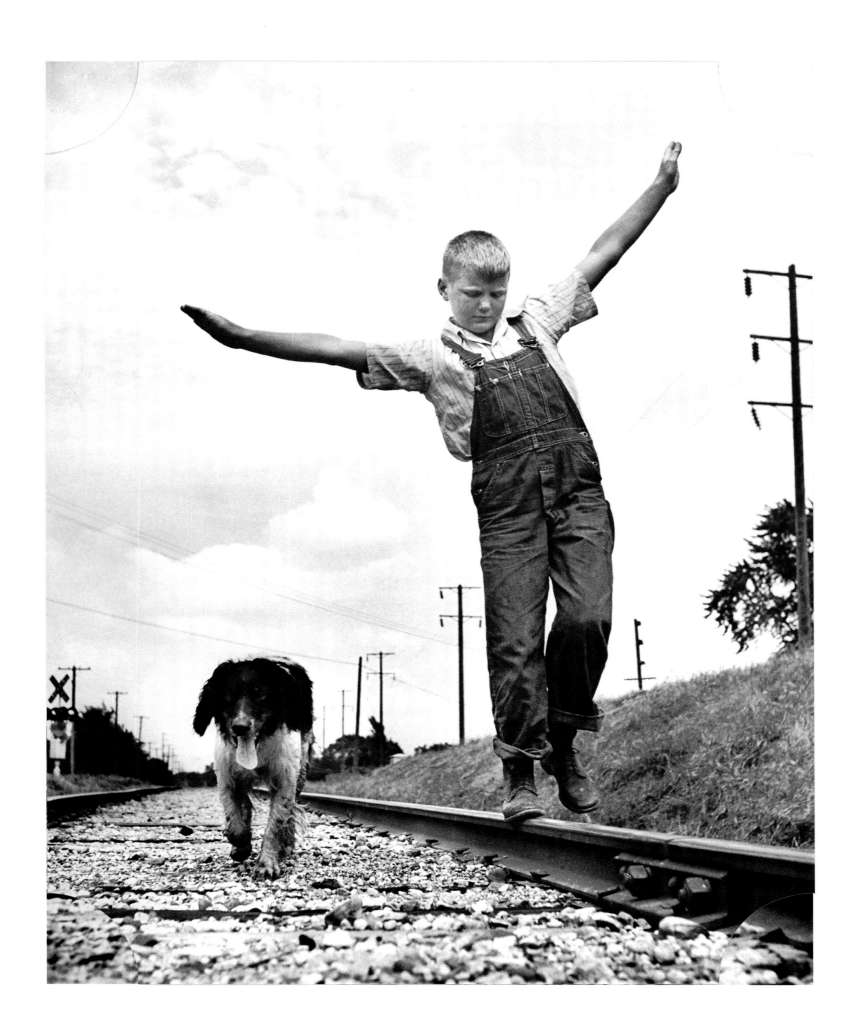

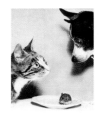

Page 128
**GUESS WHO'S COMING TO DINNER, 1955**
Many cats were stars of Miscellany pictures. Many dogs as well. And more than a few mice. In fact, if there were unwritten rules of thumb to dealing with LIFE's back page they included: (A) Leave 'em laughing. (B) Animals always work. (C) Kids do too. (D) Particularly babies. There's very little question that many of the best and funniest parting shots were not the spontaneous moments they seemed. In this case, Mitten the kitten, Tosen the canine and I'il Kim, enjoying her cheese, were all well-behaved house pets of the Lyng family in Denmark. In other words, this seemingly fraught situation had nothing but happy endings.
PHOTOGRAPH BY JYTTE BJERREGAARD

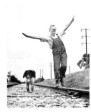

Page 129
**HUCK FINN IN THE FLESH, 1945**
Sometimes, the best picture is the one that simply makes you smile, while reinforcing your notions of what it means to be free and happy in this country of ours. Staff photographer Myron Davis had spent World War II confronting pretty horrific scenes—"I was so shocked I turned away and said, 'I cannot photograph this.' Then I thought, 'No, this is war. I've got to try to deal with this.'"—and so was happy to return home and turn his attention to the Americana that enraptured him. One day his subject was Larry Jim Holm, age 12, hanging with his dog, Dunk, in Oskaloosa, Iowa. There are two well-known shots of Larry and Dunk, the other from behind, Larry with a fishing pole draped over his shoulder. He's even wearing a straw hat. That one seems a nice photo version of a Norman Rockwell painting. This one seems a very real moment in time—and also, somehow, the reason we fought that recently ended war.
PHOTOGRAPH BY MYRON DAVIS

Page 131
**YOU MAY KISS THE BRIDE, 1946**
The photographer Allan Grant was famous for his photographs of the queens of Hollywood—Marilyn Monroe, Audrey Hepburn, Grace Kelly—as well as those of such subjects as Richard M. Nixon and bomb testing in the Nevada desert. But he had a specialty, too, in capturing the lighthearted side of life, and his work often appeared in LIFE's Speaking of Pictures section, our repository for humorous and otherwise striking images before the last page was given over to Miscellany. His first shots were accepted by LIFE in 1945, and in the July 15 issue the following year there ran this shot of Yolanda Cosmar and "Mad Marshall" Jacobs after their blissful nuptials atop a flagpole in Coshocton, Ohio. By the end of '46, Grant was a staff photographer, and he stayed with LIFE through the late 1960s.
PHOTOGRAPH BY ALLAN GRANT

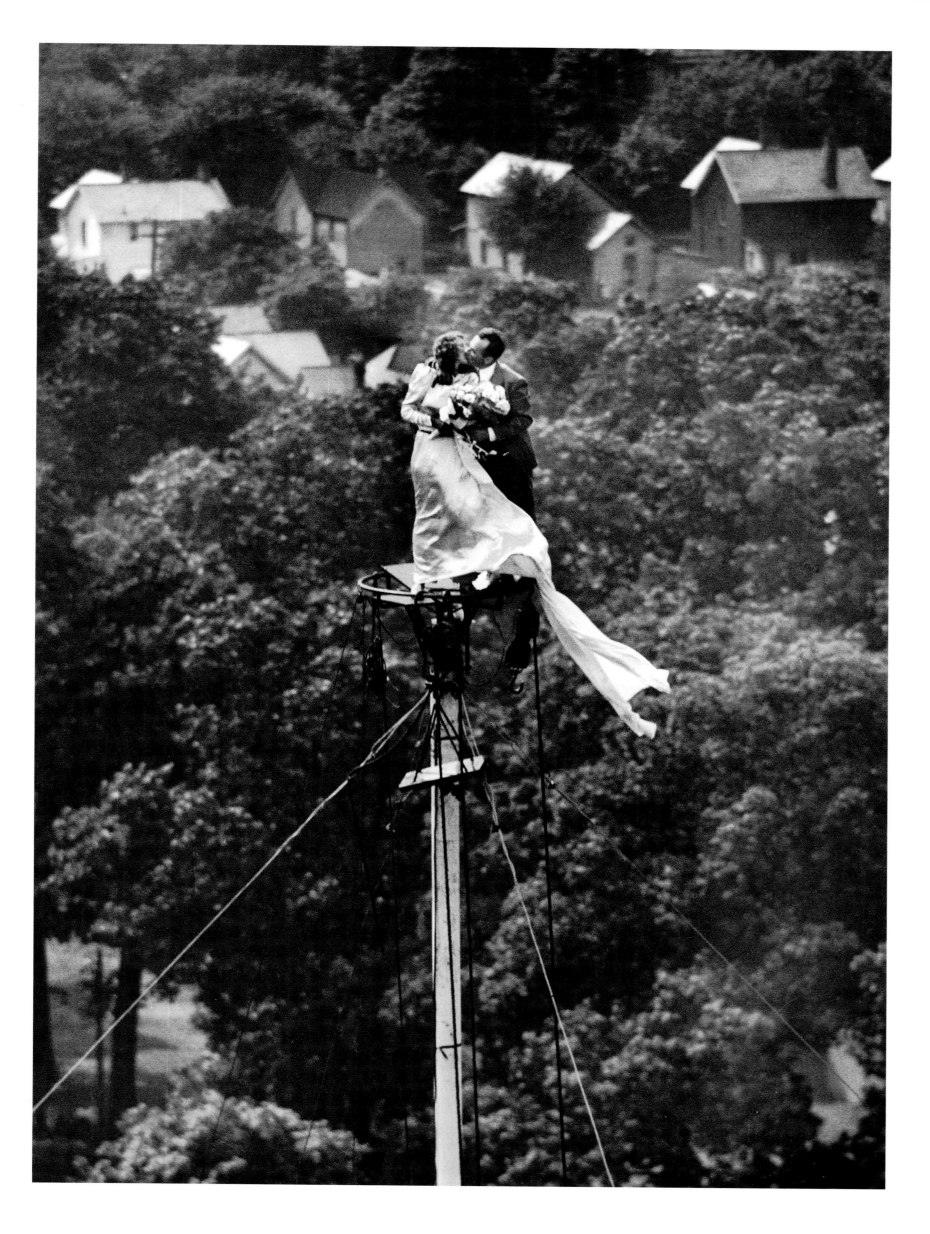

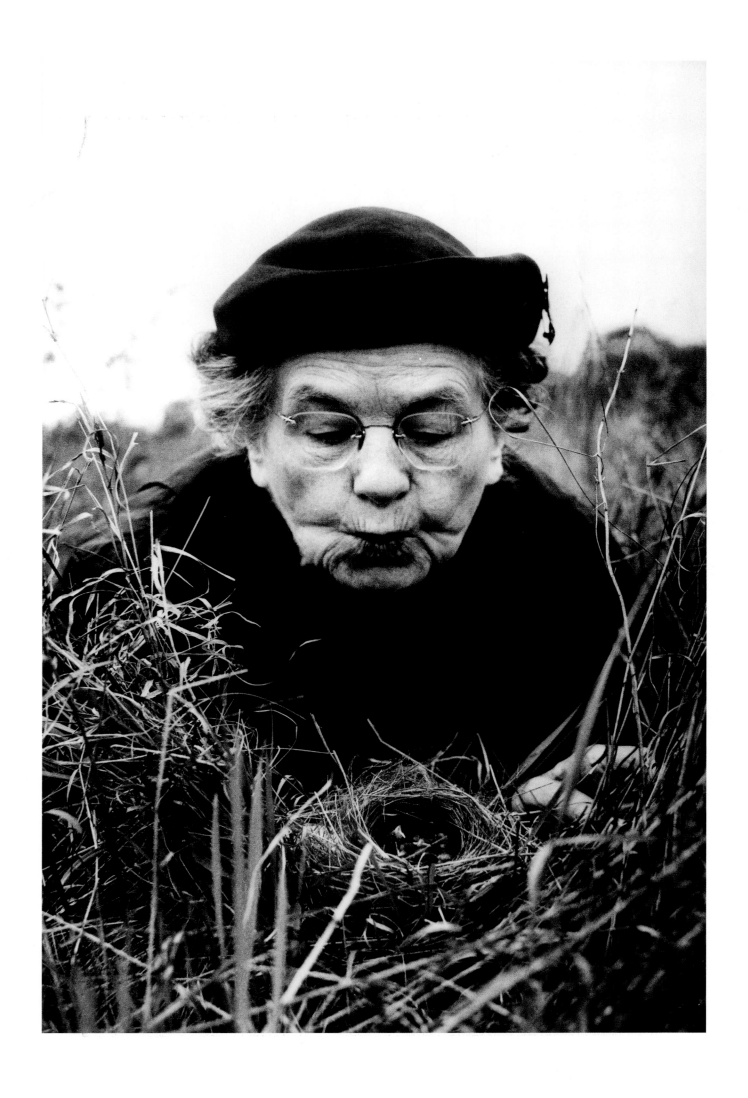

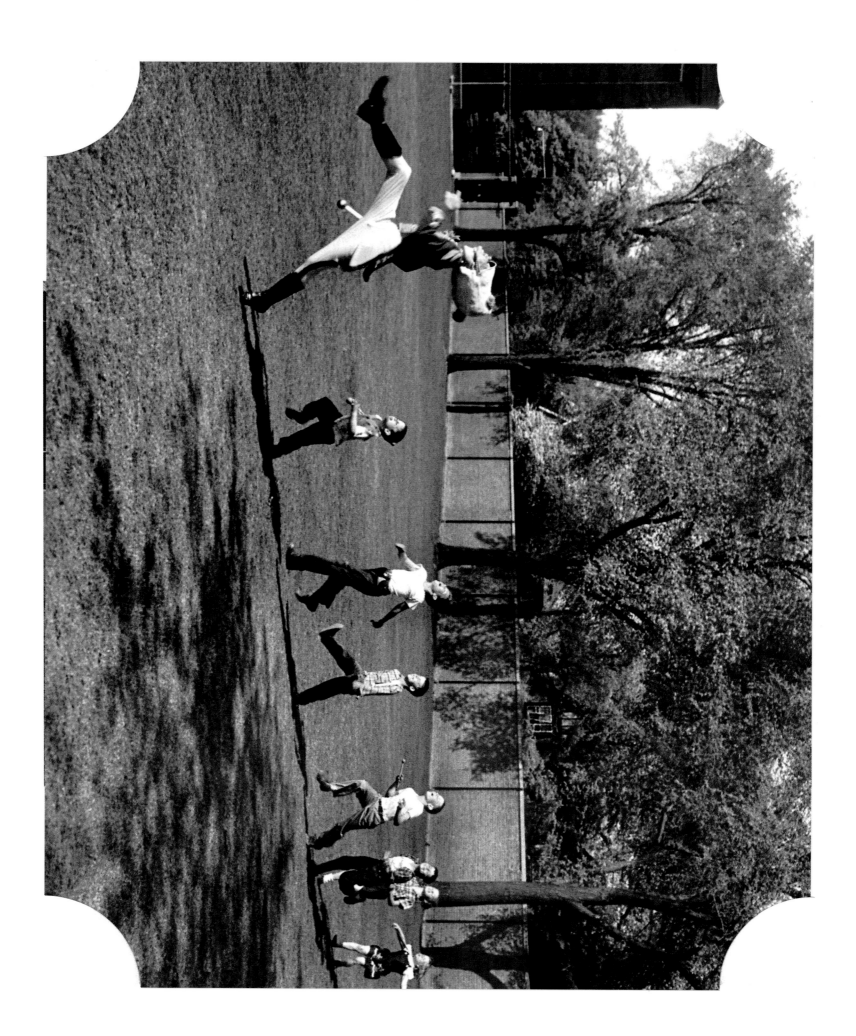

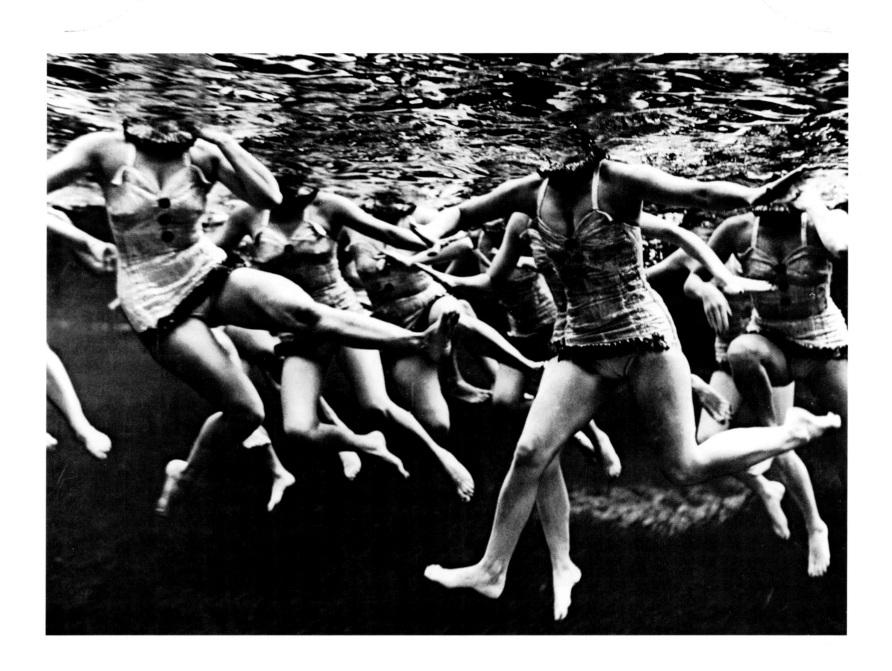

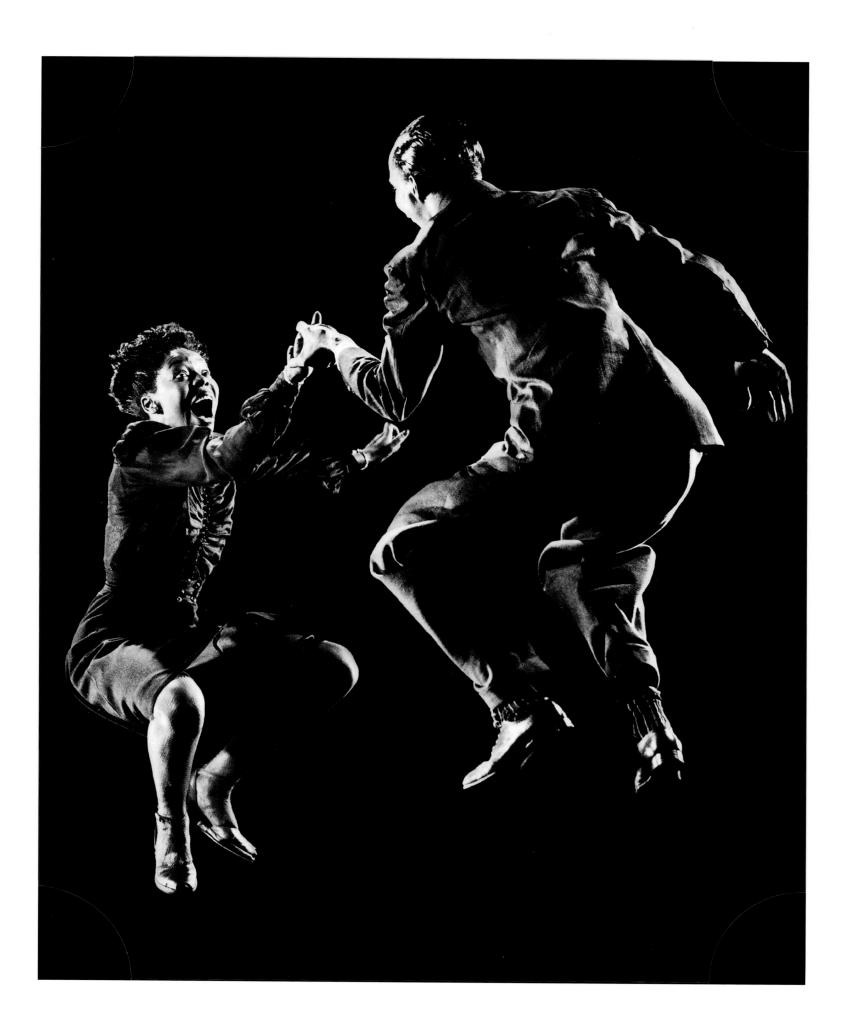

Page 140
**SORTA SYNCHRONIZED, 1953**
"A group of lovely but apparently headless mermaids trying to stay afloat." That's how LIFE's editors described this rather bizarre Halsman portrait of the championship Canadian aquacade team during a demonstration performance in Silver Springs, Fla. Seeking a unique perspective, Halsman secured a seat four feet beneath the water's surface in a glass-sided boat. As we reported at the time: "The music sounded better under water, Halsman discovered, than it did in the bleachers. And the intricate ballet numbers looked even more difficult to perform. Instead of just seeing the swimmers as they bobbed up smilingly at the surface, Halsman was able to photograph them scurrying grimly along the bottom to get into position."
PHOTOGRAPH BY PHILIPPE HALSMAN

Page 141
**HOPPIN', 1943**
The dance step called the Lindy Hop was born in Harlem in the 1920s, jumping to the beat and rhythms of, first, the Hot Jazz scene, and then that of the Big Bands. For Gjon Mili it was demonstrated against a black background by Leon James and Willa Mae Ricker. James, with his constantly moving hands and flashing eyes, was one of the greatest on-stage personalities of his era. Mili, for his part, was in 1943 a master photographer—and, the next year, a movie director. His love of jazz led him to make the classic short film *Jammin' the Blues,* starring Lester Young and other musicians. Its exuberant mood echoes that of this famous photograph.
PHOTOGRAPH BY GJON MILI

# AFTERWORD

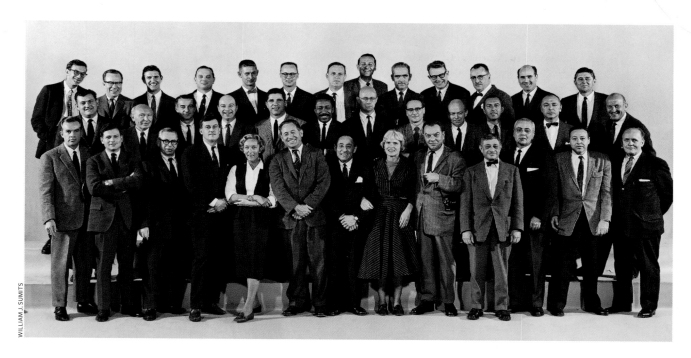

WILLIAM J. SUMITS

## The People Behind These Pictures

SO THERE WE ARE: 100 memorable pictures hanging in the LIFE Gallery. We hope you have enjoyed your visit.

Before you go, we thought you might like to see some of the faces that were behind the lenses when those pictures were made. Photographers, in particular among artists, too infrequently step forward to receive their due applause. They let their images speak for themselves, and remain all but anonymous.

In 1960 LIFE's staff photographers gathered in New York City for a class photo, and many whose work you have just seen were on hand. In the front row, from left, we have James Whitmore, Paul Schutzer, Walter Sanders, Michael Rougier and Nina Leen. Now come the original four staffers—Peter Stackpole, Alfred Eisenstaedt, Margaret Bourke-White and Thomas McAvoy—and then, continuing on, Carl Mydans, Al Fenn, Ralph Morse and Francis Miller. In the next row, again from the left, are Hank Walker, Dmitri Kessel, N.R. Farbman, Yale Joel, John Dominis, Gordon Parks, James Burke, Andreas Feininger, Fritz Goro, Allan Grant, Eliot Elisofon and Frank Scherschel. And backing them up are Grey Villet, Ed Clark, Loomis Dean, Joe Scherschel, Stan Wayman, Robert W. Kelley, J.R. Eyerman, Ralph Crane, Leonard McCombe, Howard Sochurek, Wallace Kirkland, Mark Kauffman and our intrepid New Zealander, George Silk.

Others you have met in these pages (Larry Burrows, David Douglas Duncan, Martha Holmes, Hansel Mieth, Gene Smith . . .) weren't on hand for the photo session, and others still (Harry Benson, Bill Eppridge, Joe McNally . . .) were not yet on the scene. Nevertheless: Please allow this picture to stand, if you will, as a collective bow by the great LIFE photographers. Their body of work represents, clearly, a remarkable achievement.

And from that work you now have this Classic Collection: 100 memorable pictures, and 24 prints, suitable for framing.

Ah, but didn't we promise you 25 prints?

Well, yes, we did. And in the LIFE tradition of always giving you Just One More on the last page, it is forthcoming. Can you guess which image it is? Sure you can. It's the most famous and beloved picture ever to appear in LIFE, a photograph that sings of joy, of triumph, of America. It is yet another taken by Eisie. Among the things it is not: It's not entitled "The Kiss." In fact, it has no formal title; best to just call it "V-J Day, 1945, Times Square."

As for which of many claimants was the sailor and which was the nurse, LIFE has never said, and is not saying today. The truth is, we really don't know for sure. But we do know that people have cherished this picture for more than 60 years. We thought you would like to have a copy. And now you do. Enjoy!